THE A. W. MELLON LECTURES IN THE FINE ARTS

DELIVERED AT THE NATIONAL GALLERY OF ART
WASHINGTON, D. C.

1952. CREATIVE INTUITION IN ART AND POETRY by Jacques Maritain

1953. THE NUDE: A STUDY IN IDEAL FORM by Kenneth Clark

1954. THE ART OF SCULPTURE by Herbert Read

1955. PAINTING AND REALITY by Etienne Gilson

1956. ART AND ILLUSION: A STUDY IN THE PSYCHOLOGY OF PICTORIAL
REPRESENTATION by E. H. Gombrich

1957. THE ETERNAL PRESENT: I. THE BEGINNINGS OF ART
II THE BEGINNINGS OF ARCHITECTURE by S. Giedion

1958. NICOLAS POUSSIN by Anthony Blunt

1959. OF DIVERS ARTS by Naum Gabo

1960. HORACE WALPOLE by Wilmarth Sheldon Lewis

1961. CHRISTIAN ICONOGRAPHY: A STUDY OF ITS ORIGINS by André Grabar

1962. BLAKE AND TRADITION by Kathleen Raine

1963. THE PORTRAIT IN THE RENAISSANCE by John Pope-Hennessy

1964. ON QUALITY IN ART by Jakob Rosenberg

1965. THE ORIGINS OF ROMANTICISM by Isaiah Berlin

1966. VISIONARY AND DREAMER: TWO POETIC PAINTERS, SAMUEL PALMER
AND EDWARD BURNE-JONES by David Cecil

1967. MNEMOSYNE: THE PARALLEL BETWEEN LITERATURE AND THE
VISUAL ARTS by Mario Praz

1968. IMAGINATIVE LITERATURE AND PAINTINGS by Stephen Spender

1969. ART AS A MODE OF KNOWLEDGE by Jacob Bronowski

BOLLINGEN SERIES XXXV · 16

MNEMOSYNE

THE PARALLEL BETWEEN LITERATURE

AND THE VISUAL ARTS

BY MARIO PRAZ

THE A. W. MELLON LECTURES IN THE FINE ARTS · 1967

THE NATIONAL GALLERY OF ART

WASHINGTON, D. C.

BOLLINGEN SERIES XXXV · 16

PRINCETON UNIVERSITY PRESS

Copyright © 1970 by the Trustees of the National Gallery
of Art, Washington, D. C.

Published by Princeton University Press, Princeton, New Jersey

This is the sixteenth volume
of the A. W. Mellon Lectures in the Fine Arts,
which are delivered annually at the National Gallery of Art, Washington.
The volumes of lectures constitute Number XXXV
in Bollingen Series, sponsored by Bollingen Foundation

Library of Congress Catalogue Card No.: 68–20876
SBN 691–0985F–3

Printed in the United States of America

CONTENTS

ACKNOWLEDGMENTS

The author acknowledges his indebtedness for permission to quote in the text as follows: For the poem in Chapter VII, copyright 1923 and 1951 by E. E. Cummings and reprinted from his volume *Poems 1923–1954*, to Harcourt, Brace & World, Inc., New York, and to MacGibbon & Kee Ltd., London. For excerpts from *The Waves* by Virginia Woolf and *The Waste Land* by T. S. Eliot, to Harcourt, Brace & World, Inc., New York, and respectively to the Hogarth Press Ltd. and Faber & Faber Ltd., London. For an excerpt from a poem by W. H. Auden, from his *Collected Shorter Poems, 1927–1957*, and for a passage from Gertrude Stein's *Ida* and one from *Selected Writings of Gertrude Stein*, ed. Carl Van Vechten, to Random House, Inc. For the extract from Auden, also to Faber & Faber Ltd., London. For permission to quote the poem by Gertrude Stein on p. 207, in Chapter VII, as well as the two excerpts just listed, to the Estate of Gertrude Stein, Daniel C. Joseph, Administrator. For passages from *Concluding* and *Back*, by Henry Green, to the Viking Press, Inc., New York, and the Hogarth Press Ltd., London. For a passage from *Living*, by Henry Green, to J. M. Dent & Sons Ltd., London. For a passage from *The Body*, copyright 1949 by the author, William Sansom, to the Hogarth Press Ltd., London.

LIST OF ILLUSTRATIONS

P = *source of photograph. Unless otherwise indicated, the photographs have usually been furnished by the respective institution or collection.*

Mnemosyne:

THE PARALLEL BETWEEN LITERATURE
AND THE VISUAL ARTS

CHAPTER I

"Ut Pictura Poesis"

AN AXIOM of idealistic philosophy recorded by E. M. Forster proclaims: "A work of art . . . is a unique product. But why? It is unique not because it is clever or noble or beautiful or enlightened or original or sincere or idealistic or useful or educational—it may embody any of those qualities —but because it is the only material object in the universe which may possess internal harmony. All the others have been pressed into shape from outside, and when their mould is removed they collapse. The work of art stands up by itself, and nothing else does. It achieves something which has often been promised by society, but always delusively. Ancient Athens made a mess—but the *Antigone* stands up. Renaissance Rome made a mess—but the ceiling of the Sistine got painted. James I made a mess— but there was *Macbeth*. Louis XIV—but there was *Phèdre*."[1] If, then, what interests you in a work of art is its being unique, if what interests you in a possible parallel between a poem and a painting is not what they may have in common, but rather what differentiates them and makes each of them a thing apart, if you are not interested in sources but only in the final product, then the subject of this book will appear to you academic and even futile.

On the other hand, the idea of the sister arts has been so rooted in men's minds since times of remote antiquity, that there must be in it something deeper than an idle speculation, something tantalizing and refusing to be lightly dismissed, like all problems of origins. One might say that by probing into those mysterious relationships men think to come closer to the whole phenomenon of artistic inspiration.

Indeed, even if not actually from prehistoric times (since palaeologists have shown that the first signs men traced on rock surfaces were ab-

stract), certainly from the early flowering of the civilization to which, until recently, we were proud to belong (until someone stood up to preach that art must be "raw," obeying only one's impulses and no tradition whatsoever), from those remote times until yesterday there has been a mutual understanding and a correspondence between painting and poetry. Ideas were expressed by means of pictures not only in Egyptian hieroglyphics, but throughout a long and very copious symbolic tradition, part of which has been brilliantly illustrated by Edgar Wind in his book on *Pagan Mysteries in the Renaissance*.[2]

The sphinx was not only a fantastic animal, it also possessed for the ancients a meaning which is explained by Pico della Mirandola: "that divine things should be concealed in riddles and poetical dissimulation." Just as words take up various and occasionally outwardly contrasting meanings, so did symbolical figures, and thus the sphinx meant also a guilty and demented ignorance. We seem to detect the shape of a skull in the folds of the dress which covers the Virgin's bosom in Michelangelo's *Pietà:* is it a casual arrangement, or else either a deliberate or a subconscious allusion of this artist in whom, according to Vasari, "never did a thought arise in which death was not engraved"? And while the *technopaignia* of the Alexandrians and of the seventeenth-century poets who revived that fashion were naïve attempts at suggesting objects (such as an ax, an altar, a pair of wings) through a pattern of lines of different lengths, and Apollinaire's *calligrammes* were animated by a similar intention, on the other hand one comes across much weightier pictorial suggestions in the course of literature.

These have been studied by an American scholar, Jean H. Hagstrum, in *The Sister Arts: The Tradition of Literary Pictorialism and English Poetry from Dryden to Gray*.[3] Although Hagstrum, as the subtitle states, is chiefly concerned with the English tradition, he traces the story of the alliance between painting and poetry to its origins.[4] Two stock phrases, one of Horace, the other of Simonides of Ceos, enjoyed an undisputed authority for centuries: the expression *ut pictura poesis*, from the *Ars poetica*, which was interpreted as a precept, whereas the poet had only intended to say that like certain paintings, some poems please only once, while others can bear repeated readings and close critical scrutiny; and a comment, attrib-

uted by Plutarch to Simonides of Ceos, to the effect that painting is mute poetry and poetry a speaking picture.

On such texts the practice of painters and poets was based for centuries; the former derived inspiration from literary themes for their compositions, the latter tried to conjure up before the readers' eyes such images as only the visual arts, one would have thought, might adequately convey. A glance at an old tradition dating back as far as Homer's description of Achilles' shield will easily convince us that poetry and painting have constantly proceeded hand in hand, in a sisterly emulation of aims and means of expression. This is the case whether you consider the ἐκφράσεις of the Alexandrians, the *Imagines* of Philostratus the Elder, or the plastic descriptions of Dante's *Divine Comedy* (such as the sculptural Annunciation in the tenth canto of the *Purgatory*), of Boccaccio's *Amorosa Visione*, and of the *Orlando Furioso* (to quote only instances from the Italian tradition); even down to Foscolo's *Grazie*, in which the poet has Canova for a model, and to D'Annunzio's sensuous images, which owe a good deal to the Pre-Raphaelites, who in their turn were saturated with suggestions from the literary field. And, in the English tradition, one may trace the same trend from Chaucer's description of the monuments of the worthies in the *House of Fame* and the paintings in verse in Spenser and Shakespeare (*The Rape of Lucrece*) down to Keats's passages inspired by Titian, Poussin, the Elgin marbles, and even by John Martin's spectacular compositions.[5]

The theme of "directions to the painter," which, devised at first by Anacreon, enjoyed a great vogue particularly with English poets, was no mere elegant fiction: painters actually took suggestions from writers, and followed schemes invented by the latter in the decoration of walls and ceilings as well as in the choice of subjects for single paintings. One may quote the cases of Botticelli's *Primavera, Birth of Venus*, and *Calumny,* or of some of Giorgione's paintings, but there are plenty of other instances. On the other hand the *ut pictura poesis* formula was a warning to poets, since painting served to show that art could only be effective when it kept close contact with the visible world; and Ben Jonson, after translating a passage from Philostratus to the effect that "*Whosoever* loves not *Picture* is injurious to Truth and all the wisdome of *Poetry*" (which brings to mind

the famous lines of *The Merchant of Venice* on music), adds: "Picture is the invention of Heaven, the most ancient and most a kinne to Nature."[6] The amount of prestige achieved by painting, thanks to the great Italian masters of the Renaissance, caused Picture to obtain a victory over her sister art, Poetry; witness the poets' unrelenting efforts to vie with painters in the sensuousness of their descriptions.

This "iconic convention," as Hagstrum calls it, prevailed not only in the Renaissance, but most of all during the seventeenth century, when Giambattista Marino and his followers produced "galleries" of paintings in verse culminating in Pierre Le Moyne's *Peintures morales,* and when the literature of emblems was in its heyday. Indeed, in the seventeenth century we seem to watch the acute phase of a tendency of the imagination which Diderot attempted to explain in a passage of the "Lettre sur les sourds et les muets": "Il passe alors dans le discours du poëte un esprit qui en meut et vivifie toutes les syllabes. Qu'est-ce que cet esprit? j'en ai quelquefois senti la présence; mais tout ce que j'en sais, c'est que c'est lui qui fait que les choses sont dites et réprésentées tout à la fois; que dans le même temps que l'entendement les saisit, l'âme en est émue, l'imagination les voit et l'oreille les entend, et que le discours n'est plus seulement un enchaînement de termes énergiques qui exposent la pensée avec force et noblesse, mais que c'est encore un tissu d'hiéroglyphes entassés les uns sur les autres qui la peignent. Je pourrais dire, en ce sens, que toute poésie est emblématique."[7]

Whereas the English poets of the Elizabethan period had only a vague familiarity with painters (the only Italian artist mentioned by Shakespeare, Giulio Romano, was a sculptor of wax figures)[7a], eighteenth-century English poets were generally personal friends of painters, had seen the masterpieces of Italian art, and were themselves collectors of prints and sometimes of paintings. Shaftesbury was not exaggerating when he affirmed that the invention of prints was to English culture of the eighteenth century what the invention of printing had been earlier to the entire republic of letters.[8] In this way a pantheon of painters was formed, a constellation of famous names and famous works which exerted a paramount influence on taste. At the beginning of the nineteenth century, when English painting was in its heyday, the cultural circles were satu-

rated with connoisseurship. It was mostly through prints that Keats acquired a taste for the visual arts, in the wake of Leigh Hunt, who indulged in the most extravagant and haphazard parallels between painters and poets—particularly in the case of Spenser, in whom he finds the qualities of Titian, Rembrandt, Michelangelo, Rubens, Reni, Raphael, Correggio, and others.[9]

In the eighteenth century both poets and painters idealized contemporary subjects, deriving suggestions from the ancient statues, investing modern persons with qualities and attributes taken from history and mythology. This custom dated from the times of Alexandria and Imperial Rome, when sovereigns were represented with attributes of divinity, and lasted until the time of Canova, who represented Ferdinand IV of Naples (his face rendered almost grotesque by a plump Bourbon nose) in the garb of Minerva, the goddess of wisdom and culture [1]. Botticelli represented a lady, probably Caterina Sforza-Riario, with the attributes of the homonymous saint, the palm and the wheel (Lindenau Museum, Altenburg); Girolamo Savoldo showed another lady as St. Margaret, the dragon at her side (Capitoline Gallery, Rome); Titian made a portrait [2] of a young lady as Venus binding the eyes of Cupid. Mignard and Reynolds[10] portrayed members of the nobility as mythological figures: Mignard represented the Marchioness of Seigneleys as Thetis, and the Count of Toulouse as sleeping Cupid; Reynolds made Mrs. Sheridan into a St. Cecilia [3], Mrs. Blake into a Juno, and Mrs. Siddons the Tragic Muse (Romney chose the same role for Mrs. Yates). In the second scene of the fourth act of Steele's *The Tender Husband* (1705) this fashion is ridiculed in a dialogue between Captain Clerimont, who is disguised as a painter, and Biddy Tipkin (Mr. Tipkin's niece):

Niece. Since there is room for fancy in a picture, I would be drawn like the amazon Thalestris, with a spear in my hand, and an helmet on a table before me. At a distance behind let there be a dwarf, holding by the bridle a milk-white palfrey.

Clerimont. Madam, the thought is full of spirit, and if you please, there shall be a Cupid stealing away your helmet, to show that love should have a part in all gallant actions.

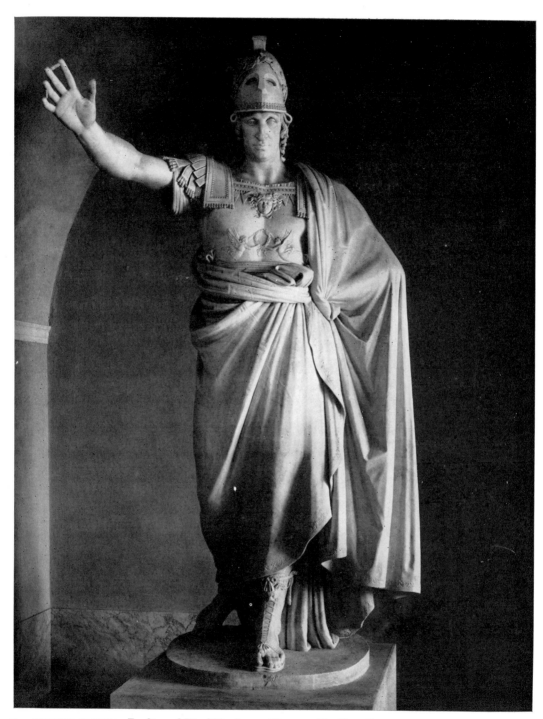

1 ANTONIO CANOVA: *Ferdinand IV of Naples as Minerva*. Marble, 1800

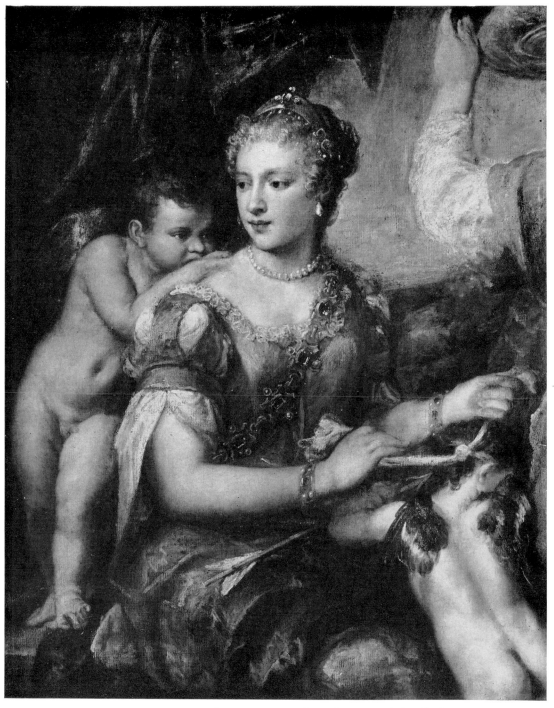

2 TITIAN: *Portrait of a Young Lady as Venus Binding the Eyes of Cupid*. Canvas, mid-1550's

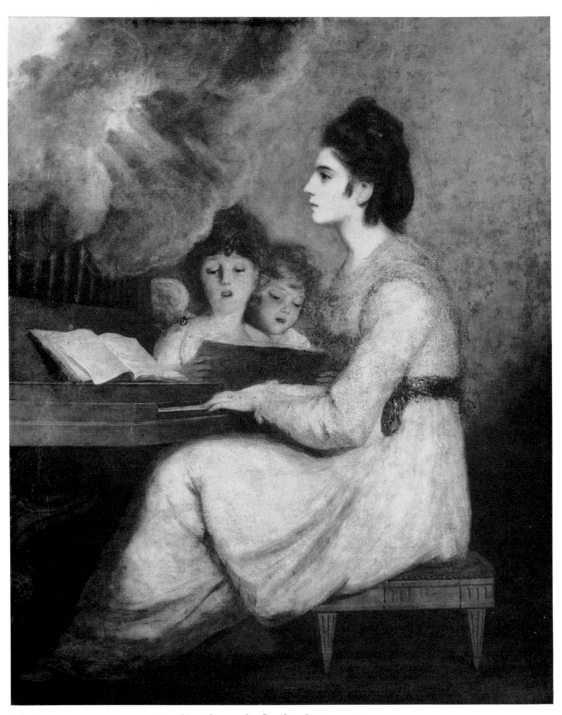

3 SIR JOSHUA REYNOLDS: *Mrs. Sheridan as St. Cecilia.* Canvas, 1775

Niece. That circumstance may be very picturesque.

Clerimont. Here, madam, shall be your own picture, here the palfrey, and here the dwarf—the dwarf must be very little, or we shan't have room for him.

Niece. A dwarf cannot be too little.

Clerimont. I'll make him a blackamoor to distinguish him from the other too powerful dwarf (*Sighs*)—the Cupid—I'll place that beauteous boy near you, 'twill look very natural—He'll certainly take you for his mother Venus.

Niece. I leave these particulars to your own fancy.

Oliver Goldsmith, in the sixteenth chapter of the *The Vicar of Wakefield*, has written a witty satire of the conversation piece in allegorical costumes: the Vicar's family, desirous of outdoing a neighboring family in point of taste, decides to be portrayed in "one large historical family piece," and as no suitable subject comes to their minds, they are contented "each with being drawn as independent historical figures," the wife as Venus, the two smaller children as Cupids, Olivia as an Amazon, Sophia as a shepherdess, and the Vicar "in his gown and band," in the act of presenting his wife—i.e., Venus—with his book on the Whistonian controversy.

Very frequently the allegories in paintings of this description were derived from the famous repertory of Cesare Ripa's *Iconology*, whose influence on the arts has been the subject of a well-known study by Emile Mâle,[11] and whose sources have been traced by Erna Mandowsky.[12] Such cultural background accounts for the pleasure, described by Joseph Warton, of people who, "in wandering through a wilderness or grove," suddenly behold "in the turning of the walk, a statue of some VIRTUE or MUSE."[13]

Thus during the eighteenth century the time-hallowed iconic tradition gathered strength from the definite influence of certain painters. We moderns have always felt no little surprise at the popularity enjoyed in that century by painters who later sank in the critics' estimation, until quite recently, when a kind of re-evaluation of them seems to have taken place: Guido Reni, the Carracci, Guercino. Reni was a past master of delicacy and grace to the eighteenth century, which extolled those qualities above all others. A widespread opinion holds that poets anticipated painters in the discovery of new realms of the imagination, but Hagstrum

has shown in his book that James Thomson, celebrated as the inventor of the romantic landscape, did nothing other than transfer into poetry themes common to seventeenth-century landscape painters, not only Claude Lorrain [4] and Salvator Rosa, but also other masters who used the natural scene as a manifestation of heroic, pastoral, or religious ideals. That the heroic, rather than the natural, landscape was Thomson's real source of inspiration is proved by his use of personifications as the focal point of the scene. Nature becomes organized around these personifications, whom the poet provides with suitable attributes, and is attuned to them. Thomson's description, in the revised version of the passage on the advent of Summer, of the "parent of Seasons," i.e., the Sun, in his "beaming car" around which the "rosy-fingered hours" dance, is evidently inspired by Guido Reni's famous ceiling with the fresco of Aurora [5].

William Collins' allegories are also indebted to Reni, and the first visual parallel to them which comes to mind is his *Fortuna*, whose alabaster body hovers on an azure globe against a pale blue sky [6]. Similarly, Thomas Gray's pantheon consisted of the Roman masters of the sixteenth century and the Bolognese of the seventeenth, on whose paintings he took copious notes during his Grand Tour; the melancholy which tinges his "Elegy" is of the same quality as that which Poussin breathed into his celebrated painting *Et in Arcadia Ego* [7]. In other poems Gray, like Thomson, makes the scene subservient to some quasi-mythological persona "whose function is to organize the details and interpret them as manifestations of some kind of animistic order and meaning."[14] Those allegories—the offspring of Ripa's iconological family—fulfill in poetry the same function that the statues had in the parks; they impart to the scene a note of meditation and reverie which shortly was to have a new name: romantic sensibility.

Thus the transitions from painting to poetry and from poetry to painting were almost imperceptible in those times. This kind of interrelation can be amply illustrated from any of the literatures of the West, and although it legitimately forms a chapter in the treatment of the whole subject of the parallel between the arts, it is by no means the most important part of it. This is because all these relationships do not tell us much about the style in which the borrowings are conducted. The fact that a poet had a painter in mind while composing his poem does not necessarily involve a similar-

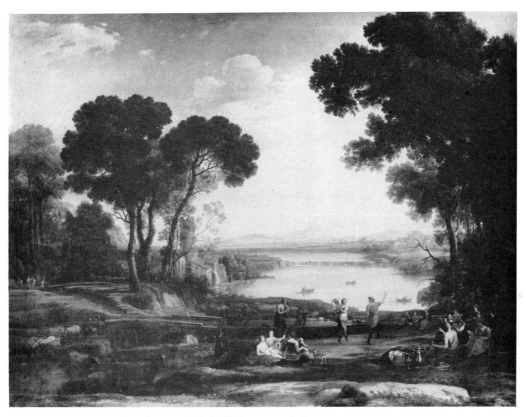

4 CLAUDE LORRAIN: *Landscape with Mill.* Canvas, 1648

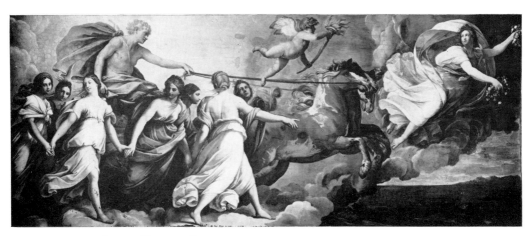

5 GUIDO RENI: *Aurora.* Fresco, 1613

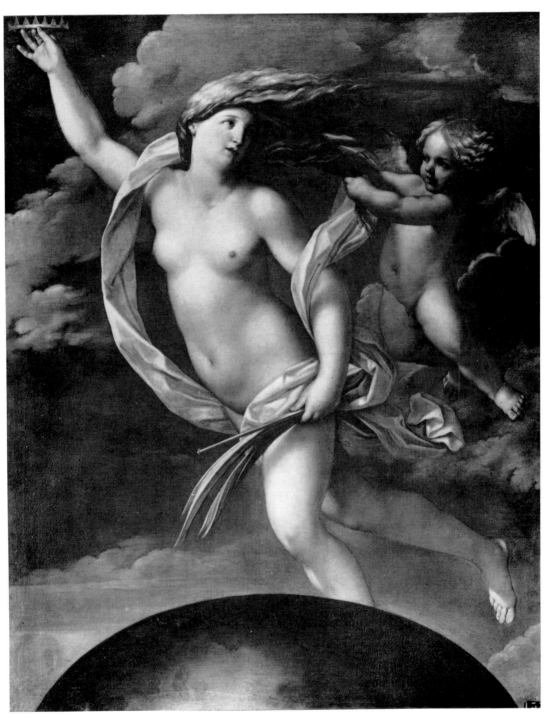

6　GUIDO RENI: *Fortuna*. Canvas, ca. 1623

ity in poetics and style. This similarity may be pressed to a certain extent, although this has seldom been attempted, in the cases of Thomson and Collins; however, their approaches to the painted source are not quite the same. If we compare, for instance, Thomson's passage on the advent of Summer, to which I have just referred, with Collins' "Ode to Evening," we see that the former is still within the boundaries of Virgilian description and the poetic diction, which impart to its lines a stately rhythm familiar to readers of Latin and neo-Latin poetry (in fact, Thomson's lines lend themselves easily to a Latin translation); whereas the latter, notwithstanding its personifications with their monumental air and *passe-partout* quality, has inflections and nuances reminding us of Milton on one side, and

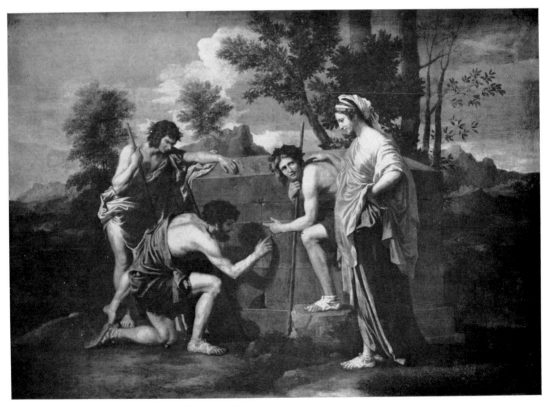

7 NICOLAS POUSSIN: *Et in Arcadia Ego*. Canvas, 1650–55

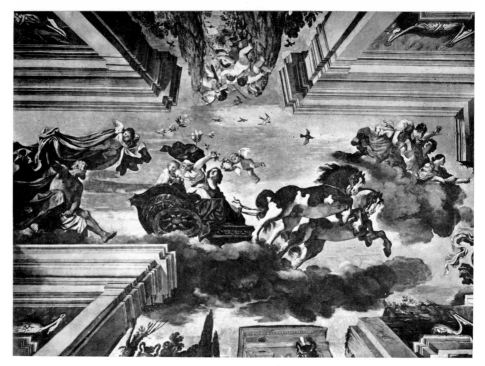

8 GUERCINO: *Aurora*. Fresco, 1621–23. Villa Ludovisi, Rome

on the other anticipating the sensibility of Keats's ode "To Autumn." Read side by side these lines from Thomson's "Summer":

> *while, round thy beaming car,*
> *High-seen, the Seasons lead, in sprightly dance*
> *Harmonious knit, the rosy-fingered hours,*
> *The zephyrs floating loose, the timely rains,*
> *Of bloom ethereal the light-footed dews,*
> *And, softened into joy, the surly storms—*

and Collins' description of the various mythical figures attending the car of Evening:

> *For when thy folding Star arising shews*
> *His paly Circlet, at his warning Lamp*
> *The fragrant Hours, and Elves*
> *Who slept in Buds the Day,*
> *And many a* Nymph *who wreaths her Brows with Sedge,*
> *And sheds the fresh'ning Dew, and lovelier still,*
> *The Pensive Pleasures sweet*
> *Prepare thy shadowy Car.*

Both passages can be termed "pictorial," and one may further add that
Thomson's description is closer to Reni's neoclassical *Aurora*, which has
been compared to a frieze or bas-relief, and Collins' to Guercino's more
melancholy and romantic *Aurora* [8] in the Villa Ludovisi, with its chiaro-
scuro effects, and the magic of cypresses and stormy clouds. In fact, a detail
[9] of Guercino's *Night* taken from Dürer's *Melencolia*, the pensive figure
sitting under a broken arch while a bat flitters by overhead, might recall
this passage by Collins:

> *Now air is hush'd, save where the weak-ey'd bat,*
> *With short shrill Shriek flits by on leathern Wing.*

It would be tempting, but unwarrantable, to assume that Thomson had
Reni's *Aurora* in mind, and Collins Guercino's; but it is safer to say that
their pictorial inspiration can be defined only loosely, whereas the poetic
tradition to which the two poets were beholden can be much more pre-
cisely assessed.

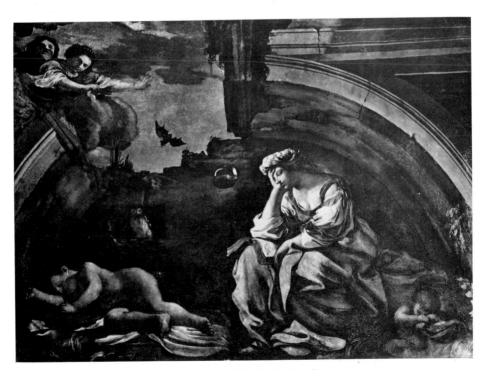

9 GUERCINO: *Night*. Fresco, 1621–23. Villa Ludovisi, Rome

Other explorations of the same kind lead us to similar conclusions. Take, for instance, Keats's notes on his Scottish tour, where he imagines on Loch Lomond a fleet of chivalry barges with trumpets and banners, fading in the azure distance among the mountains. We are told[15] that the inspiration for this fantasy came to him from Claude's so-called *Enchanted Castle,* but, unless thus warned, we would find its counterpart rather in the medieval fantasies of the conventional romantic painter Thomas Cole, whose *The Departure* and *The Return* (both in the Corcoran Gallery of Art, Washington) show crenelated castles overlooking romantic expanses of water, and barges with warriors wearing feathered helmets. Both Ingres and Delacroix have compositions on a then fashionable theme from the Near East, to whose popularity Byron's "Tales" in verse had largely contributed: the harem. Ingres's *Odalisque* [10], painted in 1814, reminds us of Canova's *Paolina Borghese as Venus;* but Delacroix's *Women of Algiers* [11] of 1834 is based on sketches made directly on the spot by the painter himself,[16] and this painting has a closer family likeness to Renoir's painting [12] on a similar subject (*Parisians Dressed in Algerian Costume,* 1872, conceived as a homage to Delacroix), than to Ingres's. In cases like this the link between art and literature is even looser than in the case of Thomson and Collins just examined. But themes mean little; it is the manner in which they are treated that deserves consideration, and Ingres had neoclassical patterns in mind (even the dancer in *Le Bain turc* seems to owe her attitude to an antique bas-relief), while Delacroix, though he too was subject to influences, relied first of all on firsthand impressions treasured with a romantic's love of experience.

All this seems to confirm the appositeness of a remark in Wellek and Warren's *Theory of Literature* that "the various arts—the plastic arts, literature and music—have each their individual evolution, with a different tempo and a different internal structure of elements. . . . We must conceive of the sum total of man's cultural activities as of a whole system of self-evolving series, each having its own set of norms which are not necessarily identical with those of the neighboring series."[17]

A similar remark concludes the volume of Helmut A. Hatzfeld, *Literature through Art, A New Approach to French Literature:* "It seemed to me not only a sound point of view but an absolute principle that the primary

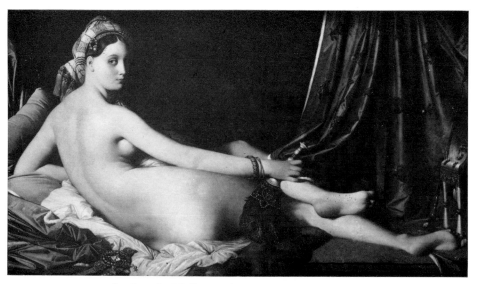

10 J.A.D. INGRES: *La Grande Odalisque*. Canvas, 1814

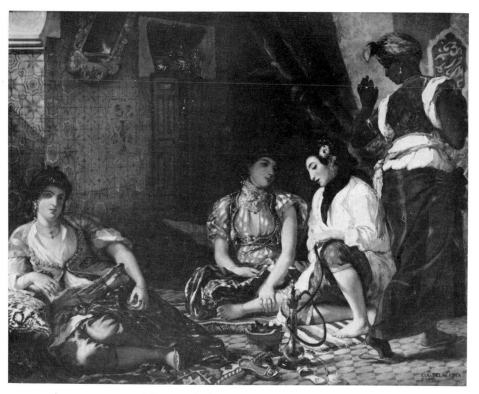

11 EUGÈNE DELACROIX: *Women of Algiers*. Canvas, 1834

and predominantly aesthetic approach in the analysis of any art cannot be replaced by any other, if art is not to be deprived of its very character." But he adds that "it must be supplemented by what some have called *Geistes-geschichte* or the 'History of Ideas,' if the aesthetic problems are to be understood." And his final words are that in his book he has attempted to apply Wölfflin's principles "to the literary field in its inseparability from art."[18]

Professor Hatzfeld's book bears however not so much on the parallel between the various arts, as on a sort of *iconologie expliquée par les textes:* its utility lies in its being a repertory of themes, though not arranged in the form of a catalogue like A. Pigler's *Barockthemen.*[19] Although he produces a number of stimulating examples, he never seems to reach a clear defini-tion of principles, and deliberately rules out a "morphology of the arts." But actually we are entitled to speak of correspondences only where there are comparable expressive intentions and comparable poetics, accompa-nied by related technical media. Too often Professor Hatzfeld is content with finding purely thematic parallels, so that his book results in an approximate fitting of literary texts to contemporary paintings, something which has always been done. No Italian secondary school teacher ever fails to mention Botticelli's *Primavera* when speaking of Politian's *Stanze:* two works whose resemblances are much less significant than their differ-ences. Some of his *rapprochements* are apposite, as when he mentions in one breath Descartes's *esprit géométrique*, the formal gardens, and the paradoxical logic of the Racinian plots. But a list of his less convincing parallels would detract from his work that modicum of originality which consists in his choice of subject. He sees in Cézanne the perfect incarna-tion of Gautier's and Baudelaire's ideas on art, and in Puvis de Chavannes's insipid frescoes a majestic simplicity whose formula would be found in Cézanne; he sees in Ingres's *Odalisque* a counterpart of Victor Hugo's *Sara la baigneuse;* he considers Georges de la Tour and Racine representatives of the same spiritual *tenebroso;* and he finds points of contact in Balzac and Renoir, and between the famous carriage drive in *Madame Bovary* and the passing of carriages in Renoir's *Les Grands Boulevards au printemps.*

If a parallel is to be found for that famous episode in Flaubert's novel, it is in nineteenth-century genre painting, where it was customary to suggest

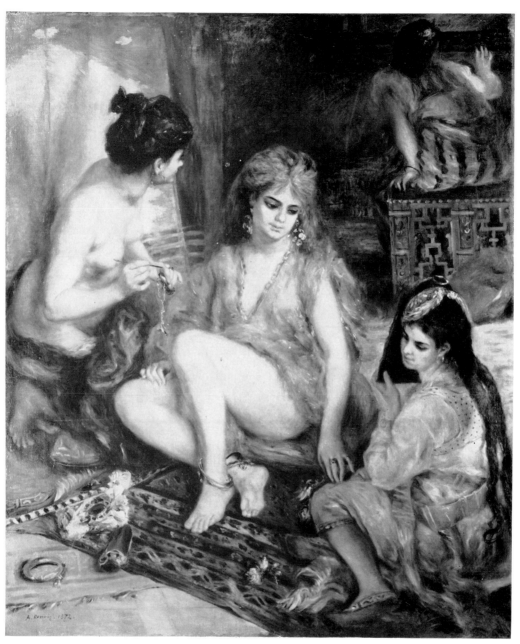

12 PIERRE-AUGUSTE RENOIR: *Parisians Dressed in Algerian Costume*. Canvas, 1872

a story through a hint, a gesture which appealed to the intellect or the feeling of the onlookers. The passage describes a moment when, in the middle of the day, in the open country, while the sun is striking on the old lanterns of the carriage, a naked hand is thrust from behind the curtain of yellow cloth at the carriage window and scatters bits of paper, which flutter like so many butterflies on a field of red clover in blossom. This impressionist attention to blots of color (silvered lanterns of the carriage, curtain of yellow cloth, bits of white paper, field of red clover) and the oppressive melancholy of the drive are typical of the nineteenth-century taste which was fond of pathetic circumstances such as cause a lump in the throat. The spirit of Flaubert's episode makes one think, however, rather of Victorian painters than of French impressionists. It is enough to call to mind Millais's *The Blind Girl* [13] who sits in the midst of an enchanting rainbow-spanned landscape with a pied butterfly resting on her shawl: all things the unfortunate girl is unable to see. Her predicament has the same appeal for the onlooker as the guess of what may be happening inside the carriage has for the reader of Flaubert's novel.

In most cases the parallelisms produced by Professor Hatzfeld are no more cogent than the vague impressions which anyone can feel in the presence of a work of art. We have already mentioned Leigh Hunt's haphazard quotations of painters apropos of Spenser. It is not uncommon to hear people linking the names of Watteau and Mozart as typical of the spirit of the eighteenth century, in the same way others, as I have said, speak of Politian and Botticelli as expressions of the mood of the Florentine Renaissance. But, in the words of Wellek and Warren, "this is the kind of parallelism which is of little worth for purposes of precise analysis."[20]

On the other hand, do we, when speaking of precise analysis, intend something like Étienne Souriau's *La Correspondance des arts*,[21] which tries to establish on a scientific basis a series of correspondences already vaguely hinted at by Gregorio Comanini? This humanist, in his dialogue *Il Figino overo del Fine della pittura*, had gone a step farther than the common belief, shared by Ben Jonson, in the affinity of poetry and painting. Comanini quoted the compositions of the bizarre painter Arcimboldo as examples of transpositions of musical tones into visual terms, and concluded by saying that the various arts walked side by side and with the same laws in

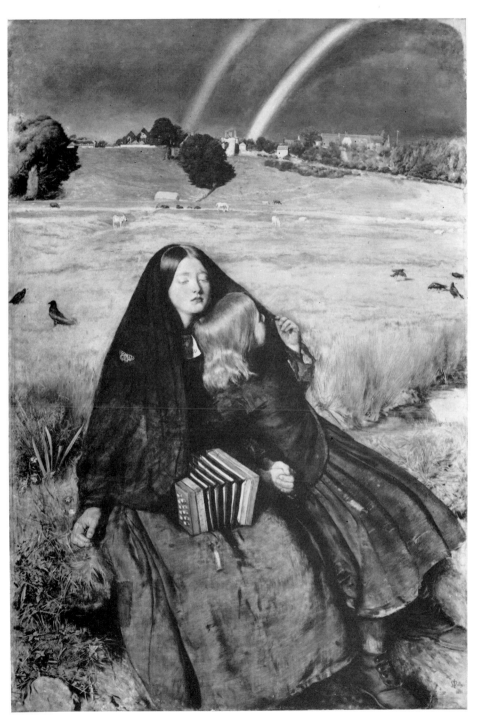

13　SIR JOHN EVERETT MILLAIS: *The Blind Girl*. Canvas, 1856

forming their images ("del pari e con le medesime leggi nel formare i lor simulacri").[22] Bolder still, Louis Bertrand Castel, in his *Optique des couleurs* (1740), described a *clavecin oculaire* in which the various colors of a palette were distributed among the keys of the instrument. And Diderot, in the "Lettre" from which we have already quoted, addressed to the author of *Les Beaux-Arts réduits à un même principe*—i.e., the Abbé Batteux[23]— wrote: "Balancer les beautés d'un poëte avec celles d'un autre poëte, c'est ce qu'on a fait mille fois. Mais rassembler les beautés communes de la poésie, de la peinture et de la musique; en montrer les analogies; expliquer comment le poëte, le peintre et le musicien rendent la même image; saisir les emblèmes fugitifs de leur expression; examiner s'il n'y aurait pas quelque similitude entre ces emblèmes, etc., c'est ce qui reste à faire, et ce que je vous conseille d'ajouter à vos *Beaux-arts réduits à un même principe*."[24]

Well may Lessing utter a warning, a few years afterwards, about the limits separating poetry and painting, stating that the field of painting is space and that of poetry is time, so that there could be no confusion between the two of them; well may he declare false the parallel which Winckelmann had drawn between Sophocles' *Philoctetes* and the *Laocoön* as expressions of pain in art. The temptation to explore the correspondence between the various arts, to discover the source of this sevenfold Nile, has sprung up again every now and then in the fantasy of artists: Baudelaire's "Correspondances," Rimbaud's sonnet on the vowels, and Des Esseintes's organ of liqueurs are instances of this recurring idea, together with Scriabin's *Poem of Ecstasy,* Op. 54, played in New York in 1908, a *Gesamtkunstwerk* with dances, music, colors, perfumes; the ideal of a complete fusion of abstract sculpture, abstract painting, and building technology expressed by J. J. P. Oud and furthered by Walter Gropius and Le Corbusier;[25] and Thomas Wilfred's curious chromatic kaleidoscope of colored waves, which can be seen in the Museum of Modern Art, New York. Not only has the *Andersstreben* of the various arts been occasionally reaffirmed by thinkers, as for instance by Goethe in his speculations on the taste of colors and by Walter Pater in a passage of his *School of Giorgione* ("Although each art has thus its own specific order of impressions, and an untranslatable charm . . . yet it is noticeable that . . . each art may be

observed to pass into the condition of some other art"); but this *Anders-streben* has given rise to systematic investigation, of which Souriau's book can be taken as a specimen.[26]

Souriau has devised a roulette of seven primary arts and seven corresponding secondary or representative arts in which the implicit primary form "can be found by suppressing the representative parameter"; in this way abstract art is justified as pure painting, but not therefore lacking in sentimental appeal and power to move. Thanks to this simple scheme and the linking of the various arts in pairs, has Souriau actually discovered the system of this delicate roulette? Music and the art of the arabesque (a primary form of design) are thus considered related. Certain passages of Chopin's *Nocturne*, Op. 9, No. 1, when translated into arabesque, yield a design which "conveniently colored, or only in *chiaroscuro*, could be used as the border of a carpet by a decorator."[27] As a matter of fact, the arabesques Souriau extracts from music have the meager and angular aspect of seismographic records; their relation to the richness and complexity of the music recalls in fact that which a seismographic record bears to that vast and formidable phenomenon the earthquake: they are faint traces of that trepidation of the spheres to which the musical composition can be compared. Possibly they represent the seamy side of music, but what artistic value can we attribute to them?

On the other hand, the reverse of this experiment is impossible. One cannot give the musical equivalent of the profile of a statue; as music proceeds by scales, all the curves would assume an angular aspect as in cross-stitching. Souriau does not feel discouraged by this, he insists rather on the magic of the arabesque, of the profile of a curve: Cleopatra's nose, capable of changing the destiny of the world; the outline of his mistress' leg against the sunset, which so fascinated Baudelaire. Souriau does not ask himself, but we wonder whether the secret of the parallel between the arts might actually turn out to be only a secret of calligraphy.

Perhaps this is what it all amounts to, as I shall say in a moment. Each epoch has its peculiar handwriting or handwritings, which, if one could interpret them, would reveal a character, even a physical appearance, as from the fragment of a fossil palaeontologists can reconstruct the entire animal. The arabesque extracted from Chopin's music bears the

same relation to it that a sample of handwriting bears to the complexity of the live individual. What, in practice, do Souriau's theories boil down to? His system of the roulette of the arts may be of some interest, but when in the Sistine Chapel he finds a correspondence between Pontelli's[28] architecture, Perugino, and Michelangelo, we fail to see the point. What is there in common between Perugino and Michelangelo? Souriau sees the same spirit in Dürer's illustrations to Revelation and in Doré's to the *Rime of the Ancient Mariner* (the only affinity we seem to perceive here is that between the names of the two artists, Dürer and Doré); in certain Byronic fantasies of Delacroix; and in Beethoven's overtures to *Coriolan* and *Egmont*, "works in which," he says, "with various degrees of success, the affinity of the related compositions, either musical or visual or literary, seems to culminate in an effort to express in the same manner the same inexpressible thing, to conjure up through different spells the same half-revealed metaphysical world [*pour évoquer par des formules magiques différentes un même au-delà semi-suscité*]. Perhaps all works of art intercommunicate at that height."[29] As Pierre Francastel has said: "La conciliation est facile sur le plan des idées vagues."[30] Or, rather, in the rarefied atmosphere of *ars una, species mille*, no comparison has any sense and the colors of the rainbow are annihilated into a uniform grayness, and "the wretched infidel gazes himself blind at the monumental white shroud that wraps all the prospect around him," as in Melville's famous passage about the whiteness of Moby Dick.

The remark I have just made about handwriting may, however, offer us a starting point for a more satisfactory approach to the parallel between the various arts.[31] Souriau has shown us that a piece of music can be translated into a graphic form which is, so to say, its cipher, the sign manual of the artist. And what else is handwriting but the concentrated expression of the personality of an individual? Of all the sciences or pseudo-sciences which presume to interpret the character and destiny of man from signs, graphology is surely the one which has the soundest foundation. Handwriting is taught, and certain of its characteristics belong to the general style of the period, but the personality of the writer, if it is at all relevant, does not fail to pierce through. The same happens with art. The lesser artists show the elements common to the period in a more

conspicuous manner, but no artist, no matter how original, can avoid reflecting a number of traits. In terms of handwriting one can speak of a *ductus,* or hand, or style of writing not only in actual handwriting, but in every form of artistic creation, which is to an even greater extent an *expression,* something pressed or squeezed out of the individual.

If the language I am using now seems to come close to Croce's definition of aesthetics as "a science of expression and general linguistic," I must declare from the outset that I do not share, on the other hand, Croce's belief that "the single expressive facts are like as many individuals, each incomparable with the other except in a very general way. To put it in terms of scholastic philosophy, this is a species which cannot in its turn fulfill the function of a genus. The impressions, i.e. the contents, vary: every content differs from another, because nothing repeats itself in life; and from the continuous variety of contents there follows the irreducible variety of the expressive facts, which are the aesthetic syntheses of the impressions."[32]

This passage in Croce's *Aesthetic* immediately precedes his statement that translations are impossible and that every translation creates a new expression. And consequently Croce would dismiss as inappropriate any talk about a parallel between the various arts. In the passage just quoted he says that the single expressive facts are incomparable with each other except in a very general way ("I singoli fatti espressivi sono altrettanti individui, l'uno non ragguagliabile con l'altro se non genericamente, in quanto espressione"). It remains to be seen what range we may give to the qualification "se non genericamente"; and this is what we shall try to determine in the next chapter.

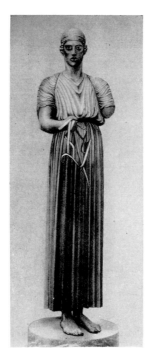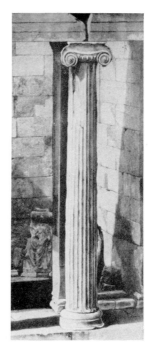

14　Charioteer of Delphi and Ionic Column

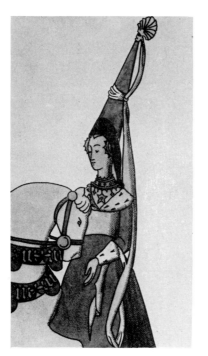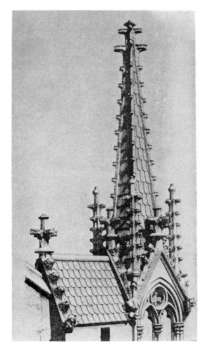

15　The Hennin and Gothic Pinnacle

Time Unveils Truth

SOME time ago that great authority on clothes and underclothes, Mr. James Laver, brought out a little book[1] in which, following a suggestion from Gerald Heard's *Narcissus, An Anatomy of Clothes*,[2] he took a surprising short cut to prove that the style of a period is stamped on all its art forms, even on the commercial art of dressmaking, for all its so-called caprice. This seems a truism—what about those old-fashioned school textbooks of literary history where we find each section introduced by a passage which purports to show that political events are reflected in the character of any given period of literature? Have we not heard enough about the *Zeitgeist*, the spirit of the age? Still, in his compact little book, simply by matching on opposite pages an Assyrian mitre and a Chaldean ziggurat, the *Charioteer of Delphi* and an Ionic column [14], the shape of a medieval knight's helmet and a Gothic arch, the hennin, that typical headdress of fifteenth-century ladies, and a *flamboyant* Gothic pinnacle [15], a trunk hose and an Elizabethan table leg, and so on, Mr. Laver contrives to put before us, beyond all doubt, a fact which elaborate disquisitions about the spirit of the age very often tend to obscure: the close relationship, or *air de famille* as we may call it, between the expressions of the various arts in any given epoch of the past.

Remarks to the same effect have been made by a historian of Italian costume, Rosita Levi Pisetzky:

"Unity of taste is more or less distinctly discernible in all historical periods. It is therefore useful to compare the characteristics of architecture and of clothes respectively, because this will help us to understand the climate in which the dresses fashionable at the time were created. Thus, sixteenth-century palaces strike us by the greater stress laid on effects of

volume, as contrasted to the linear flatness of fifteenth-century construc-
tions and by the appearance of the curve as a paramount structural
element, in the frequency of arches, in the circular plan of many court-
yards, in the spiral shape of many stairs, whereas in the previous age the
straight line, variously combined, was the basis of architectural design. The
harmonious characteristics of architecture reappear in the serene gardens
rich in fruits and flowers which stretch in front of the luxurious Cinque-
cento country houses, with calculated vistas that frequently converge into
large oval spaces; even in the waterworks whose jets fall archwise into
variously curvilinear ponds, in the swelling waterfalls which often pour
their liquid lawn within the frame of large round niches of stagelike
columned grottoes. . . . Dresses, particularly women's, are on the whole
conceived so as to amplify the human figure without altering its propor-
tions. The simplified synthesis which triumphs in the Cinquecento, with
its emphasis on effects of volume, is evident also in the ample and majestic
flow of the fabrics on the forms of the body. Thus the break—already

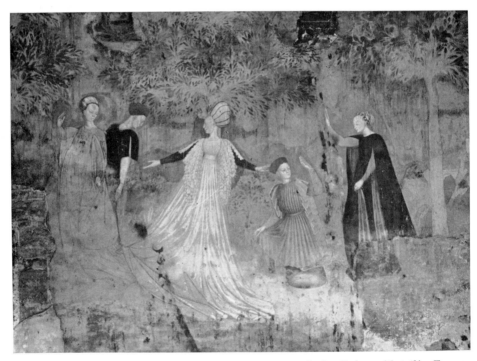

16 MASTER OF THE BORROMEO GAMES: *The Game of the Palma* (detail). Fresco,
ca. 1450; Casa Borromeo, Milan

begun at the end of the fifteenth century—is completely effected from the sharp Gothic predilection for the straight line [16] which delighted in the naïve and curious invention of minute details. Italian fashions find a balance in a masterly and broad accord of forms and colors, with a calm alternation of horizontal lines which cut across the vertical shape of the figure. The low-hung sleeves harmoniously emphasize the shoulder line in all its broadness [17]. The square décolletage underlines the width of the bust, the waist marked in its natural position without stiffness, and the round skirt of the women, the knee-breeches of men, are features which cut down the figure instead of stressing its slimness as in the Gothic fashions."[3]

The same author observes that in the seventeenth century the search for effects of chiaroscuro, so typical of baroque painting and architecture, finds a counterpart in the textile fabrics, where such effects are achieved at times by employing various working processes in turns, as in ciselé velvets, and at times by varying the hues and shades with an almost Caravaggio-like touch in distributing colors, light and dark [18].

Such a close relationship between the expressions of the various arts seems almost inevitable. Far from being dictated by the whim of a court lady or the commercial speculation of a dressmaker, "clothes," says Mr. Laver, "are nothing less than the furniture of the mind made visible, the very mirror of an epoch's soul."[4] Skeptics may think that some of the instances of parallelism given are mere coincidences. But the amount of evidence to the contrary is such that one ends by wondering whether, in this difficult field, we are nowadays in the position of those early linguists who discovered the family relationship among Indo-European languages: like Filippo Sacchetti, for instance, who, traveling in India at the end of the seventeenth century, noticed the linguistic affinity between a few Sanskrit and Italian words, or like the Bohemian scholar Gelenius who, in 1537, was the first to connect the Slavic with the Western languages.

Another proof of the peculiarity of the *ductus* or hand of each given period comes also from an unexpected field: the field of art fakes. It is not at all true to say, as Léo Larguier once remarked in an otherwise delightful little book calculated to appeal to all art-lovers, *Les Trésors de Palmyre*, that "time works to confer a patina on fakes which are too evident nowa-

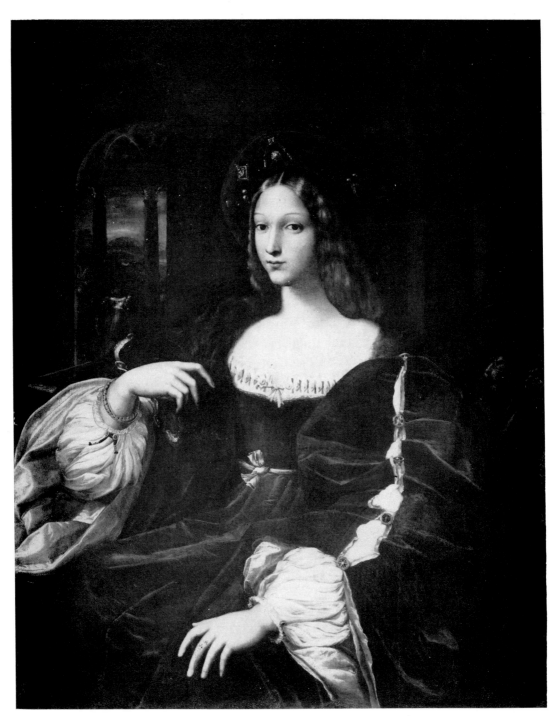

17　SCHOOL OF RAPHAEL: *Portrait of Giovanna d'Aragona*. Canvas, ca. 1518

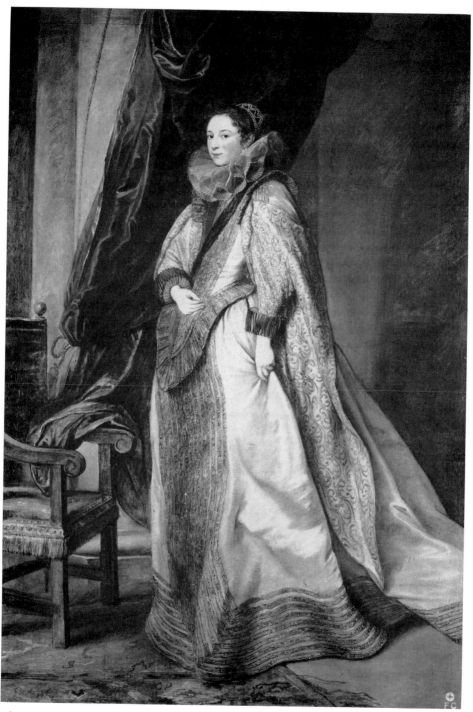

18 ANTHONY VAN DYCK: *Paola Adorno, Marchesa di Brignole Sale.* Canvas, 1622–27

days, so that these after many years will be the pride of the museum of some town in America or Czechoslovakia."[5] Rather, the hackneyed saying that "Time unveils truth" is never so punctually verified as in the case of fakes. And this is not because fakes are detected in due course, or because modern processes enable us to fix the age of the materials of a work of art. X-rays, chemical tests, the quartz lamp—all these are fine inventions, but there is another factor, much simpler and equally infallible, which comes into play.

Every aesthetic evaluation represents the meeting of two sensibilities, the sensibility of the author of the work of art and that of the interpreter. What we call interpretation is, in other words, the result of the filtering of the expression of someone else through our own personality. This is evident in a musical performance, but no less evident in any form of imitation. It is evident, but not necessarily so to contemporaries, and this is the point. Because the interpretation of a work of art consists of two elements, the original one supplied by the artist of the past and the one which is superimposed by the later interpreter, one must wait until the latter element also belongs to the past in order to see it peep through, just as would happen with a palimpsest or a manuscript written in sympathetic ink. Contemporaries are as a rule not aware of this superimposed element, because it is the common way of feeling at the time, it is in the air one breathes; they are no more aware of it than a healthy person is of his own physiological functions. But let a few years pass (they need not be many), and the point of view changes insensibly but inevitably; historical and philological research alters the data of a problem; and certain aspects of the personality of an artist, not apparent before, are brought into the light, with the result that we no longer feel as our fathers did, or as we ourselves felt yesterday.

Now the imitator of a work of art crystallizes the interpretation and the taste of the time in which he is working. With the passing of years the second of those two elements which I have mentioned is emphasized and exposed; and just as, in the film inspired by Stevenson's famous story, Jekyll's profile pierces through the face of the dead Mr. Hyde little by little, so in forgeries the profile of the faker gradually emerges from underneath the disguise. "Since every epoch acquires fresh eyes," Max J. Friedländer

has acutely remarked, "Donatello in 1930 looks different from what he did in 1870. That which is worthy of imitation appears different to each generation. Hence, whoever in 1870 successfully produced works by Donatello, will find his performance no longer passing muster with the experts in 1930. We laugh at the mistakes of our fathers, as our descendants will laugh at us."[6] How many today when confronted with Dossena's sculptures can help wondering how it was possible for renowned experts to be deceived by them!

No great flair is needed nowadays to see through Macpherson's pastiche of Ossian's poems, which caused so much discussion at the time, or through the poems attributed to an imaginary Rowley but actually written by Chatterton (who paid for his forgery indirectly by killing himself). The castle Horace Walpole built in the Gothic style at Strawberry Hill in the middle years of the eighteenth century strikes us today not so much as Gothic as, rather, Rococo in a Gothic travesty. The painting of Jupiter and Ganymede which Winckelmann admired as a genuine antique, whereas it had been executed by his contemporary Mengs, reveals itself to us clearly as a neoclassical composition. We detect the languid *art nouveau* flavor in certain "antique" Sienese and Florentine paintings forged by Icilio Federico Joni [19]. Joni himself remarked about his own forgeries in his memoirs:

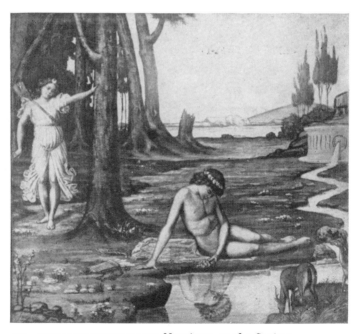

19 ICILIO FEDERICO JONI: *Narcissus at the Spring*

"The illusion was perfect at the time," and: "The illusion, even if not perfect, was good enough for the time."[7] Even if the forger succeeds in imitating perfectly the technique of the ancient painter, the craquelure of the painting, the details of costume without anachronisms, even if he succeeds in producing a painting not put together by copying details from this and that old canvas, but recreated in what he believes to be the spirit of the remote artist; well, granted all this, there is one element which will always betray him: his own idea of beauty, that is, his taste, which will fatally bear the stamp of the forger's own time. Botticelli, as the decadents saw him, is not the painter we see fifty years later, nor the one seen by the celebrated Japanese art critic Yukio Yashiro, who illustrated his book on the Florentine painter with photographs of details of Botticelli's work so exquisitely and perversely isolated as to look almost like Japanese compositions.

Consider the insertion of classical elements in eighteenth-century and in Empire furniture: in each case what catches the eye first is the character of the imitating, not the imitated, period; or consider the imitations of Empire furniture made at the end of the nineteenth century: they have a *fin de siècle, art nouveau* touch. A Renaissance *applique* like the one in the Kress Collection (National Gallery of Art, Washington) and an Empire one inspired by the same motifs betray a different manner of seeing the antique. "What you call the spirit of past times, my dear sirs," Goethe has said, "is after all nothing but your own spirit, in which those times are reflected."

In the light of this, we should conclude that the type of art criticism advocated by William Hazlitt is not art criticism proper but merely a variation of *artifex artifici additus*. Hazlitt maintained that "the critic, in place of analysis and an inquiry into the causes, undertakes to formulate a verbal equivalent for the aesthetic effects of the work under consideration."[8] The transmutation of a painting or some other work of visual art into a literary composition implies the registering of the writer's own emotions in front of that work of art: this approach was introduced by Diderot and came to a climax with Oscar Wilde's *The Critic as Artist*. A famous instance is Walter Pater's passage about Leonardo's *La Gioconda*, which interprets that elusive figure on the lines of the fatal woman of the

Romantics.[9] But the description of the façade of St. Mark's given by Ruskin in *The Stones of Venice* is even more telltale:

"A multitude of pillars and white domes, clustered into a long low pyramid of coloured light; a treasure-heap, it seems, partly of gold, and partly of opal and mother-of-pearl, hollowed beneath into five great vaulted porches, ceiled with fair mosaic, and beset with sculpture of alabaster, clear as amber and delicate as ivory,—sculpture fantastic and involved, of palm leaves and lilies, and grapes and pomegranates, and birds clinging and fluttering among the branches, all twined together into an endless network of buds and plumes; and in the midst of it, the solemn forms of angels, sceptred, and robed to the feet, and leaning to each other across the gates, their figures indistinct among the gleaming of the golden ground through the leaves beside them, interrupted and dim, like the morning light as it faded back among the branches of Eden, when first its gates were angel-guarded long ago. And round the walls of the porches there are set pillars of variegated stones, jasper and porphyry, and deep-green serpentine spotted with flakes of snow, and marbles, that half refuse and half yield to the sunshine, Cleopatra-like, 'their bluest veins to kiss'—the shadow, as it steals back from them, revealing line after line of azure undulation, as a receding tide leaves the waved sand; their capitals rich with interwoven tracery, rooted knots of herbage, and drifting leaves of acanthus and vine, and mystical signs, all beginning and ending in the Cross; and above them, in the broad archivolts, a continuous chain of language and of life—angels, and the signs of heaven, and the labours of men, each in its appointed season upon the earth; and above these, another range of glittering pinnacles, mixed with white arches edged with scarlet flowers,—a confusion of delight, amidst which the breasts of the Greek horses are seen blazing in their breadth of golden strength, and the St. Mark's lion, lifted on a blue field covered with stars, until at last, as if in ecstasy, the crests of the arches break into a marble foam, and toss themselves far into the blue sky in flashes and wreaths of sculptured spray, as if the breakers on the Lido shore had been frost-bound before they fell, and the sea-nymphs had inlaid them with coral and amethyst."

This kind of description, apart from the fact noted by Peter Collins, that "as an architectural appraisal [it] clearly suffer[s] from the defect of being

concerned only with the external surfaces, not to say superficial decorative
veneer,"[10] conjures up before our eyes Pater's prose poem on the *Gioconda*,
and its model, Winckelmann's description of the *Belvedere Torso*, rather
than the actual building in question. Just as Ruskin thinks of "the morning
light as it faded back among the branches of Eden, when first its gates
were angel-guarded long ago," and of "marbles, that half refuse and half
yield to the sunshine, Cleopatra-like, 'their bluest veins to kiss,'" and "the
shadow, as it steals back from them, revealing line after line of azure
undulation, as a receding tide leaves the waved sand," just so, to Winckel-
mann, the left side of the ribs of the Torso, with the muscles nimbly
twined together as in a smooth interplay of levers and rods, offered the
image of the sea when it begins to stir and "its surface swells little by little
and produces a dim tumult of its waves, which urge each other and are
pushed on by others still," and the sight of the back shows him, like a
broad expanse of happy hills, "varied and magnificent hillocks of muscles
round which, often, imperceptible glades twist like the course of winding
Meander—more sensed by feeling than perceptible to the eyesight."[11]

Such amplifications and embroideries seem to me to bear witness to the
romantic taste of these interpreters rather than to the character of the
work of art that has given rise to them, and it is not unfair to conclude
with the words of Robin Boyd regarding Ruskin's passage on St. Mark's
Square:

"With every respect for the Venetian magic we do not see St. Mark's
Square today through Ruskin's eyes. Even in his own day he was criticized
for insisting on using the words beauty and ornamentation interchangea-
bly, and his rhapsody on Venice as a series of ornamented boxes finds little
response with us, who are more impressed by the spaces, perspectives and
relationships between the buildings and their two paved squares and the
vertical exclamation marks and the great open vista to the sea. Ruskin's
metaphysics succeeded only in doing what many earlier architectural
theorists had done: in building an order upon the moist foundations of his
special private delights, preconceptions, and prejudices in building.

"We may be as precise as Ruskin was about the things we admire in
Venice, and no doubt a future generation, reading the various apprecia-
tions of St. Mark's Square still being written in the twentieth century, will

respect our reasons for admiring it, as we can respect Ruskin's. . . . The beauty of the square may well be attributed by a future generation to qualities unperceived by us, and not consciously intended by its creators."[12]

While Winckelmann's description of the Belvedere Torso betrays in retrospect the neoclassical appreciation of qualities in ancient art which appealed to that generation, so much so that the outcome of this type of appreciation was the smooth, delicately modulated surface of Canova's statues; while Pater's prose poem on the *Gioconda* ("She is older than the rocks among which she sits; like a vampire, she has been dead many times, and learned the secrets of the grave. . . . The fancy of a perpetual life, sweeping together ten thousand experiences . . .") transfers to Leonardo's portrait all the fantasies which the Gautier-Baudelaire-Flaubert-Swinburne tradition had been weaving around the fatal woman, a tradition which we can follow down to Rider Haggard's popular romance of the eighties, *She;* in the same way Ruskin's minute, curious elaboration of details makes us think of the *horror vacui* and stuffiness of a Victorian drawing room. The passing of time has revealed the contemporary flavor of each of these descriptions—in other words, the type of *ductus* or handwriting proper to each single period—just as it betrays the taste of the period in the case of forgeries.

On the other hand, if we take an instance where a painting is transposed into words by a contemporary of the painter, that is, by a person belonging to the same phase of taste, Hazlitt's plea for a verbal equivalent of the aesthetic effects of the work of art under consideration has more chance of convincing us. Huysmans, when he sees in a *sacra conversazione* attributed at the time to the fifteenth-century painter Bianchi Ferrari sinful and gruesome implications, unspeakable lusts and subtle perversions, seems to us so far gone astray as to provoke our mirth. But his verbal paraphrase of Gustave Moreau's *The Apparition* [20], notwithstanding the protests of some of the painter's admirers, who tried to clear him of the accusation of decadence, seems close enough to the spirit of the painting: "La face recueillie, solennelle, presque auguste, elle commence la lubrique danse qui doit réveiller les sens assoupis du vieil Hérode; ses seins ondulent et, au frottement de ses colliers qui tourbillonnent, leurs bouts se dressent; sur la moiteur de la peau les diamants, attachés, scintillent; ses bracelets, ses

ceintures, ses bagues, crachent des étincelles; sur sa robe triomphale, couturée de perles, ramagée d'argent, lamée d'or, la cuirasse des orfèvreries dont chaque maille est une pierre, entre en combustion, croise des serpenteaux de feu, grouille sur la chair mate, sur la peau rose thé, ainsi que des insectes splendides aux élytres éblouissants, marbrés de carmin, ponctués de jaune aurore, diaprés de bleu d'acier, tigrés de vert paon."[13] This passage, in fact, brings out clearly the *art nouveau* element in Moreau's inspiration; it has caught its spirit so well as to be at the same time an imitation of his handwriting and an interpretation of it.

One would think, then, that if an artist is at the same time a writer, we should be likely to find in his work the surest test of the theory of a parallel between the arts. But according to Wellek and Warren's *Theory of Literature,* we are bound to be disappointed:

"Theories and conscious intentions mean something very different in the various arts and say little or nothing about the concrete results of an artist's activity: his work and its specific content and form.

"How indecisive for specific exegesis the approach through the author's intention may be, can best be observed in the rare cases when artist and poet are identical. For example, a comparison of the poetry and the paintings of Blake, or of Rossetti, will show that the character—not merely the technical quality—of their painting and poetry is very different, even divergent. A grotesque little animal is supposed to illustrate 'Tyger! Tyger! burning bright.' Thackeray illustrated *Vanity Fair* himself, but his smirky caricature of Becky Sharp has hardly anything to do with the complex character in the novel. In structure and quality there is little comparison between Michelangelo's sonnets and his sculpture and paintings, though we can find the same Neo-Platonic ideas in all and may discover some psychological similarities. This shows that the 'medium' of a work of art (an unfortunate question-begging term) is not merely a technical obstacle to be overcome by the artist in order to express his personality, but a factor pre-formed by tradition and having a powerful determining character which shapes and modifies the approach and expression of the individual artist. The artist does not conceive in general mental terms but in terms of concrete material; and the concrete medium has its own history, frequently very different from that of any other medium."[14]

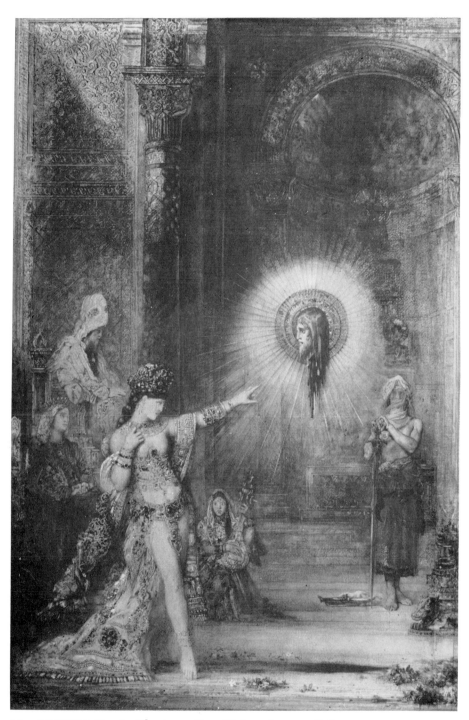

20 GUSTAVE MOREAU: *The Apparition.* Water color, ca. 1876

Of course one cannot deny that, for instance, certain metrical forms themselves contain the seeds of their future development, that the sonnet and the heroic couplet progress through successive stages like live genera, and that Pope brought to perfection characteristics which had been noticeable in the heroic couplet since the time of Drayton. Paul Valéry confessed to F. Le Fèvre that the decasyllabic rhythm of the "Cimetière marin" haunted him before the subject and the verbal elements of the poem had taken form in his mind.[15] Pope was also something of an artist (he had taken painting lessons from his friend Charles Jervas), and he planned his own garden at Twickenham [21, 22] and advised friends on their gardens. Now, his principles of gardening were very close to the pattern of his heroic couplet. Let us hear what Edward Malins has to say about them in *English Landscaping and Literature, 1660–1840:* "How did Pope manage to put into practice, in so small an area as his estate, his Rules—'Contrasts, the management of Surprises and the concealment of Bounds'? It seems that he achieved contrasts through varied planting in irregular patterns and serpentine lines; surprise by the tunnelled entry into the grotto under the Hampton turnpike road . . . and by placing temples and other architectural features to confront one suddenly on turning a corner; and the concealment of bounds by giving the eye an uninterrupted view to infinity by ingenious planting leading through vistas down to the Thames. The lights and shades he managed by 'disposing the thick grove work, the thin, and the openings in a proper manner.' As a painter, he writes, 'you may distance things by darkening them, and by narrowing the plantations more and more towards the end.' "[16]

Now, if you think of the various devices he employed to prevent the heroic couplet (a narrow enough unit of verse) from sounding monotonous, through a skillful use of the caesura and of various rhetorical figures —the *figura sententia* (like "Damn with faint praise, assent with civil leer"), the antimetabole or inversion, and so on—which result in the typical pattern of antithetical wit, you will find that Pope had already put into practice that correspondence between the art of gardening and scansion which Capability Brown stressed in a famous explanation of his principles: "Now *there,* said he, pointing his finger, I make a comma, and there, pointing to another spot where a more decided turn is proper, I

21　*A Plan of Mr. Pope's Garden as it was left at his Death, Taken by Mr. Serle his Gardener* (1745)

22　WILLIAM KENT: *A View in Pope's Garden.* Drawing, ca. 1720–30

make a colon; at another part (where an interruption is desirable to break the view) a parenthesis—now a full stop, and then I begin another subject."[17]

If one examines the verse of minor poets, one finds that in employing different metrical forms they come recognizably under the influence of the poets who stamped these forms with their own character: Vincenzo Monti writes *terza rima* in the manner of Dante and of the latter's eighteenth-century revivalist Alfonso Varano, but when he writes blank verse, his model is different, since Carlo Innocenzo Frugoni was his master in this metrical form. So that the objection formulated by Wellek and Warren about the difference of media would apply not only to two different arts, but would also work within the boundaries of the same art. The various genres had their own rules and traditions, and when John Singleton Copley composed in the heroic manner he followed different models than when he painted portraits.

Actually, then, the objection that one cannot compare the various arts because each of them has a tradition of its own has less weight than might at first seem to be the case. On the other hand, the instances put forward in the *Theory of Literature* to show that artists who are at the same time poets express themselves in very different, or even divergent, styles according to the media they use, can be qualified to some extent.

Michelangelo was supreme as an artist and only of middle stature as a poet, but can we actually maintain that there is such a gap between his work as a painter, sculptor, and architect on one side, and his sonnets on the other, as to make a comparison futile? Erwin Panofsky, in "The Neoplatonic Movement and Michelangelo," observed that "each of his figures is subjected . . . to a volumetric system of almost Egyptian rigidity. But the fact that this volumetric system has been forced upon organisms of entirely un-Egyptian vitality, creates the impression of an interminable interior conflict. And it is this interior conflict, and not a lack of outward direction and discipline, which is expressed by the 'brutal distortions, incongruous proportions and discordant composition' of Michelangelo's figures. . . . Their movements seem to be stifled from the start or paralyzed before being completed, and their most terrific contortions and muscular tensions never seem to result in effective action, let alone locomo-

tion."[18] This sense of man struggling under a weight that he contrives to support but never succeeds in overthrowing, expressed by the twisted postures of Michelangelo's heroes and by the roughly hewn portions of some of his statues, is evident also in the harsh and jagged style of the sonnets. In this respect Michelangelo stands out as unique in the Italian tradition of Neo-Platonic sonneteers. The only compositions which offer some similarity to his are Donne's *Holy Sonnets:* in both poets the "devout fitts come and go away / Like a fantastique Ague"; faith has proved such a difficult conquest for them, that they are continually afraid of slackening in zeal; both of them try to overcome the aridity of their hearts, they feel between their hearts and God a barrier which only God can break. In his peculiar mixture of realism and Platonism, in the dramatic turn of his genius as well as in his laborious yearning for beauty and religion, in that double character of half-baffled, half-triumphant struggle, in his power of depicting the horrors of sin and death and the terrible effects of the wrath of God, Donne is perhaps nearer to Michelangelo than to anybody else.[19]

As for Blake, if we do not restrict ourselves to comparing the poem "The Tyger" to the "grotesque little animal" intended for its illustration, but take into consideration the whole range of Blake's mythical figures, there are plenty of fearsome, awe-inspiring beings which can vie with the tiger of the poem in intensity and power: see for instance the title page to *Milton, The House of Death,* or *Nebuchadnezzar* [23]. There is certainly some exaggeration in J. H. Hagstrum's contention that Blake "molded the sister arts, as they have never been before or since, into a single body and breathed into it the breath of life," and that "no matter that . . . [Blake's figures] are often formally distorted and plastically outrageous . . . Blake's strong sense that his symbolic figures were the living persons of a cosmogonic drama gave them a solid flesh that no other personifications of the period possessed."[20] But surely one cannot deny that the same *ductus* is discoverable both in the eclectic work of the painter, which drew on such heterogeneous sources, ranging from the medieval Books of Hours to the mannerist draughtsmen, from the sixteenth-century artist Hendrick Goltzius to Blake's own contemporary Henry Fuseli, from the sublime compositions of Raphael and Michelangelo to Flaxman's flat illustrations; and in his poetry, which derived from such various Castalian springs as the clear

Elizabethan songs and the muddy flow of the Ossianic poems. The same difference that is to be found between the title pages of the *Songs of Innocence* [24] or the *Book of Thel* on the one side, and the illustrations *Jerusalem* or *Har and Heva Bathing Attended by Mnetha* [25], on the other, is also to be found between the two strains of poetry just mentioned, and the difficulty of bringing together the poetry and the paintings of Blake is no greater than that of recognizing the same hand within each of those fields.

It is only a superficial judgment that would conclude that since Rossetti's poetry derived from the early Italian poets (but also from Robert Browning, whose poetry was totally different in character) and his paintings from Italian masters of the Renaissance (particularly the Venetians), the two arts as he practiced them were not on the same level, or even followed divergent paths. It is more difficult to reconcile the sonnets of *The House of Life* with "Sister Helen," or "My Sister's Sleep," or "Antwerp and Bruges," than to admit that Rossetti's poetry and paintings are products of

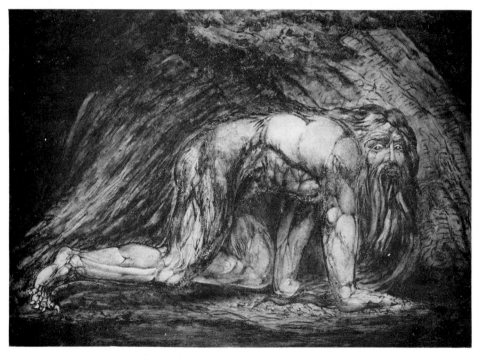

23 WILLIAM BLAKE: *Nebuchadnezzar*. Color-printed drawing, 1795

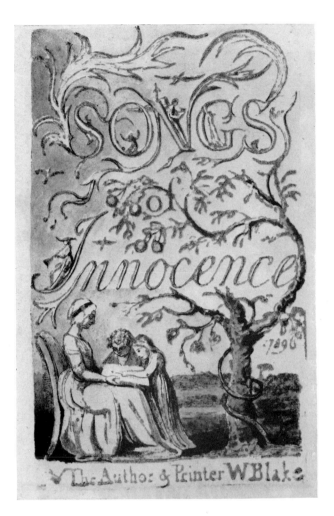

24 WILLIAM BLAKE:
Title page
of *Songs of Innocence*
Color print, 1789

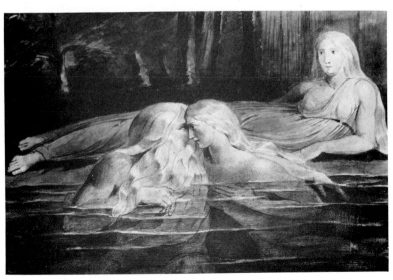

25 WILLIAM BLAKE: *Har and Heva Bathing Attended by Mnetha.*
Design illustrating *Tiriel*, ca, 1789

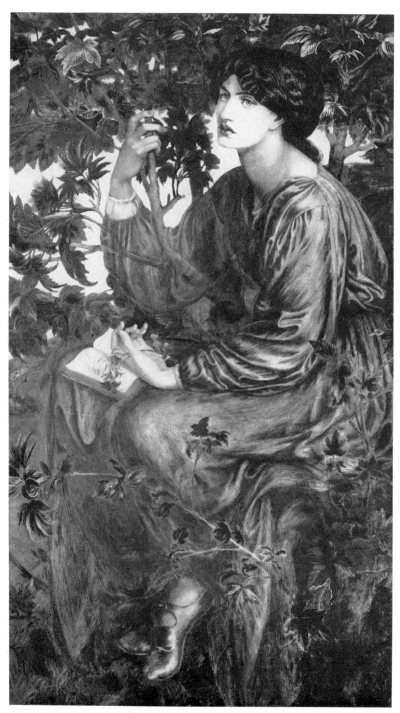

26 DANTE GABRIEL ROSSETTI: *The Daydream*. Canvas, 1880

the same inspiration. One of the high lights of the poems are the sonnets under the heading "Willowwood," in which elements borrowed from the *stil nuovo* gain in complexity and refinement, and achieve a vision of sensuous and melancholy symbolism. But is not this the character of Rossetti's paintings [26 and 27], of his blessed damozels and merciless ladies, Astartes and sibyls? These are twin allegories which, instead of representing now goodness, now evil, are the two-faced image of the same morbid

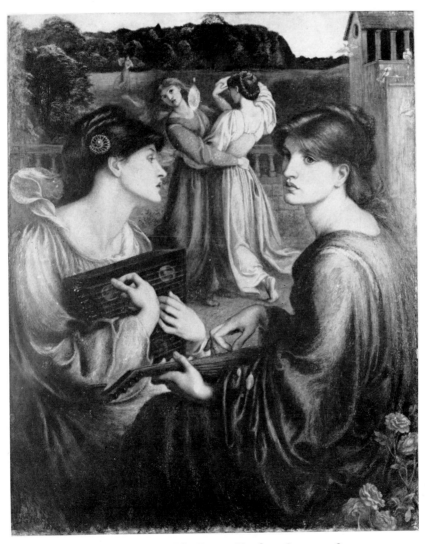

27 DANTE GABRIEL ROSSETTI: *The Bower-Meadow.* Canvas, 1872

and yearning sensuality. He permeates with sensuality the idealization which characterized the work of Dante and his circle, and instills a meta-physical meaning into Venetian-looking portraits of women [28].

In the case of *Lady Lilith* [29], a modern impression is created in terms of Venetian stylization. Although Rossetti was, on the whole, very severe with all the modern French painters with whose work he became acquainted during his visit to France, he did not fail to be duly impressed by Courbet.[21] Now Courbet's *The Woman with the Mirror* [30] seems to have suggested the pose of Lady Lilith.[22] But Courbet's red-haired woman is a portrait from real life; she is dressed according to distinctly mid-nineteenth-century fashions, and her face could not be said to conform to a recognized pattern of beauty; there is something abstract about Lady Lilith, and in fact, whereas she was at first inspired by Fanny Cornforth, she was later redrawn from a different model. The result is as ambiguous as that in "Willowwood." Just as those sonnets remind us of the *stil nuovo* and at the same time, seen in this light, sound sophisticated and spurious,

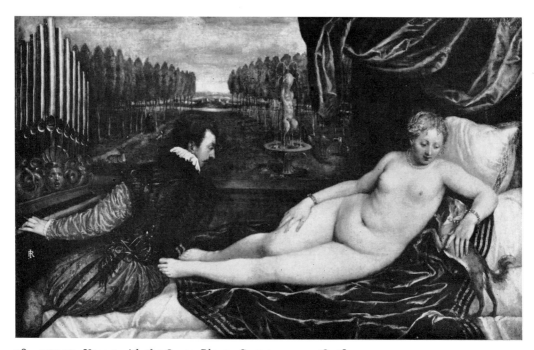

28 TITIAN: *Venus with the Organ Player*. Canvas, ca. 1546–48

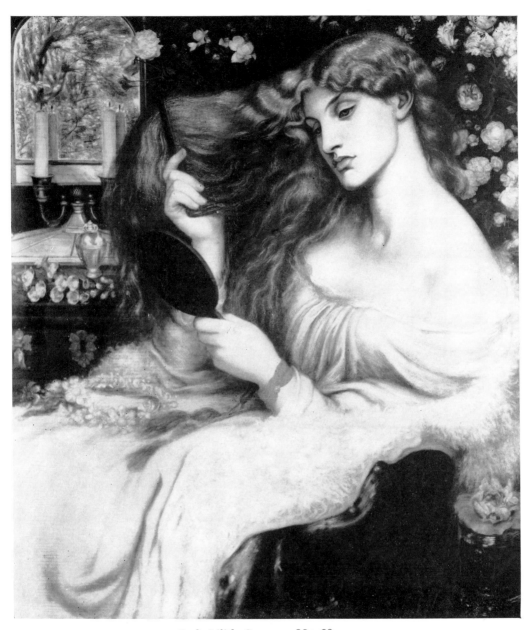

29 DANTE GABRIEL ROSSETTI: *Lady Lilith*. Canvas, 1864–68

so *Lady Lilith* has not the purity of style found in Titian's *Flora* [31], of whom one may be reminded at first, and at the same time lacks also the truth to life which strikes us in Courbet's *The Woman with the Mirror.*

Then there is the case of Victor Hugo, whose pen and ink drawings [32] and *gouaches* show contrasts of light and shade which have parallels in his literary technique. Gautier wrote of him in his *Histoire du romantisme:* "S'il n'était pas poëte, [il] serait un peintre de premier ordre; il excelle à mêler, dans des fantaisies sombres et farouches, les effets de clair-obscur de Goya à la terreur architecturale de Piranèse."[23]

Other cases of artists active in various fields, which would bring more support to the contention of the authors of the *Theory of Literature,* could be quoted. One may question, in fact, what common link there is between Degas's poems and his drawings, paintings, and sculptures inspired by the

30 GUSTAVE COURBET: *The Woman with the Mirror (La Belle Irlandaise).* Canvas, 1866

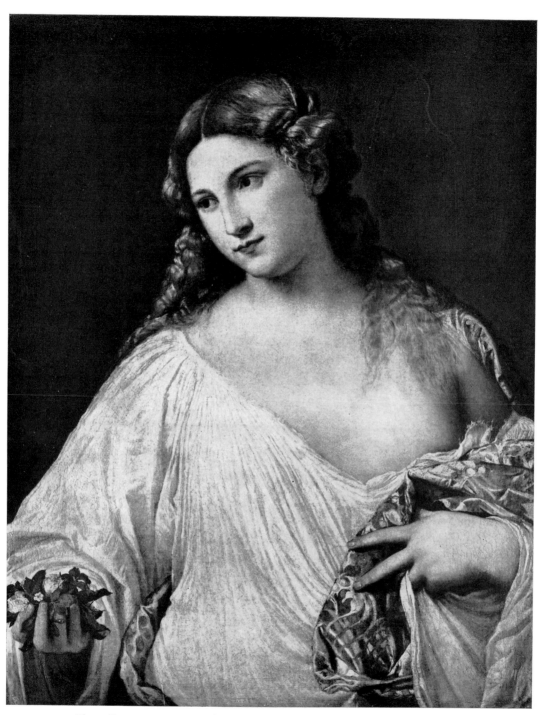

31 TITIAN: *Flora*. Canvas, ca. 1515–16

same themes. Degas as a poet is a mere follower within the Baudelairian tradition, whereas he is a genuine creator in the visual arts; in the latter he writes in his own handwriting, whereas in the poetry he is like a beginner practicing in the Cyrillic alphabet. But take other cases in which there is an equally great discrepancy between the achievements of an artist in the various arts—take, for example, the case of Canova as a painter: there is the same accent of deliquescent sweetness in his group of *Eros and Psyche* as there is in his mediocre painting (Museo Correr, Venice) on the same subject.

To conclude, it can be maintained that there is a general likeness among all the works of art of a period, which later imitations confirm by betraying heterogeneous elements; that there is either a latent or a manifest unity in the productions of the same artist in whatever field he tries his hand; and that traditions exert a differentiating influence not only between one art and another, but also within the same art, so that there is nothing in the contention of Wellek and Warren, any more than there is in Lessing's objections formulated in *Laokoon*, to discourage us from searching for a common link between the various arts.

32 VICTOR HUGO: *Hauteville House, Guernsey.* Drawing, 1866

Sameness of Structure in a Variety of Media

THE reasons why one should not speak of a "time spirit" determining and permeating all art seem to be of the same order as those brought forward against the possibility of a bumblebee's flying: the volume and weight of the insect, the smallness of its wing surface, rule out the possibility; still, the bumblebee flies. Or think of how Bertrand Russell made fun of the traditional representation of angels: with such large wings they ought to have a chest projecting like the prow of a ship; still, angels are imagined with normal human bodies. Of such angels theology, literature, and the visual arts are full, and nobody seems to find them preposterous. Angels are of course metaphysical beings and as such they hardly offer a convincing example; but bumblebees *do* exist, and they are by no means the sole instance in natural phenomena of a physical impossibility overcome in some mysterious way. Perhaps the whole subject of the correlation of the arts has been wrongly approached in most cases; men have sought for resemblances where there could be none, and have overlooked an obvious fact which was there all the time for the seeing but which, like Poe's purloined letter, nobody noticed. One wonders whether something has happened here corresponding to what Vladimir Ja. Propp encountered in the field of fairy tales.

This Russian professor, whom the structural critics of today have recognized as a pioneer in their method, noticed that in a series of Russian fairy tales on the common theme of the persecution of the stepdaughter there was identity of action, though some of the figures appearing in them were different. While a Crocean philosopher would have maintained that the

variety of contents resulted in a variety of aesthetic syntheses and impressions, each one possessing a singularity of its own, Propp concluded that the difference of actors should not obscure the fact that we are in the presence of the same plot. He formulated in consequence a morphology of the fairy tale. Characters and their attributes vary, but actions and functions remain the same, just as was the case when the characteristics and functions of the pagan gods were transferred to Christian saints. Uniformity and repetition are at the bottom of a number of phenomena which strike us at first as endowed with a surprising variety and a picturesque heterogeneity. Thus Propp was able to reduce all "magic" tales to thirty-one functions and seven characters, and suggested that one could trace them all to a single archetype.[1]

Moreover, certain fairy tales, like that of the princess and the frog, are common to ethnic groups between which historians can find no possible relation; so that one wonders whether, just as all children at certain stages of their development show the same reactions and accomplish the same acts, as all human communities, in the foundation of cities, resort to a quadripartition of space, and as certain sexual anomalies give rise to the same images and find a spontaneous expression in the same symbols, all human communities thus eventually formulate, each independently from the other, the same myths.

In the same way one may ask oneself whether, irrespective of the media in which works of art are realized, the same or similar structural tendencies are at work in a given period, in the manner in which people conceive or see or, better still, memorize facts aesthetically, and whether a basis for the parallels between the arts can be found here. The various media, then, would correspond to the variety of characters in fairy tales: the proposition that the characters vary, while the function remains the same, would find a counterpart in another proposition: the media vary, the structure remains the same.

Perhaps this is the right way to find a sound basis for the parallels between the various arts, to prove that it is not a pseudo-scientific fantasy like the theory current during the seventeenth century, according to which all the species of terrestrial animals had counterparts in the fauna of the sea.

Antonio Russi, an Italian philosopher, who at one time taught at an American University, having established in his book on *L'Arte e le Arti* that "in normal experience every sense contains, through the medium of memory, all the other senses," applies this formula to aesthetic experience, and maintains that "in every art, through memory, all the other arts are contained."[2] This must not be understood in the sense either of an actual translation of one art into another (which, as Lessing has shown in his *Laokoon*, is manifestly impossible) or of one work of art into another within the same mode of artistic expression (literature, painting, and so on). The colors and shapes that a musical experience may suggest are not to be confused with the colors and shapes that painting and sculpture can suggest directly. While in practical experience an object, realized through one of the senses, can always, whenever the necessity or opportunity offers itself, be realized through all the other senses, this is not the case in art. A state of mind expressed through one of the arts cannot be fully realized through the direct and simultaneous employment of all the other arts.

Having excluded the possibility that the concomitant sensations awakened in us by the direct perception of a work of art may be realized through the senses, and having further excluded the possibility that they may be realized through the arts taken as aesthetic substitutes for the senses, Russi concludes that they are only realized through memory. Memory therefore "does not assume in art a subsidiary or ancillary function as happens in normal life, but is, itself, Art, in which all the various arts are united without residua. Ancient mythology saw this clearly, in a way, when it imagined that Mnemosyne was the mother of the Muses."[3]

Modern aesthetics has cleared up the misunderstanding arising from the conception of the senses as being present in art in the same way they are present in practical experience, but it has not cleared up other misunderstandings which derive from conceiving of memory as operating in art in the same way it intervenes in sensorial experience. The object, which in the old aesthetic theory of imitation was external, offered to the senses, has proved to be an internal one, that is, a state of mind. But once the senses are excluded, this internal object—Russi argues—can only be offered by memory. And he might have added at this point Wordsworth's famous definition in the preface to the *Lyrical Ballads,* the manifesto of

the English romantic movement: poetry has its origin in "emotion *recol-
lected* in tranquillity" (italics mine).[4] Art theorists have given to "fancy"
all the attributes which Russi considers proper to "aesthetic memory"; and
he maintains that many misunderstandings about the unity of the arts
would have been avoided if people had spoken of "memory" rather than of
"fancy."

And what are the characteristics of aesthetic memory in art? Its inca-
pacity to be realized—says Russi—on the level of the senses. The concomi-
tant sensations which offer themselves to memory through the perception
of a work of art cannot but remain memory and can never be lived other
than in memory. The work of art is an allusive object: according to the
various materials employed for expression, it appeals directly now to one
side of the soul, now to another, and suggests, through memory, all its
other aspects. The various arts do not co-operate as the senses do; each art
works in its proper field, and a characteristic of aesthetic experience is that
through a single art one succeeds in expressing art as a whole, whereas all
the arts, joining their efforts, succeed only in hampering each other. Just
the contrary happens in sensorial experience, where an object can be
realized only on condition that all the senses intervene. The greatness of a
work of art always consists in the faculty left to memory of establishing—
starting from the sensorial data offered by a given art—a certain margin
of indetermination for all the rest. And this is the difference between
practical memory and aesthetic memory: that whereas in the former the
corresponding actual sensation can substitute for the imagined sensation,
aesthetic memory is instead always substantially memory, because no
actual sensation nor any sum of actual sensations can substitute for the
sensations it offers to consciousness.

As the distinctions among the arts are distinctions among the sensorial
directions of aesthetic expression (sight, speech, hearing), the visual arts
crystallize a state of mind at its farthest point, where it borders on the
images of things. The verbal arts seem instead to arrest the uncertain
impression which a state of mind produces in us before it assumes that
simplification which is able to reconcile it with space and make it a visual
image. One is reminded of what Matthew Arnold said, that "poetry is more
intellectual than art, more interpretative . . . poetry is less artistic than

the arts, but in closer correspondence with the intelligential nature of man, who is defined, as we know, ' a thinking animal,' poetry thinks and arts do not."[5]

A fitting illustration seems to me to be offered by a parallel that R. F. Storch draws between Wordsworth and his contemporary Constable: they both engage their imagination in "nature," without having recourse to a mythological or heroic medium.[6] There is no numinous imposition from the outside, as there is, for instance, in Claude Lorrain's landscapes. The sense of something holy emerges from nature itself as it is seen in the light of common day, but Constable conveys this sense implicitly, in the shapes of the clouds, in his rendering of the grass and fresh foliage, and in his perception of a building, be it a cottage or Salisbury Cathedral; Wordsworth conveys it by describing the motions stirred in the soul by landscape, or the aura of infinity radiating from the scene. "The grandest efforts of poetry," said Coleridge, "are where the imagination is called forth not by distinctive form, but by a strong working of the mind."[7] The media of expression employed by the painter and the poet are different, but the two have in common a taste and a message.

"The affinities between Wordsworth and Constable are, then," writes Storch, "very real, though not where they are usually looked for. The loving description of natural objects (in the Ruskinian sense) together with a Victorian uplift, a delight in cottage life and similar humble subjects, they are all accessories to the true achievement of either poet or painter. They both engage their imagination in 'nature,' but for them this means the primary dimension of experience, and primary is perhaps best explained as that dimension where the energies of life assume a religious quality. The painter uses design, color, and shape, together with the perceptions of meadow, sky, cottage, or cathedral, in order to body forth the delight and the mystery at the very center of our terrestrial experience. The poet narrates occasions of energy and motion, linking natural forces within and outside man, and conveys the awful stillness at the center of things. Neither Wordsworth nor Constable are 'romantic' in the usual sense, for they do not find the mysterious origin of light and energy on a distant horizon:[8] their vision embraces the world of common experience. But we have to add that the common experience they reveal is their own discovery."

Both poet and painter are illustrations of that "unmediated vision" on which Geoffrey H. Hartman wrote a remarkable book.[9] Different media are employed to convey the same interpretation of the immanent holiness of nature. Constable crystallizes this feeling at the point where it borders on the images of things, Wordsworth sets down in words the vague impressions that this feeling produces in us before assuming that simplification which makes it a distinct visual image. Certain lines of the poem on Tintern Abbey (emphasis mine) seem indeed to stress the common basis of inspiration that Wordsworth and Constable shared:

> *The sounding cataract*
> *Haunted me like a passion: the tall rock,*
> *The mountain, and the deep and gloomy wood,*
> *Their colours and their forms, were then to me*
> *An appetite; a feeling and a love,*
> That had no need of a remoter charm,
> By thought supplied, nor any interest
> Unborrowed from the eye.

But then the interpretative nature of poetry crops up in that well-known passage of the poem which seems to make articulate what one feels in front of Constable's landscapes [33]:

> *a sense sublime*
> *Of something far more deeply interfused,*
> *Whose dwelling is the light of setting suns,*
> *And the round ocean and the living air,*
> *And the blue sky, and in the mind of man:*
> *A motion and a spirit, that impels*
> *All thinking things, all objects of all thought,*
> *And rolls through all things.*

What the painter has conveyed in a visual image, the poet renders in a language which vaguely hints at the implications of the natural scene.

When speaking of similarity of structure in a variety of media, a well-known case from remote antiquity comes to mind. A study of the dimensions and proportions of Greek temples[10] has revealed, besides certain

deliberate deformations calculated to produce "optical adjustments," some other irregularities, equally intentional but more difficult to explain—particularly in the diameters of the columns and the distances between the columns. In a number of Greek monuments, the Parthenon and the Propylaea among others, it has been found that the disposition of the columns on the basement or stylobate is apparently regulated by numbers which are rigorously proportional to the elements of the Pythagorean scale [34], taking the width of the basement as canon (a musical string, the length of which is made to vary by movable bridges in order to obtain different intervals and pitch). We are made to understand that Greek art was ruled ·by Pythagorean and Platonic ideas of eurythmy to such an extent that one is subconsciously aware of this even if certain parts are disguised or suppressed. The vanishing profile of a woman, a portion of a shoulder, the curve of a hip, a fragment of a distant silhouette are sufficient for the subconscious to reconstruct or guess the harmony of the whole. A Greek statue

33 JOHN CONSTABLE: *Branch Hill Pond, Hampstead* (?). Canvas, ca. 1821

of the golden age, mutilated and reduced to a fragment which would normally be shapeless (as has befallen marbles from the Parthenon and others), reveals the melody expressed at its creation in its integrity, because

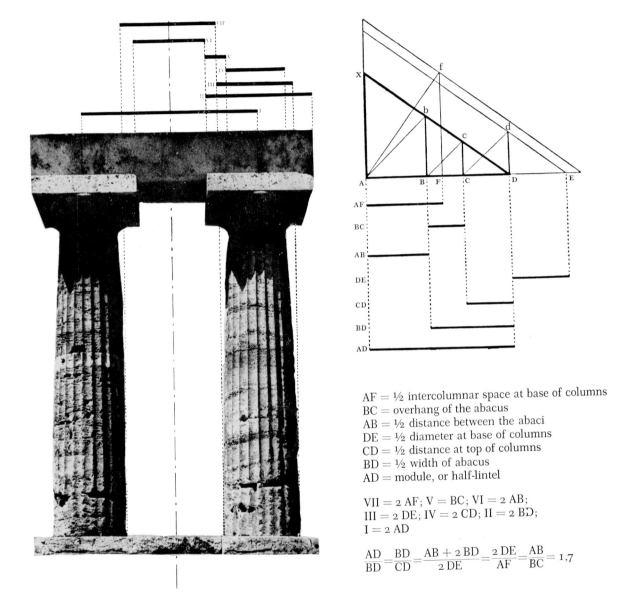

AF = ½ intercolumnar space at base of columns
BC = overhang of the abacus
AB = ½ distance between the abaci
DE = ½ diameter at base of columns
CD = ½ distance at top of columns
BD = ½ width of abacus
AD = module, or half-lintel

VII = 2 AF; V = BC; VI = 2 AB;
III = 2 DE; IV = 2 CD; II = 2 BD;
I = 2 AD

$$\frac{AD}{BD}=\frac{BD}{CD}=\frac{AB+2\,BD}{2\,DE}=\frac{2\,DE}{AF}=\frac{AB}{BC}=1{,}7$$

34 Triangulation of the order of the temple of Hera Argiva, Paestum

the architectural, or tonic, or plastic rhythm is perceived as a whole. The fact that some tracts of proportion are missing or obliterated does not in general affect the rhythmic unity of the whole, nor the awareness of it; the reconstruction in the perceiving mind is, so to say, automatic. In the same way, in the incomplete odes of Pindar, the missing parts may be reconstructed in a close enough approximation of the original, once the metrical pattern is established. Such coherence is mirrored in Leon Battista Alberti's definition of beauty in *De re aedificatoria:* "The harmony and concord of all the parts achieved in such a manner that nothing could be added or taken away or altered except for the worse."[11]

In a world so controlled by definite laws of rhythm, of which the golden section was the supreme flower, the parallels among the arts would find their ideal ground; in fact the same *ductus* prevailed in all manifestations of art in this age. The structure of a Greek temple has been equated to music,[12] and could with no less propriety be compared to the structure of a Greek tragedy, with its equidistant intervals of dialogue and choric song, the choric song being divided into set portions and the dialogue often disposed in entries of one line each (stichomythia), like a frieze.[13] In these Pythagorean norms, then, is to be found the reason for the extreme fitness which strikes us in the decoration of the Greek temples, in the proportions between the sculptures and the architectural elements, and no doubt in the paintings too, had they been preserved. Perhaps there never was such consistency of *ductus* in any period of art.

The Pythagorean tradition passed on, through the practices of architects and stonecutters, to the builders of Gothic cathedrals, as is witnessed to by a thirteenth-century text of Campanus of Novara, in which this canon of Paris, while commenting on Euclid's principles of geometry, pays homage to the golden section: "proportionem habentem medium duoque extrema."[14] On the other hand, relations between music and Romanesque sculptures have been studied by Marius Schneider, who has pointed out that the idea of interpreting music in terms of sculpture, already in existence in India, continued in medieval Europe, as can be seen from the capitals at Cluny, which represent tones, and from those of the Catalan cloister of S. Cugat del Vallès, which record in stone the melodic structure

of the hymn *Iste Confessor,* in a special version followed by that cloister for the Feast of St. Cucuphatus.[15] In the cloister of Gerona Cathedral the capitals seem to have been arranged in analogy with the rhythm of a rosary or a litany.

Both Campanus' appreciation of the golden section and the singing of the stones should be seen in the light of medieval principles, which aimed at a spiritual significance in all artistic expressions. Works of art, as well as the scriptures, lent themselves to a fourfold interpretation—literal, tropological, allegorical, and analogical—as is well known to all readers of the *Divine Comedy.* The abstraction suggested by the physical aspect was considered more beautiful than the object itself, which had only the function of attuning the soul to a supersensible harmony. Alongside this metaphysical standard, another standard prevailed in the appreciation of works of art: the skill of execution, which related a work of art to the other rarities and curiosities of nature. (We must bear in mind that in the early museums, the *Wunderkammern,* natural wonders such as ostrich eggs, coconuts, fossils, and bezoar stones were exhibited side by side with gold and silver artifacts and paintings and sculptures.) The idea that art was the expression of an artist's personality took a long time to develop; it only broke through with Dante, Petrarch, and Villani in the bourgeois milieu of the culture that developed in the free cities of Italy. Before this time only the manual skill of the artist was appreciated, not his creative power, which was credited to God.

All this accounts for the aspect of medieval literature which strikes modern times as very peculiar: namely, its monotony, its flatness and prolixity, and its apparent disregard of the most elementary principles of narrative efficiency. It may be surprising to find so many different attitudes and expressions within a conception of art whose products bore the stamp of anonymity, and which called for standardized representation inspired by an idea rather than by a close study of real phenomena. Thus, for different reasons, the art of the Middle Ages, no less than Greek classical art, reveals similarities of structure calculated to achieve certain aims. Nancy Lenkeith, speaking of "the organic unity of the Church, reflected in its cone-shaped hierarchy," has said that "this doctrine found expression in mediaeval art, and particularly in the symbolic conception of

the Gothic cathedral,"[16] and has stressed the search for unity in philosophy (unification of knowledge) and in alchemy (reduction of all metals to a basic constituent) no less than in political doctrine (the theory of a universal state patterned after the universal Church).[17] In fact, the comparison of the *Divine Comedy* to a Gothic cathedral has been frequently made, and could be worked out in detail by comparing the episodes of the various *cantiche* to the bas-reliefs adorning the portals of a cathedral; the diversity of language found among the various characters (down to the "Papè Satan, Papè Satan aleppe" ascribed to demons) to those singing stones of which Marius Schneider speaks; and the piling up within a canto of the single units of verse, the *terzine,* to the *fleurons* scoring the pinnacles of a Gothic church tower.

Architecture, the art which was least tied to the currents of religious and philosophical thought, came to be the most typical expression of the ideal principles of the Middle Ages through a happy coincidence. There is no doubt, as Paul Frankl has shown in his fundamental work on the Gothic,[18] that the Gothic style was born out of the solution to the technical problem involved in the construction of the vault, and developed when the other members of the building were made to agree with the new structural principle by taking the shapes of ribs, buttresses, pinnacles, up to that triumphal conclusion (once reputed, erroneously, Paul Frankl maintains, to be a form of decadence), the final phase of flamboyant Gothic with its multiplication of symmetrical laces; so that no other single style reminds us to the same extent of the natural process seen in the life of insects and in the formation of crystals, a natural process that has no need of the help of scholasticism and poetry in order to be perfectly followed and understood [35]. No metaphysical culture could have been of any use to the workmen, and on the other hand the skill of an architect in building a vault could not make him progress by one step in the discussion of philosophical theses, whether nominalist or realist.[19] There is no point in speaking of the influence of the Crusades, which was felt at a date later than the first appearance of the Gothic, or of the influence of liturgy or philosophy—all external considerations in comparison with the interior process of the evolution of a style.

The introduction of the ribbed vault created an impact, set in motion a

sequence of surprises, with the final result that the Gothic cathedral became that type of edifice which seems to us to incarnate the religious ideal of the Middle Ages, its aspiration to a spiritual, metaphysical kingdom: a springboard from which to dive into space, a yearning to be free of matter, a nostalgia for infinity. A Gothic cathedral is a fragment of a vast entity which transcends it; it integrates itself with the cosmos, whereas a Renaissance building is shut up in itself, complete and perfect in its isolation. Thus the Gothic cathedral, following a different path, the path created by the skill of engineers and stonecutters, came eventually to express the same message as did a literary work born under the direct influence of philosophical and religious thought, the *Divine Comedy,* and it has been possible for Willi Drost and Erwin Panofsky to see a perfect correspondence between the Gothic cathedral and scholastic philosophy.[20] The same spirit informs all the products of a culture, owing to a cause no less mysterious than the one controlling the growth of natural organisms.

It should not be thought, however, that the spirit of an epoch permeates all its artistic productions simultaneously. The paradox of the Middle Ages is that its spirit asserted itself first of all in the art which was the most independent of cultural suggestions: born out of a purely technical problem, developing logically according to lines determined by the solution, medieval architecture soon reached a perfect and typical expression. (Gothic sculpture, on the other hand, reached the standard of architecture only by about 1380.) No modern art historian would dare to suggest cuts and omissions in an architectural work of the period: there is no portion of it which strikes us as monotonous or superfluous.

Such an unqualified admiration does not seem possible for literary works of the same age. One critic, Croce, has seen a perishable side even in the *Divine Comedy,* the "theological romance." While the allegorical figures we "read" on the façade of Gothic cathedrals often deeply impress our imaginations, it is difficult to feel the same degree of interest for the allegories in literary works; the same allegories which stand out so powerfully on the buildings become mere verbal abstractions. Julius von Schlosser's observation that "there is a powerful structure of thought behind every mediaeval work of art"[21] hardly applies to literature. Only the builders of cathedrals fully responded to the ideas of Hugh of Saint Victor, who

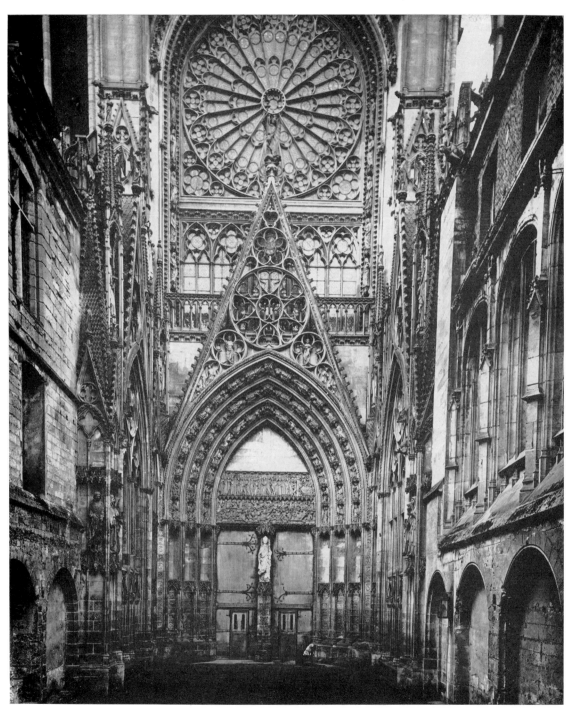

35 Rouen Cathedral, Portail des Libraires. Thirteenth century

supplied the theoretical basis for the taste for brilliant colors and stained glass, and stressed a concern with unity in multiplicity and multiplicity in unity.

Erwin Rosenthal, in a famous study of Giotto published in 1924, has given a convincing explanation of the affinity between Dante and the great painter who was his contemporary, an affinity frequently ascribed to a direct influence of the poet on Giotto: in both artists the earthly element and the supernatural are combined in a similar synthesis. Already, as early as 1892, Janitscheck had written that "Giotto has discovered for painting the nature of the soul, as Dante had discovered it for poetry," and in 1923 Hausenstein had concluded that "Saint Thomas Aquinas, Dante and Giotto are the theological, the poetical and the figurative expression respectively of the same thought." For Rosenthal, Giotto's art, like Dante's poetry, "represents the highest moment of a process of individualization" consisting "on one side in the rise and progress of so-called naturalness, on the other in the progressive embodiment of the supernatural in a single human life," a process which is supposed to have begun in France towards the middle of the twelfth century and to have been concluded in Italy at the beginning of the fourteenth. According to Rosenthal, the affinity between the poet and the painter is revealed first of all in the affinity of the types they present, as, for instance, the angels, the "nuovi amori" into which the "eterno amore" has expanded (*Paradise*, XXIX, 18), and then in the discovery and representation of certain states of mind, certain situations of spiritual and psychological intimacy—as for instance Giotto's musing figure of Joachim slowly advancing among the shepherds, in the fresco of the Arena Chapel [36], compared with certain attitudes of Dante's Virgil (". . . E qui chinò la fronte / e più non disse, e rimase turbato," *Purgatory*, III, 44–45). Giotto's affinity to Dante is then to be understood "not as a consciously parallel tendency, but as a necessarily analogous way of becoming form, in a definite historical moment, of similar historical and spiritual premises."[22]

By the time Chaucer began to imitate the "grete poete of Ytaille" ("Monk's Tale," 3650), the unity of the medieval world which was at the back of Dante's inspiration was crumbling, and Chaucer's unfinished construction of the *Canterbury Tales* is evidence of this decay. If—and this is

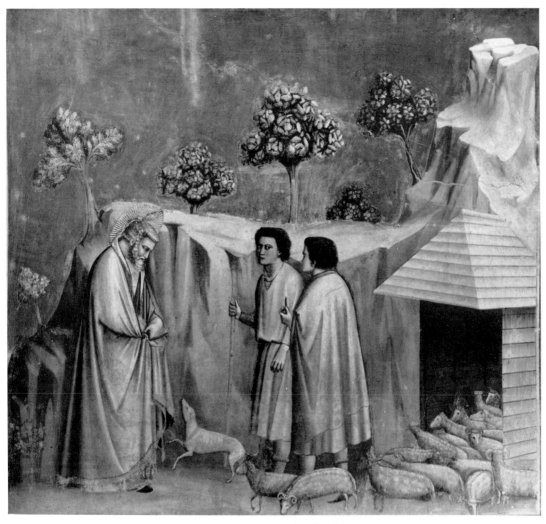

36 GIOTTO: *Joachim Wandering Among the Shepherds*. Fresco, 1303–05. Arena Chapel, Padua

possible, as I have tried to show elsewhere[23]—in bringing together the various tales written in different periods Chaucer thought to follow in a way Dante's scheme in the *Divine Comedy*, he had the episodes of the Italian poem in mind, not its structure. All kinds of characters from all stations of life, the lowest to the highest, appear and talk to Dante during his pilgrimage through the realms of the dead; all modes and shades of human souls find expression in Dante's drama. But a pilgrimage to the other world was not among the bourgeois Chaucer's possibilities. He clings to the dear everyday world, and brings down to the homely plane of common sense the situations he finds in his model. Though trained in the school of French allegory, he was for the concrete, and understood in terms of reason the visions of philosophers and divines. No pilgrimage to the kingdoms of the other world for the man who was no "divinistre," but an earthly pilgrimage to the shrine of the national saint. On this pilgrimage there were no demons or angels to be met, but all varieties of human folk, and Chaucer cared only for human beings. In this way Chaucer succeeded in being "Dante in ynglyssh," a human instead of a divine Dante, summarizing, like the Florentine, the Middle Ages in the compass of a dramatic epos. But what aspect of the Middle Ages?

The period of the Middle Ages in which Chaucer lived was in a way an overripe and decadent one: its Gothic was flamboyant Gothic, in which structure had been subordinated to decoration.[24] In literature, the counterpart of this (on a much lower artistic level, of course) is to be found in the elaborate metrical schemes of the followers of Guillaume de Lorris, Guillaume de Machaut, and Jean Froissart. In the *Fontaine amoureuse*, for instance, Machaut writes down a lover's complaint and then checks it in order to be sure that he has not repeated the same group of rhymes; he is pleased to find that no pattern of rhyme recurs. Rhetorical devices such as *amplificatio, dilatatio, expolitio* helped to beat out the discourse into a fine embroidery of phraseology.

This is the period of the great unfinished cathedrals, and, as I have said, the *Canterbury Tales* is itself an unfinished building. Feudalism, having reached a stage of well-being which had cost centuries of hard work, was dissolving into tournaments and pageants; it was a brilliant, stylized epoch, whose representative painter was no longer Giotto, but, for in-

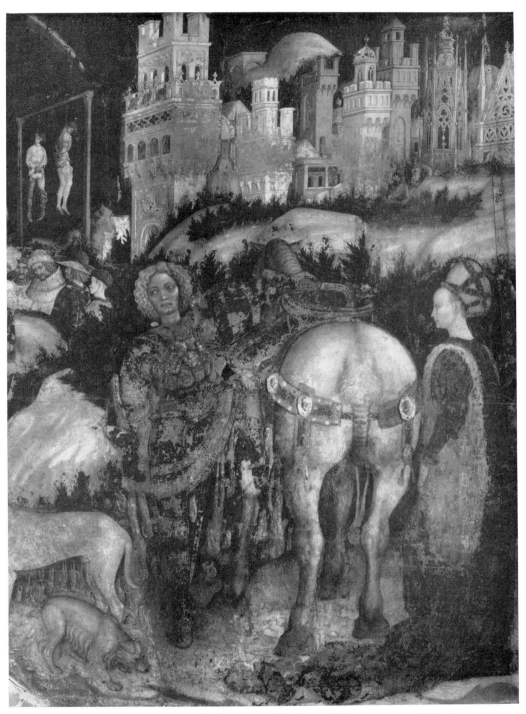

37 PISANELLO: *Saint George and the Princess of Trebizond.* Fresco, 1433–38. S. Anastasia, Verona

stance, Altichiero da Verona, remarkable for his exaggerated love of costume and finery, his delight in trivial detail, and his preoccupation with local color; or Pisanello [37], who holds up an idealizing mirror to the sunset of chivalry.

Now, if you look at Chaucer's characterization of the pilgrims, you at once perceive the affinity with those painters: his characterization is done from the outside, he dwells on their dress, although there is always a psychological implication in such descriptions. The portrait of the Wife of Bath, or this one of the Prioress, also from the Prologue (ll. 151–62), are good examples:

> *Ful semyly hir wympyl pynched was,*
> *Hir nose tretys, hir eyen greye as glas,*
> *Hir mouth ful smal, and therto softe and reed;*
> *But sikerly she hadde a fair forheed;*
> *It was almoost a spanne brood, I trowe;*
> *For, hardily, she was nat undergrowe.*
> *Ful fetys was hir cloke, as I was war.*
> *Of smal coral aboute hiere arm she bar*
> *A peire of bedes, gauded al with grene,*
> *And theron heng a brooch of gold ful sheene,*
> *On which ther was first write a crowned A,*
> *And after* Amor vincit omnia.

This is a description worthy of a painter of miniatures [38], which, however, succeeds in creating that miracle of truth to life that in the following age was to be the great achievement of the Flemish masters, a Van Eyck or a Memling. Chaucer lovingly gives us every detail of the Prioress's appearance, as Jan van Eyck was soon to do in the portrait of his wife [39] and in that of Arnolfini's spouse, or, later, as Memling did in the portrait of Barbara Moreel [40]. Such care for detail is never found in Dante and Giotto. With Chaucer the interest is shifted from the wider issues to the episodes: see how in rendering the Ugolino story he misses its point and omits the final invective against Pisa with the apocalyptic vision of divine revenge which follows, thus transmuting a cosmic tragedy into a pathetic genre painting.

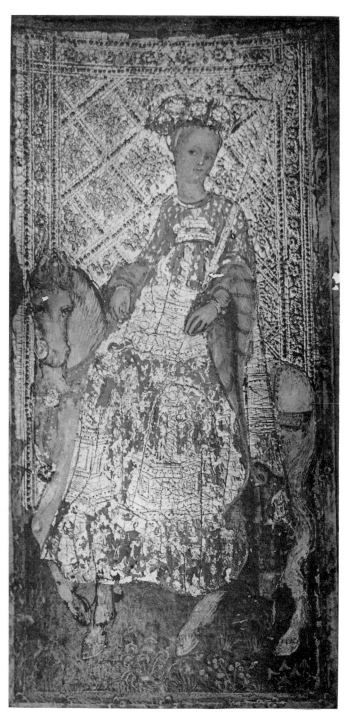

38 Tarot card. Ca. 1428–47

The loose construction of the *Canterbury Tales* becomes almost a symbol. I have mentioned Van Eyck and Memling. But the looseness of construction, the stress on the accessories, the humorousness of the situations (a result of Chaucer's awareness of the relative value of everything) make one think also of Pieter Bruegel, though he lived two centuries later. In *Saint John the Baptist Preaching* a crowd of people from every social class is assembled in a forest, within sight of a pleasant river in which is mirrored a distant town [41]; there are townsmen, artisans, peasants, gypsies, monks of various orders, and our eye runs over the picturesque throng until, in the midst of it, quite in the background, it picks out the figure of the man who should be the protagonist of the picture. The pilgrimage to Canterbury is only an occasion for a social gathering, and although among the tales there are a pious legend and a moral treatise, this is just for the sake of variety. The spirit which animates that assem-

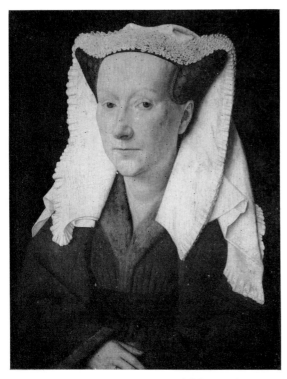

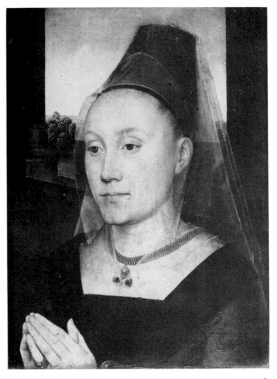

39 JAN VAN EYCK: *Portrait of Marguerite van Eyck.* Panel, 1439

40 HANS MEMLING: *Portrait of Barbara Moreel.* Wood, ca. 1478

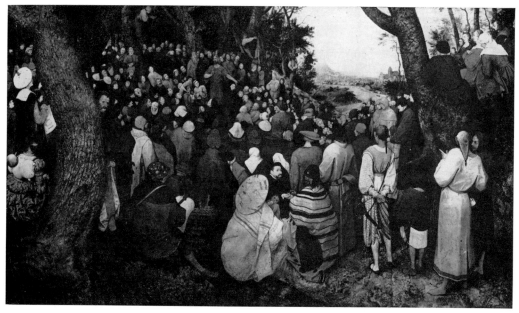

41 PIETER BRUEGEL, the Elder: *Saint John the Baptist Preaching.* Wood, 1566

blage of people is not a religious but a secular one. There is no longer a
common center; instead of a pilgrimage, you have a pageant.

In Bruegel's *Fall of Icarus* [42] you see a tract of sea bathed in an
enchanted light, and on land, in the foreground, exquisite details like those
found in a Book of Hours: a plowman wrapped in sunlight, and, on the
promontory amongst his sheep, a shepherd raising his face towards the
sky; lower down is a fisherman intent on his line; in the blue sea a caravel
sails by, and in the shadow of the caravel there is a flicker of white legs
amongst the curling waves—and that is Icarus. The little marginal figures
from Ovid (*Metamorphoses*, VIII, 217ff.) are the ones that stand out
conspicuously; and Bruegel has even managed to slip an old man's corpse
into the wood on the left, to illustrate a German proverb.[25] The bourgeois
anecdotal and moral bias has reduced the heroic theme to a mere pretense.
In the *Procession to Calvary* [43], also, although the group of sorrowing
Marys is figured in the foreground, Christ is barely discernible among the
picturesque crowds which, with a profane, holiday-making air, dominate
the scene. W. H. Auden, in his "Musée des Beaux Arts," comments forcibly
on this aspect of Bruegel:

About suffering they were never wrong,
The Old Masters: how well they understood
Its human position; how it takes place
While someone else is eating or opening a window or just walking
 dully along;
How, when the aged are reverently, passionately waiting
For the miraculous birth, there always must be
Children who did not specially want it to happen, skating
On a pond at the edge of the wood:
They never forgot
That even the dreadful martyrdom must run its course
Anyhow in a corner, some untidy spot
Where the dogs go on with their doggy life and the torturer's
 horse
Scratches its innocent behind on a tree.

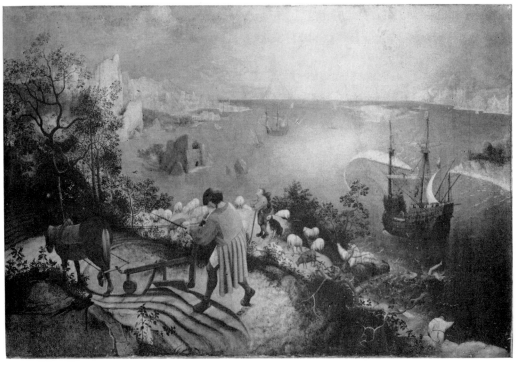

42 PIETER BRUEGEL, the Elder: *Landscape with the Fall of Icarus*. Canvas, ca. 1544–55

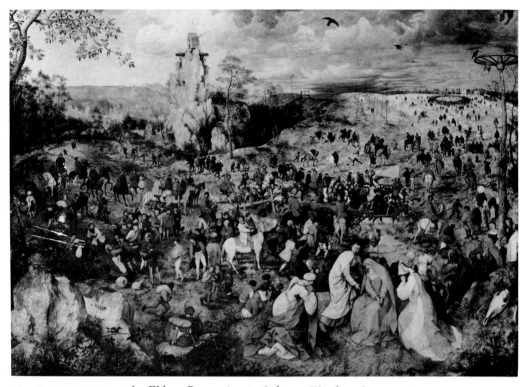

43 PIETER BRUEGEL, the Elder: *Procession to Calvary.* Wood, 1564

In Brueghel's Icarus, *for instance: how everything turns away*
Quite leisurely from the disaster; the ploughman may
Have heard the splash, the forsaken cry,
But for him it was not an important failure; the sun shone
As it had to on the white legs disappearing into the green
Water; and the expensive delicate ship that must have seen
Something amazing, a boy falling out of the sky,
Had somewhere to get to and sailed calmly on.

Chaucer had not traveled so far as Bruegel along the path of this disenchanted view of human destinies. He stuck to the old medieval conception of Fortune's fickleness and the fall of princes, which was certainly a step in that direction, though still imbued with Christian humility. But the lines about the death of Arcite in "The Knight's Tale" (ll.

2809ff.), containing what is probably an allusion to Dante, show clearly
enough that the world to which he belonged was no longer the hierarchi-
cally arranged cosmos of the *Divine Comedy:*

> *His spirit chaunged hous and wente ther,*
> *As I cam nevere, I kan nat tellen wher.*
> *Therfore I stynte, I nam no divinistre;*
> *Of soules fynde I nat in this registre,*
> *Ne me ne list thilke opinions to telle*
> *Of hem, though that they writen wher they dwelle.*
> *Arcite is coold, ther Mars his soule gye!*

This is not in the spirit of Dante, but of Jean de Meun, whose no-nonsense
attitude called in question so many tenets of the medieval world. Such
difference of outlook would necessarily result in a difference of structure.
There being no longer a firm center to fix the writer's attention, aspects
which were once marginal acquire a new importance; hence the discon-
nected, desultory, shapeless, though here and there extremely lively, flow
of the second part of the *Roman de la Rose,* and the uneven, variegated,
unpretentious surface of most of Chaucer's works. Beatrice has receded, or
appears in the domesticated form of Dorigen; Criseyde and the Wife of
Bath (anticipated by de Meun's "la Vieille") come to the foreground.
Dante held up the mirror to a world of eternity, Chaucer to an age of
mutability.

CHAPTER IV

Harmony and the Serpentine Line

THERE have been in recent times many discussions about the time-hallowed division between the Middle Ages and the Renaissance, some (like C. S. Lewis) maintaining that this division was simply an invention of humanist propaganda, others (like Erwin Panofsky) resorting to a common-sense proof like the one devised by Dr. Johnson to show that, contrary to Berkeley's contention, matter existed. Panofsky compared Our Lady's Church at Trèves (of about 1250) with Palladio's Villa Rotonda (about 1550), and concluded that the Rotonda has more in common with the Pantheon than either of these buildings has with Our Lady's Church at Trèves, although only three hundred years separate Palladio's villa from the German church, whereas between the latter and the Pantheon there elapsed more than eleven centuries. Even a slow-witted man could not help being aware that "something rather decisive, then, must have happened between 1250 and 1550." There had been, admittedly, two short-lived periods of renascence during the Middle Ages, under Charlemagne and in the twelfth century; the Renaissance, on the contrary, came to stay, was total and permanent, and differed from its forerunners not only in scale but also in structure. Both medieval renascences approached the classical world "not historically, but pragmatically, as something far-off yet, in a sense, still alive"; they lacked that "perspective distance" which the men of the Renaissance possessed to such a degree that they projected antiquity onto an ideal plane and made it the object of a passionate nostalgia. Therefore "the mediaeval concept of the Antique was . . . concrete and at the same time . . . incomplete and distorted; whereas the modern one" was comprehensive and consistent but, "if I may say so, abstract."[1]

Another scholar has maintained that Burckhardt's interpretation of the Renaissance is "basically sounder and more balanced than that of certain modern scholars who find medieval England 'implicit in Elizabethan England.' "[2]

Partial readjustments fail to disprove that the cultural values of the Renaissance differed radically from those of the Middle Ages.[3] To illustrate this point Watson has traced the history of the concept of honor in classical antiquity, especially among the Romans: not a single thinker, with the sole exception of Marcus Aurelius, held in disdain the desire for fame and honors. Passing on to the Middle Ages, Watson has shown that St. Thomas took a stand midway between the classical cult of glory and the ascetic Christian thirst for humility (in St. Francis, however, we see the first rejected altogether), putting honor among those things held to be transitory and imperfect but not to be condemned. Finally, in the Renaissance, a study of the *Nichomachean Ethics* independent of the medieval interpretation transformed Aristotle from an ally of Christianity into its greatest enemy (as Henri Busson says in *Les Sources et le développement du rationalisme*); that work of Aristotle and Cicero's *De officiis* are the fundamental texts of the Renaissance ethic, repeated and imitated as they were *ad nauseam* in a series of treatises, first Italian, then foreign, which form a vast library of volumes beautifully printed and bound, but whose contents are monotonous to a degree. This body of literature, which today amazes us by its squalid aridity, was a didactic force of major importance in the Italian Renaissance and in the age of Shakespeare; this aspect of its influence was emphasized in matters of theory by all authors, including Shakespeare himself, when, in the second scene of the third act of *Hamlet*, he said that the goal of dramatic art is "to hold, as 'twere, the mirror up to nature; to show virtue her own feature, scorn her own image, and the very age and body of the time his form and pressure." In practice, however, this didactic aim was mixed with something else: in Shakespeare it was his burning interest in the protean human soul and its emotions, and in other authors (such as Castiglione) something much more limited, a graceful turn of speech, an elegance of manner. It is this "something else" which helps to keep their works alive, but this does not mean that those works are

not children of their own time or that they did not possess the features common to the age.

As far as moral principles were concerned, Shakespeare's epoch follows a pagan-humanistic pattern, setting as its goal a moral perfection oblivious of the cardinal virtues of piety and humility, as well as of the cardinal Christian doctrine regarding man's sinful nature and fall from grace. How can one reconcile this attitude with Christian religion? In Castiglione's *The Courtier*, as its latest editor remarks, "one has a sense of a humanity molded for action and looking for worldly glory, the sense of a worldly culture by no means directed towards the salvation of the soul, let alone mystical ecstasy, but rather towards serving man's concrete and vital interests. The position of religious dogma within the framework of the *Cortegiano* is peculiar in this regard. Castiglione, as we know from his other writings and from what can be inferred from this very work, was a pious man, narrowly and rigidly orthodox, and yet, except for certain fleeting references, religion is firmly excluded from the whole construction of his dialogues. As one finds with all the humanists, the plane of worldly wisdom and that of religious dogma (this latter accepted basically as a matter of faith, but perhaps more as tradition than faith) are kept severely separate. The philosophy of the *Cortegiano* is on a terrestrial, exclusively human, plane."[4]

It is our lack of familiarity with this ambivalent position and with the facility with which people of that time shifted from a system of pagan-humanistic values to one derived from the Christian tradition, without attempting to reconcile the contradictions, it is our failure to take this ambivalence and facility into account that has led some of Shakespeare's critics to assume that he never lent himself to the support of a definite point of view. It is this that has induced some to find in *King Lear* a message of disconsolate nihilism, some to read it as a Christian parable, and many others to believe that the ideologic substratum of the Elizabethan age was inconsistent, or downright decadent.

But there is a hierarchy of values upon which Shakespeare's world rests, although the dramatic form itself, with its ambiguities, prevents us from seeing it clearly, as we do in the case of Edmund Spenser. The ethical

principles of Shakespeare are not suspended; they are, rather, complex. His heroes have the virtues and cultivate the ideals common to the pagan-humanistic culture; and the Christian element, which is not absent, does not come into the foreground: it is limited to the spirit of unexpected forgiveness, penitence, and compassion which characterizes *The Tempest* and a few of the comedies. It has been remarked by E. E. Stoll that Shakespeare's heroes and heroines are not sustained in their supreme moments by thoughts of a life beyond or by faith in God and his inscrutable ways.[5] They rely upon their own interior fortitude rather than on God —without, however, being stoical, as is claimed by T. S. Eliot;[6] how indeed could one describe as stoical the impassioned participation in tragic events which we find in these characters?

A strong sense of the social hierarchy, the virile virtues of strength and constancy (which did not exclude bursts of magnanimous anger), a thirst for honors and magnificence, the desire for continuity both through perpetuation of one's kind and posthumous fame (a recurrent theme of the *Sonnets*), apotheosis accepted as a poetic convention, exaltation of loyalty and friendship, public ignominy considered the worst disgrace that could befall a man, justification of suicide and the duel, and the obligation to meet death in an exemplary way: these are the positive values which, directly or indirectly, Shakespeare absorbed from the culture of his age. This is why Cleopatra wishes to show herself to Mark Antony, at their final meeting, in all the regal splendor of queenly pomp: not out of exaggerated vanity, but as an instance of that virtue of magnificence which the epoch, imbued with Aristotelian precepts, expected in a sovereign.

In this world of the Renaissance where religion, though continuing to be a main source of inspiration for artists, had in fact—paradoxically enough —become peripheral, man was actually the measure of the universe: "l'uomo è misura del mondo," as Leonardo put it. Behind this blunt statement there lies a trend of philosophic thought, the complex Pythagorean-Platonic theory of which we have already spoken, whose chief manifestation was in architecture, though all the other arts, including literature, were permeated by it. Here is to be found the main structure, the *ductus* of the age; first of all, as is natural, in the country which was the cradle of the Renaissance: Italy. In his *Architectural Principles in the Age of Human-*

ism Rudolf Wittkower has exhaustively shown how "Renaissance artists firmly adhered to the Pythagorean conception 'All is Number' and, guided by Plato and the Neo-Platonists and supported by a long chain of theologians from Augustine onwards, they were convinced of the mathematical and harmonic structure of the universe and all creation," that "With the Renaissance revival of the Greek mathematical interpretation of God and the world, and invigorated by the Christian belief that Man as the image of God embodied the harmonies of the Universe, the Vitruvian figure inscribed in a square and a circle [44] became a symbol of the mathematical

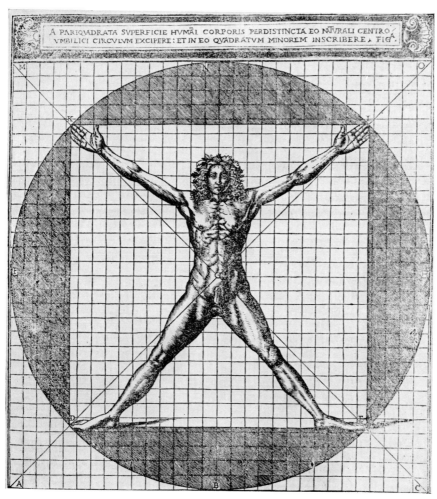

44 Man inscribed in a square and a circle, from Cesare Cesariano's
edition of Vitruvius (Como, 1521).

sympathy between microcosm and macrocosm. How could the relation of Man to God be better expressed, we feel now justified in asking, than by building the house of God in accordance with the fundamental geometry of square and circle?"[7] Hence perfect geometry is essential in buildings even if accurate ratios are hardly manifest to the eye. In his *Summa de arithmetica*, published in Venice in 1494, Luca Pacioli maintained (dist. VI, tract. 1, art. 2) that divine functions are of little value if the church has not been built *con debita proportione*. These proportions depended on the Pythagorean-Platonic division of the musical scale. Leon Battista Alberti discussed the correspondence of musical intervals and architectural proportions: "With reference to Pythagoras he stated that 'the numbers by means of which the agreement of sounds affects our ears with delight, are the very same which please our eyes and our minds,' and this doctrine remains fundamental to the whole Renaissance conception of proportion. . . . For Alberti, harmonic ratios inherent in nature are revealed in music. The architect who relies on those harmonies is not translating musical ratios into architecture, but is making use of a universal harmony apparent in music: 'Certissimum est naturam in omnibus sui esse persimilem.' "

A passage from Daniele Barbaro's commentary of 1556 on Vitruvius is explicit enough: "Nature, our master, teaches us how to have to proceed in the measures and proportions of the buildings consecrated to God, as she does not want us to learn the symmetries which we have to adopt in temples, from any source other than the holy temple made in God's image and likeness, that is Man, in whose composition all the other marvels of nature are contained, and thus the ancients were well advised in deriving all criteria of measuring from the parts of the human body."[8] Francesco Giorgi gives detailed measurements, based on the Greek musical scale, for S. Francesco della Vigna in Venice, and considers the *cappella grande* at the far end of the nave to be like the head of the human body. The fact that the three men who were consulted about Giorgi's memorandum—the painter Titian, the architect Serlio, and the humanist Fortunio Spira—showed no undue surprise at his number symbolism and mysticism, makes it clear that this esoteric knowledge was fairly widespread, and that the unity of all arts and sciences made every initiate a trustworthy judge in these matters.[9] Architecture was not conceived as an isolated discipline,

but as one of the innumerable manifestations of the human mind which
all follow the same law.

The builders of the Middle Ages planned their churches in the shape of
the Cross; their Latin Cross plan was the symbol of Christ crucified. But
with the Renaissance the image of Christ triumphant (of the type of
Michelangelo's *Resurrected Christ* in the church of S. Maria sopra Mi-
nerva) takes the place of the Man of Sorrows, parallel with the new
conception of the dignity of man; and the church façade is modeled on the
triumphal arch, as the façade of Alberti's S. Andrea at Mantua [45], for
example, was inspired by the Arch of Trajan at Ancona [46]. The system of
the façade is repeated in a continuous sequence in the interior: a system of
spanning arches (the chapels) alternating with closed walls according to
the rhythm a–b–a. Now if you invert the direction, and proceed from the
nave to the façade, the latter represents the final bar of the whole move-

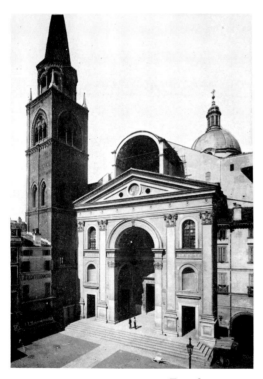

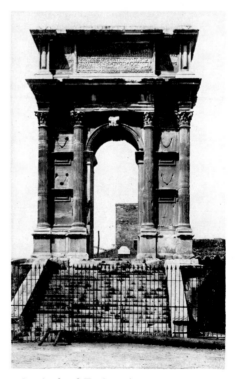

45 LEON BATTISTA ALBERTI: Façade,
 S. Andrea, Mantua. 1470

46 Arch of Trajan, Ancona. A.D. 112

ment, and you are reminded of the structure of the sonnet. To both forms Alberti's definition of beauty could be applied: "the harmony and concord of all the parts achieved in such a manner that nothing could be added or taken away or altered except for the worse."

We must note that Alberti wanted the buildings proportioned to the human scale, harmonized with man's size and integrated with the urban surroundings, and therefore endowed with that *mediocritas* which would not stand out among them. The aesthetic rule was at the same time an ethical one, and reminds us of Castiglione's principles for a perfect courtier: "the surest way in the worlde is, for a manne in hys lyving and conversation to governe himself alwaies with a certeine honest meane, whych (no doubt) is a great and moste sure shield againste envie, the whiche a manne ought to avoide in what he is able."[10] There is a parallel also between Alberti's definition of beauty and the behavior of the complete gentleman as set forth by *The Courtier:* ". . . and not onely to set his delite to have in himself partes and excellent qualities, but also to order the tenour of his life after suche a trade, that the whole may be answerable unto these partes, and see the selfe same to bee alwayes and in every thing suche, that it disagree not from it selfe, but make one body of all these good qualities, so that everye deede of his may be compact and framed of al the vertues, as the Stoikes say the duetie of a wiseman is: although not withstanding alwaies one vertue is the principall, but all are so knit and linked one to an other, that they tende to one ende, and all may be applyed and serve to every purpose."[11]

The close connection of this rule of conduct with the arts is shown by what follows, for Castiglione goes on to say that the courtier must throw his virtues into relief by contrast, "as the good peincters with a shadow make the lightes of high places to appeere, and so with light make lowe the shadowes of plaines, and meddle divers coulours together, so that throughe that diversitie bothe the one and the other are more sightly to behoulde,[12] and the placing of the figures contrarie the one to the other is a helpe to them to doe the feate that the peincters mynde is to bring to passe."[13]

While the principle of harmony by contrast is applied in these precepts, a final effect of diapason is never lost sight of. Spherical forms seemed

particularly calculated to achieve it. Hence the cupola became the crowning feature of a church, and Leonardo obtained a captivating smile in his *Gioconda* by molding the line of the mouth on the arc of a circle whose circumference touches the outer corners of both eyes [47].[14] In the group of *The Virgin and Child with St. Anne* the contrasting motions of the figures are brought to a close as they culminate in the head of St. Anne, which is the vertex of a triangle [48].[15]

The octave became a favorite metrical form in Italian poetry because of the final rhyming couplet (*rima baciata*), and the same may be said of the sonnet because of the crowning effect of the tercets. Of the many passages of the *Orlando Furioso* that could be quoted in this connection, the well-known one on the theme of the loss of virginity (Canto I, 42–43) may be chosen as a good instance:

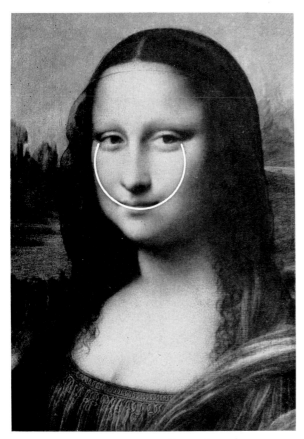

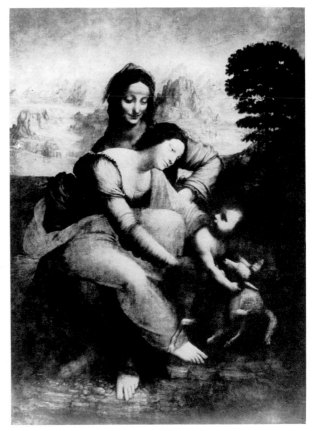

47 LEONARDO DA VINCI: *La Gioconda* (*Mona Lisa*). Canvas, ca. 1503. Detail, with a superimposed geometrical design

48 LEONARDO DA VINCI: *The Virgin and Child with St. Anne*. Canvas, ca. 1507–13

La verginella è simile alla rosa,
ch'in bel giardin su la nativa spina
mentre sola e sicura si riposa
né gregge né pastor se le avicina;
l'aura soave e l'alba rugiadosa,
l'acqua, la terra al suo favor s'inchina:
gioveni vaghi e donne inamorate
amano averne e seni e tempie ornate.

These three parallel movements (a first group of four lines, followed by two pairs) are contrasted in the following stanza, and concluded with the simile and the moral:

Ma non sì tosto dal materno stelo
rimossa viene, e dal suo ceppo verde,
che quanto avea dagli uomini e dal cielo
favor, grazia e bellezza, tutto perde.
La vergine che'l fior, di che più zelo
che de' begli occhi e de la vita aver de',
lascia altrui côrre, il pregio ch'avea inanti
perde nel cor di tutti gli altri amanti.

The movement follows closely the Latin model (Catullus, "Vesper adest," ll. 39ff.: "Ut flos in saeptis secretus nascitur hortis," etc.), but the rhymes emphasize the scansion and bring about an effect which is related to that produced by the structure of Leonardo's group of St. Anne and her kindred. A similar structure of contrasted movements, brought to a close with a moral, is found in Shakespeare's famous Sonnet 129:

Th' expense of spirit in a waste of shame
Is lust in action; and till action, lust
Is perjur'd, murd'rous, bloody, full of blame,
Savage, extreme, rude, cruel, not to trust;
Enjoy'd no sooner but despised straight;
Past reason hunted, and no sooner had,
Past reason hated, as a swallowed bait
On purpose laid to make the taker mad;

Mad in pursuit, and in possession so;
Had, having, and in quest to have, extreme;
A bliss in proof—and prov'd, a very woe;
Before, a joy propos'd; behind, a dream.
 All this the world well knows; yet none knows well
 To shun the heaven that leads men to this hell.

This tracing of parallels between the structure of a poem and that of a painting or a building cannot, however, ignore a judicious warning uttered by Wittkower: "In the eyes of the men of the Renaissance musical consonances were the audible tests of a universal harmony which had a binding force for all the arts. This conviction was not only deeply rooted in theory, but also—which is now usually denied—translated into practice. It is true, that in trying to prove that a system of proportions has been deliberately applied by painter, sculptor or architect, one is easily misled into finding in a given work those ratios which one sets out to find. Compasses in the scholar's hand do not revolt.[16] If we want to avoid the pitfall of useless speculation we must look for practical prescriptions of ratios supplied by the artists themselves."[17]

These "prescriptions," common enough among architects, are only rarely provided by other artists. But the common aims of architecture and poetry are clearly stated in Daniele Barbaro's commentary on Vitruvius: "Every work of art must be like a very beautiful verse, which runs along according to the best consonances one followed by the other, until they come to the well ordered end."[18]

This passage seems to fit very well the poems we have just read. In fact, while it would be useless to try to find in poets such strict rules as those practiced by architects,[19] it can hardly be denied that the Renaissance and particularly the Italian Cinquecento saw an unprecedented blossoming of prescriptions for all the arts. So-called violations and improprieties were often blamed in poets—in Dante, for instance, whose renown was at its lowest in this period obsessed by formalities;[20] rules were enforced for all literary genres, and extravagant ones were dictated for the *impresa* or device.[21] That belated humanist Milton adhered to Tasso's precepts as expounded in his *Discorsi dell'arte poetica* and *Discorsi del poema eroico*,[22] with particular attention to *magnificenza* and *musica,* so that a long pas-

sage towards the end of the second act of Tasso's tragedy *Torrismondo* can be said to contain the pattern of Milton's style in *Paradise Lost*.[23] The same principles Milton found in Tasso, Nicolas Poussin absorbed during his stay in Rome, where Cassiano dal Pozzo, that enthusiastic collector of antiques, acquainted him with Gioseffo Zarlino's *Istitutioni harmoniche* (published in Venice in 1558), from which he derived ideas that cause his pictorial work to appear to us as a visual counterpart of Milton's epos.[24] Poussin found in Zarlino's treatise support for his kind of painting, since for him painting, like music, had to be a transposition of states of mind For him the Horatian precept *ut pictura poesis* acted in reverse; his creed was *ut poesis pictura*,[25] and poetry was for him, as for Milton, first of all music.

In the course of time, as Professor Wittkower has shown,[26] the unity of the arts maintained by Renaissance theorists ceased to be a common belief. By the middle of the eighteenth century it remained a living force only with isolated artists such as Bernardo Antonio Vittone,[27] for whom the basic elements of an Attic column were equivalent to a concert of four voices within the limits of an octave, and even the fillets between moldings were compared to the melodic passages which make the essential notes of the accord more agreeable. The Pythagorean justification of the kinship between the two languages of architecture and music has, however, been substituted for here by a psychological and sensorial one.

But the possibility of objective truth, which was the foundation of Renaissance aesthetics, came to be generally denied. Particularly in England the whole structure of classical aesthetics collapsed, owing to Hogarth, Hume ("Beauty is no quality in things themselves: It exists merely in the mind which contemplates them; and each mind perceives a different beauty"), Lord Kames, and Alison (for whom the beauty of forms was produced solely by association), until Julien Gaudet, in *Eléments et théorie de l'architecture* declared that mathematical ratios were chimerical and "les proportions, c'est l'infini."[28]

But already the anti-Renaissance movement which goes by the name of mannerism,[29] attracted as it was by the picturesque, the bizarre, and—in a word—the particular, rather than by the Platonic ideal and the universal, had sought effects which implied a reversal of classical usage, and resulted

in disquieting arrangements in literature and the visual arts. Wittkower has remarked that mannerist architects were enchanted with the "unfinished" appearance of the rusticated order, and has recorded other stock features of mannerist architecture as exemplified in certain buildings of Palladio in that phase of his development when he was discovering the unclassical tendencies in ancient architecture[30] (for instance in the Porta de' Borsari at Verona). Michelangelo had set the example for such oddities in the anteroom of the Laurentian Library [49]: the slender grace of rectangular hollows over the tabernacles forms a playful contrast with the solemn character of the rest of the framework; small grotesque heads peep over the moldings of the capitals of the columns; frieze and architrave are abolished, and the entablature is reduced to a thin and elegantly profiled

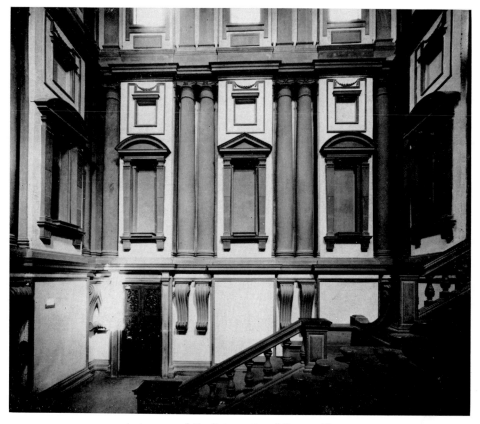

49 MICHELANGELO: Anteroom of the Laurentian Library, Florence

band full of tension; isolated triglyphs are employed in a quite unorthodox way to support the corbels of the tabernacles.[31] The unusual relation of equivalence between the lower and the upper order creates an effect of vertical tension. The wavelike staircase connecting the Ricetto with the Reading Room counterbalances the centrifugal motion of the compressed walls. Tension and counterpoint are the main features of mannerism: their most common formula is the *linea serpentinata*, which is a recurrent pattern of so much mannerist art (see, for instance, Salviati's *La Carità* [50] at the Uffizi, Bronzino's *An Allegory* [51] at the National Gallery, London, and Giambologna's statues).[32]

A picture like *Bathsheba Betaking Herself to David* [52] by Salviati is typical. A figure in the foreground on the right, seen from the back, is shown in the favorite pose of the mannerists: head turned to one side, arms to the other, pivoting with a slow grace as if to start a dance. Another

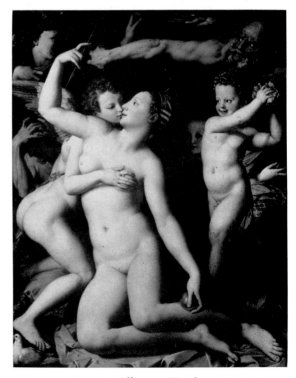

50 SALVIATI: *La Carità.* Canvas, ca. 1540–50

51 BRONZINO: *An Allegory.* Wood, ca. 1550–55

52 SALVIATI: *Bathsheba Betaking Herself to David.*
Fresco, 1552–54. Palazzo Sacchetti, Rome

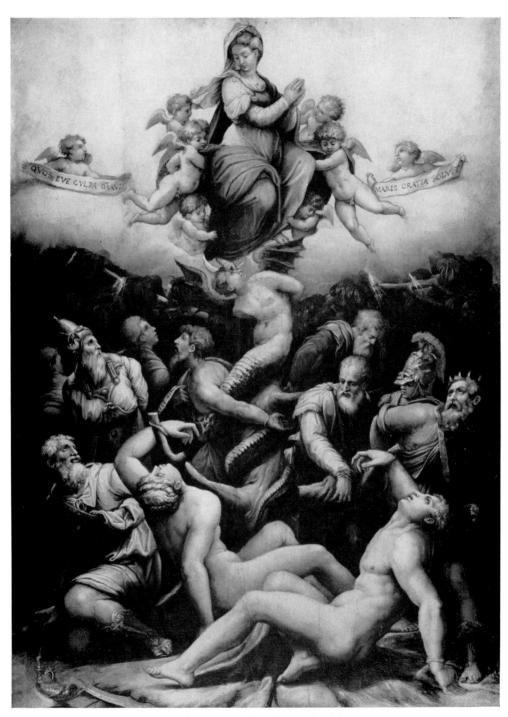

53 GIORGIO VASARI: *Allegory of the Immaculate Conception.* Canvas, ca. 1540

figure, setting her foot on the stair, also turns her head away from the direction in which the body is thrust; a third figure at the top of the stairs, is also turning her head to the side, away from the direction of her intended movement. All these twisted motions are communicated to the stairs, which are spiral with a suggestion of precariousness and caprice.

Another typical mannerist composition is Giorgio Vasari's *Allegory of the Immaculate Conception*, in which Adam and Eve tied to the tree and the Devil coiled around it all conform to the serpentine pattern [53].

In mannerist paintings the color as well is frequently unsteady, passing from one hue to another through the technique of *cangiantismo;* vases take serpentine forms embossed with strange swellings, as if instinct with animal life. Even space is pervaded by ambiguity: there are often two different spaces in the same painting, somehow unrelated, shot through with ambiguity. In Jacopo da Pontormo's *Joseph in Egypt* [54] different scenes of the Joseph story are combined. This device had precedents,[33] but what most strikes the onlooker here is the presentation of unrelated spaces as a unique vision.[34] The two statues on pillars hardly give unity to the composition: the spiral staircase on the right borders on a central scene whose figures, though painted smaller as if at a greater distance, actually appear to be closer to the foreground than the figures at the top of the staircase; this is because although the staircase seems to end beyond the central scene, the figures at its top are, oddly enough, bigger than those in the center of the painting. A tendency to abstraction, rather than pure imitation of nature, is common to painters like Pellegrino Tibaldi, Rosso Fiorentino, Parmigianino, and Beccafumi, with the result that reality is seen, so to say, metaphorically, and compositions often acquire an aspect which appeals to the surrealists of our time. Allusive forms partake now of the flexibility of snakes, now of the impassive splendor of semiprecious stones (as, for instance, in Bronzino's *Allegory*); deformation of shape reaches its climax with Luca Cambiaso's "cubic men" and Arcimboldo's anthropomorphic still lifes [55 and 56]. In his remarkable study of the Depositions by Rosso Fiorentino and Pontormo, Daniel R. Rowland has observed that Rosso's colors are often frankly dissonant, and that Pontormo carries this tendency to an extreme. In his *Deposition* "the eye can never come to rest on anything, but is kept constantly traveling around

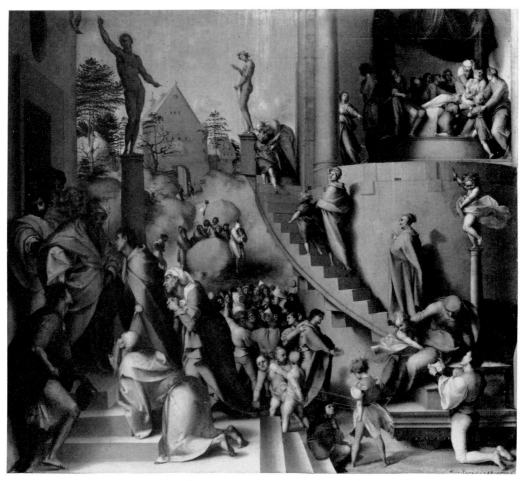

54 JACOPO DA PONTORMO: *Joseph in Egypt*. Canvas, ca. 1517–18

and around the composition following the curving lines of drapery until a sense of nausea is produced,"[35] and Rowland compares this effect to that produced by certain madrigals of the mannerist musician Carlo Gesualdo, which convey a sense of unsteadiness and musical seasickness.[36]

If one considers the tortuous pattern of John Donne's lyrics, one cannot help concluding that his chief characteristic does not lie in his conceits and witticisms, although these are bound to arrest one's attention first.[37] His chief trait is the nervous dialectic of his impassioned mind, a trait which Odette de Mourgues has noticed.[38] It finds parallels in the poetry of Maurice Scève in France, and can be traced ultimately to Petrarch. Donne uses the elements of the Petrarchan subject matter, but in a bizarre, unorthodox way that recalls the use of classical elements by Michelangelo in the anteroom of the Laurentian Library. I have noticed elsewhere[39] certain affinities of Donne with the proceedings of mannerist painters, in particular in the prominence given to an accessory detail, thus turning upside down what in other poets would have been the normal process.[40] Donne's tortuous line of reasoning frequently takes the form of a state-ment, reversed at a given point by a "but" at the beginning of a line. Thus in "The undertaking," after declaring that it would be of no use to teach how to treat a matter which is no longer in existence (like the specular stone, a simile for a sublimated love), Donne proceeds: "But he who lovelinesse within / Hath found, all outward loathes . . ."; in "Aire and Angels," after: "Still when, to where thou wert, I came, / Some lovely glorious nothing I did see," he goes on: "But since my soule, whose child love is, / Takes limmes of flesh . . ."; in "The Anniversarie," after: "Alas, as well as other Princes, wee . . . Must leave at last in death, these eyes, and eares," comes the reversal: "But soules where nothing dwells but love. . . ." In "The Dreame," "I thought thee . . . an Angell, at first sight," is immediately gainsaid by: "But when I saw thou sawest my heart / And knew'st my thoughts, beyond an Angel's art . . ."; in "A nocturnall upon S. Lucies Day" the watershed of the poem is reached with: "But I am by her death . . . Of the first nothing, the Elixer grown"; in "Witchcraft by a picture" the second stanza, beginning "But now I have drunke thy sweet salt teares," contradicts what has been said in the first. In "A Valediction: Forbidding Mourning" two parallel movements are each reversed by a

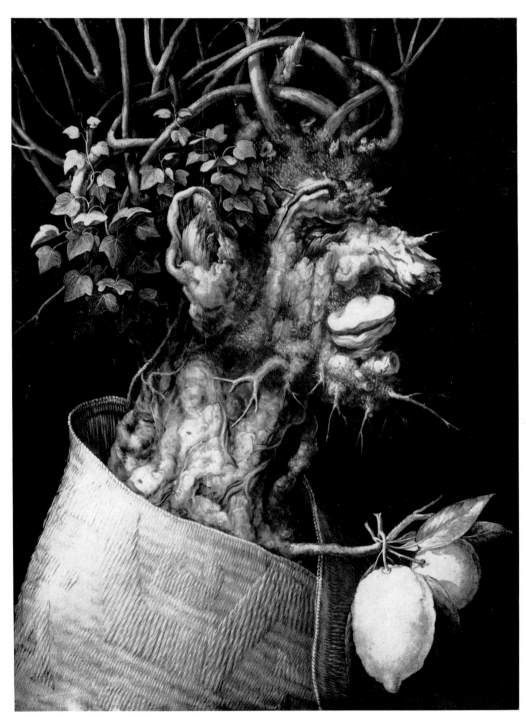

55 GIUSEPPE ARCIMBOLDO: *Winter*. Panel. 1563

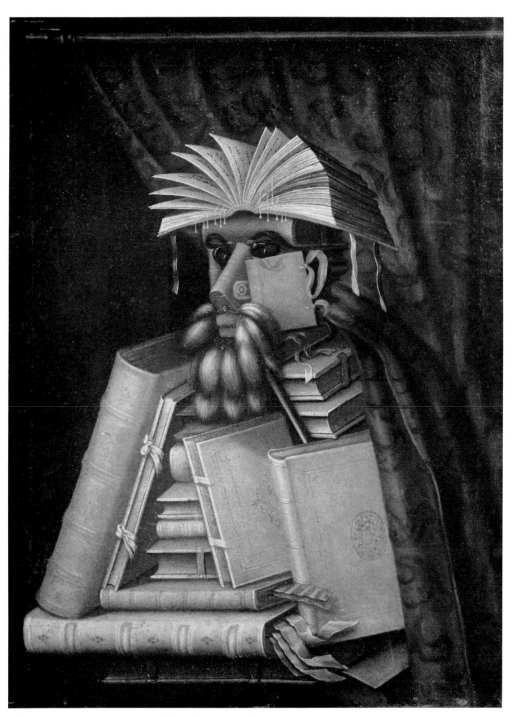

56 GIUSEPPE ARCIMBOLDO: *The Librarian*. Wood, ca. 1580

"but" at the beginning of a subsequent line: "Moving of th'earth brings harmes and feares . . . But trepidation of the spheares"; "Dull sublunary lovers love . . . cannot admit Absence . . . But we by a love, so much refin'd . . . Care lesse, eyes, lips, and hands to misse." The same manner of proceeding can be shown in some of the *Holy Sonnets:* in "Thou hast made me" ("But our old subtle foe so tempteth me . . ."); in "At the round earths imagin'd corners . . ." ("But let them sleepe, Lord, and mee mourne a space"); in "Spit in my face" ("But by my death can not be satisfied / My sinnes"); in "Batter my heart, three person'd God" ("But is captiv'd But am betroth'd unto your enemie").

If this kind of dialectic can be traced back to Petrarch, as I have said, a comparison of Donne's poetry with that of one of the most elegant followers of Petrarch in the Cinquecento, Pietro Bembo, will clearly show how far Donne has traveled from the orthodox pattern.[41] Take this sonnet from Bembo's *Rime:*

> *Bella guerriera mia, perché sì spesso*
> *v'armate incontro a me d'ira e d'orgoglio,*
> *che in atti et in parole a voi mi soglio*
> *portar sì reverente e sì dimesso?*
> *Se picciol pro del mio gran danno expresso*
> *a voi torna o piacer del mio cordoglio,*
> *né di languir né di morir mi doglio,*
> *ch'io vo solo per voi caro a me stesso.*
> *Ma se con l'opre, ond'io mai non mi sazio,*
> *esser vi pò d'onor questa mia vita,*
> *di lei vi caglia, e non ne fate strazio.*
> *L'istoria vostra col mio stame ordita*
> *se non mi si darà più lungo spazio,*
> *quasi nel cominciar sarà finita.*[42]

The same conclusion is transformed thus in Donne's "Loves exchange":

> *For this, Love is enrag'd with mee,*
> *Yet kills not. If I must example bee*
> *To future Rebells; If th'unborne*
> *Must learne, by my being cut up, and torne:*

Kill, and dissect me, Love; for this
Torture against thine owne end is,
Rack't carcasses make ill Anatomies.

Instances of rhetorical patterns in literature parallel to the *linea serpentinata* in the visual arts are easier to find in prose than in verse, although Giovanni Della Casa's reform of the sonnet through the introduction of enjambment or run-on lines, to replace end-stopped ones, is a clear enough instance of the prevailing mannerist taste. Della Casa was contemporary with the blossoming of the mannerist vogue in French art, introduced there by Primaticcio, Niccolò dell'Abbate, and Luca Penni.[43]

The exquisitely decorative character of the School of Fontainebleau can be best realized by comparing the *Allegory* [57] by an unknown painter with Botticelli's *Primavera*, of which it looks like a late and more voluptuous version; or by envisaging together the delightful Maître de Flore [58] and Ronsard's famous ode "Mignonne, allons voir si la rose," instinct with luminosity and sweet perfume. The pervasive presence of flowers in the most attractive compositions of the Fontainebleau School puts us in mind of the closing line of Ronsard's sonnet "Comme on voit sur la branche au mois de May la rose":

Afin que vif et mort ton corps ne soit que roses.

And as the abstract and elegant art of the French mannerists found its most congenial application in emblems (Maurice Scève's *Délie* being an exquisite instance of the combined resources of poet and painter), the general coloring of the prose of Lyly and Sidney has the same emblem-like quality.

The latter especially, in the second version of his *Arcadia* modeled on Heliodorus' Hellenistic romance, offers a good instance of *serpentinato* style in prose, making his sentences tortuous through the use of subordinate clauses, in order to obtain a subtler analysis of emotions:[44] "But when the messenger came in with letters in his hand, & hast in his countenance, though she knew not what to feare, yet she feared, because she knew not; but she rose, and went aside, while he delivered his letters and message; yet a far of she looked, now at the messenger, & then at her husband: the

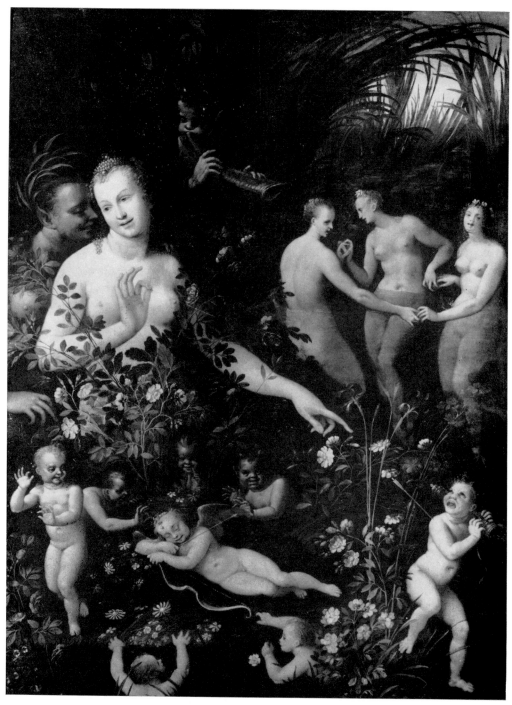

57 SCHOOL OF FONTAINEBLEAU: *Mythological Scene: Allegory of Love.* Canvas, ca. 1590

58 MAÎTRE DE FLORE: *Triumph of Flora*. Canvas, ca. 1560–65

same feare, which made her loth to have cause of feare, yet making her seeke cause to nourish her feare. And wel she founnd there was some serious matter; for her husbands countenance figured some resolution betweene lothnesse and necessitie: and once his eie cast upon her, & finding hers upon him, he blushed; & she blushed, because he blushed; and yet streight grew paler, because she knew not why he had blushed. But when he had read, & heard, & dispatched away the messenger (like a man in whom Honour could not be rocked on sleepe by Affection) with promise quickly to follow; he came to *Parthenia*, and as sorie as might be for parting, and yet more sorie for her sorrow, he gave her the letter to reade. She with fearful slownes tooke it, and with fearefull quicknesse read it; and having read it, *Ah* my *Argalus* (said she) . . ." (Bk. III, Chap. 12, §5).

This style, which Sidney derived from the study of Greek and Spanish romances, with its "but" and "yet" making a continuous transition from one mood to another, follows a tortuous course typical of mannerism.[45] Sidney's delight in this play of twists and turns reminds one of the closely worked, elaborate embroideries of the Elizabethan period, precious and barbaric at the same time.

Although mannerism was the most typical phenomenon of the sixteenth century, it by no means exhausted all the aspects of the visual arts and the literature of the period. Some of its features are present in many artists and writers, its dialectical elements are noticeable in Tintoretto and El Greco; but the Renaissance ideals of symmetry and serenity were still holding the field. The smooth, unruffled style of Bembo can achieve effects that Titian was able to attain in painting, and in a period in which the visual arts loomed large it is only too natural that writers should tend toward luscious descriptions, vying with the palette in their appeal to the taste of the ruling class. Yet should we try to illustrate this aspect, we might easily fall into the fallacy of taking for fundamental similarities what is only a common patrimony of themes.

A popular theme was the description of female nudes. Francesco Colonna, in his *Hypnerotomachia*, caressed with words all the details of a sleeping nymph, and we are reminded that Giorgione came out of the same circle of Venetian culture. Bandello in the third novella of his First Book also conjured up a naked beauty in bed for the eyes of courtiers to gloat

upon, just as Titian created for them his nudes.[46] Ariosto described Angelica tied to the rocks of Ebuda, a victim offered to a monster, and we are naturally referred to the many Andromedas displayed in paintings to pander to the taste of voluptuous and perverted gentlemen: particularly Titian's *Perseus and Andromeda* [59] and Tintoretto's painting of beautiful slaves being freed by knights in armor [60], where the contrast of nudes with chains and steel plates seems calculated to stir special sensibilities.

The same may be said of Shakespeare's *The Rape of Lucrece*. The taste for ἐκφράσεις according to the old recipe *ut pictura poesis* and for women in pathetic circumstances is indulged in by Shakespeare in his early poems to an extent equaled only by Marino in Italy. But although it has been maintained that Shakespeare saw Titian's *Venus and Adonis*,[47] commissioned by Philip II while he was the husband of Bloody Mary, he must have responded to a taste widely diffused in literature rather than to the impression of a special painting. The model was as old as the Ariadne episode in Catullus' sixty-fourth poem. The fact that one critic has thought of Titian, and another has compared Shakespeare's treatment to Rubens', shows that the common way of approaching the parallel between the various arts must be wrong.

One could with equal and probably greater justification compare Shakespeare's famous description of Cleopatra's barge in *Antony and Cleopatra* to the mannerist panels which decorate the Studiolo of Francesco I de' Medici in the Palazzo Vecchio at Florence. In fact, both this description and, on a lower artistic level, those in the early poems show the same attention to minute details, the same engrossment in rare and curious forms that Vasari displayed in his *Perseus and Andromeda*, Allori in his *Coral Fishing* in the Studiolo, and Zucchi in another painting [61] on the same subject in the Borghese Gallery—all mannerist painters who had felt the influence of Northern European masters.[48] Nothing in these panels or in the passage by Shakespeare I have mentioned suggests the broad, serene, Platonic manner of the great Italian masters, or Rubens' tumultuous feast of colored masses; we find rather the minute preciosity, the delight in curious shapes and in rare materials typical of the mannerists. The poet who wrote those descriptions belonged to the same phase of English taste as Sidney and the miniature painters of the court of Elizabeth.

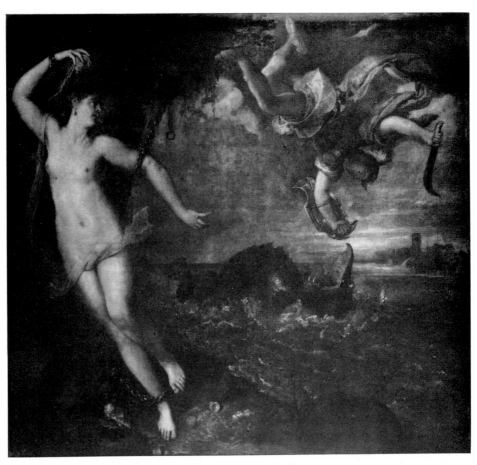

59 TITIAN: *Perseus and Andromeda*. Canvas, ca. 1562

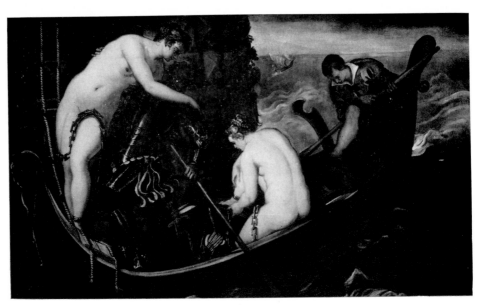

60 TINTORETTO: *The Rescue of Arsinoë*. Canvas, ca. 1556

61 JACOPO ZUCCHI: *Coral Fishing*. Copper, ca. 1572

The Curve and the Shell

ARCHITECTURE and costume, being the arts which are closest to everyday life, offer the clearest indications of the temper of an age. Painting, sculpture, music, even literature, prominent as they are, and important as embodying the chief expressions of artistic genius, have a relatively limited appeal compared with the arts which involve the satisfaction of practical needs common to all men: houses to live in, public buildings which stand for such fundamental institutions as religion and government, clothing for everyday wear and for state ceremonies. And it is in architecture and costume that, side by side with clear indications of new tendencies, we find a persistent undercurrent of classicism, whose powerful influence on European civilization never completely died out but rather reasserted its presence in the very heart of the baroque period, and, kept alive in the long tradition of English Palladianism, fought its way to the foreground in the second half of the eighteenth century with the neoclassical revival fostered by the discoveries of Herculaneum.

If we consider how men dressed during the period in which mannerism prevailed in literary and artistic expressions, we shall find it hard to reconcile the predilection for black, unadorned, severe clothes for men with the delight in variegated surfaces and the *cangiantismo* of the painters, and with the polychromy in the decoration of churches and monuments and the samples of marbles and semiprecious stones so common in tombs, altars, and cabinets of the period. In the vogue, in both women's and men's clothing, for cuts in the sleeves and for extremely elaborate shirt-collars (which in due course developed into ruffs), we do indeed find a counterpart of mannerist features in the arts. Precious stones employed for adornment and as symbolic language, the use of mottoes and

devices, are recorded in Chapman's *Ovids Banquet of Sence* (stanzas 70 and 71), where Julia gives a heart-shaped arrangement to her hair:

> *And then with Iewels of deuice, it graced:*
> *One was a Sunne grauen at his Eeuens depart,*
> *And vnder that a Mans huge shaddow placed,*
> *Wherein was writ, in sable charectry,*
> Descrescente nobilitate, crescunt obscuri.

> *An other was an Eye in Saphire set,*
> *And close vpon it a fresh Lawrell spray,*
> *The skilfull Posie was,* Medio caret,
> *To showe not eyes' but meanes must truth display.*
> *The third was an* Apollo *with his teme*
> *About a Diall and a worlde in way.*
> *The motto was,* Teipsum et orbem,
> *Grauen in the Diall; these exceeding rare*
> *And other like accomplements she ware.*

The impression conveyed by this description is the same as that we receive when confronted with the manner of allegorical portrait painting which was in vogue in England during the seventeenth century, in most cases the work of Flemish artists. Such a one was Antwerp-born Hans Eworth, who supposedly painted the portrait of Sir John Luttrell,[1] a rendering in pictorial terms of the allegorical verses inscribed on the picture [62]:

> *More tha[n] the rock admydys the raging seas*
> *The consta[n]t hert no da[n]ger dreddys nor fearys.*

Sir John is represented naked, wading waist-high in raging seas; a ship wrecked by storm and lightning is in the background, its survivors being overwhelmed in little boats. On his wrists are bracelets inscribed in Latin: "Money did not deter him, / nor danger wreck," and he gazes up confidently at a vision in the sky, from which a naked figure of Peace reaches to succor him; more remote attendant figures hold his spear, his armor, his charger, and his moneybags: probably an allusion to his dual role of warrior and merchant-adventurer.[2] In another portrait by Eworth (this one

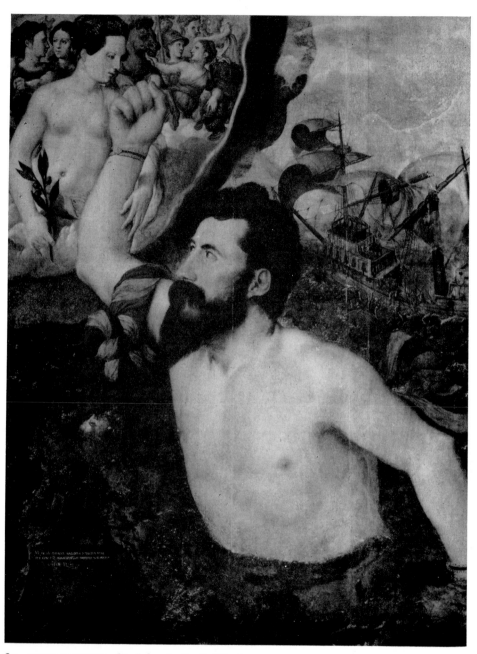

62 HANS EWORTH: *Sir John Luttrell.* Wood, 1550

painted about 1555), Lady Dacre is represented against a background full of accessories, which give the effect of a flat arabesque, the same effect we note in so many stanzas of Spenser's *The Faerie Queene*, where the crowding of details seems to imitate the painstaking technique of that branch of painting which dominated all others during Queen Elizabeth's reign: the miniature. In another of Eworth's paintings (1569), also akin to Spenser in spirit, we see Queen Elizabeth confounding Juno, Minerva, and Venus by receiving the golden apple in their stead [63], just as she did in the verses of the Spenserian Richard Barnfield's *Cynthia*, written at a later date (1595).[3] The term "mannerist," applied to such Flemish painters as Eworth, fits English authors like Spenser and Sidney equally well.

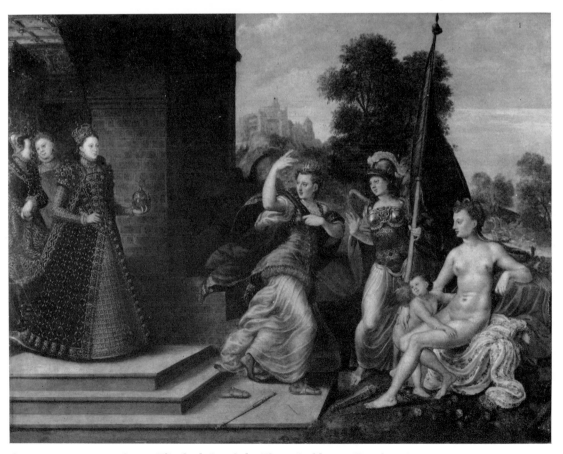

63 HANS EWORTH: *Queen Elizabeth I and the Three Goddesses*. Panel, 1569

64 JACOPO DA PONTORMO: *Double Portrait*. Wood, ca. 1516

But the prevalence of unadorned black in men's dress throughout the sixteenth century in Italy and Spain (the latter country is wrongly supposed to have originated this fashion, but in fact its origin was Venetian)[4] —that severe fashion, praised by Castiglione at the beginning of the century and by Francesco Sansovino[5] soon after its middle, illustrated in many portraits of men by Pontormo [64], Salviati, and other painters of the

mannerist tendency—corresponds to the ideals of gravity and majesty advocated for prose. This may be seen in numberless cases in Italian literature, and in English in the writings of Milton, Taylor, Bacon, Hooker, in the Bible translations, and even the work of writers like Donne and Sir Thomas Browne, who have a strong mannerist component in their artistic inspiration. Take Browne, for instance: his way of showing images in all their facets, his setting them in his prose with the exquisite skill of a goldsmith setting precious stones, are without doubt mannerist traits. With all this, his predilection for long words of Latin origin, and for a solemn flow of sentences, recalls the gravity of the Bible and of the *Book of Common Prayer*. In this passage from Browne's *Christian Morals* (Part I, Sec. 24), the imaginative contents leave unruffled the surface of the traditional, solemn prose of Latin origin: "To well manage our Affections, and Wild Horses of *Plato*, are the highest Circenses; and the noblest Digladiation is in the Theater of our selves: for therein our inward Antagonists, not only like common Gladiators, with ordinary Weapons and down right Blows make at us, but also like Retiary and Laqueary Combatants, with Nets, Frauds, and Entanglements fall upon us. Weapons for such combats are not to be forged at *Lipara: Vulcan's* Art doth nothing in this internal Militia: wherein not the Armour of *Achilles*, but the Armature of St. *Paul,* gives the Glorious day, and Triumphs not Leading up into Capitols, but up into the highest Heavens."

In architecture humanist ideals were never completely eliminated by the all but sweeping fashion for the Baroque. It is a well-known fact that in his later years Bernini himself as a sculptor turned to "an austere and, one is tempted to say, classical framework for his compositions," and this "shows that he was not independent of the prevalent tendencies of the period"; as for the colonnade of St. Peter's, according to Wittkower "no other Italian structure of the post-Renaissance period shows an equally deep affinity with Greece."[6] It is this same turn we find in the later compositions of Poussin and Milton, that classical strain which is so marked in some of the painters as to make us wonder whether neoclassicism was not already at hand. Guido Reni, when asked by his pupils where he found models as beautiful as the figures of his paintings, replied by pointing out casts of ancient statues. His *Girl with a Wreath* [65] is conceived after the antique.

65 GUIDO RENI: *Girl with a Wreath*. Canvas, ca. 1635

The tendency is already observable in Raphael, whose last works show signs of his preoccupation with archaeology. Annibale Carracci's Farnese Gallery is closer to the second half of the eighteenth century than to Rubens or even to Michelangelo, some of whose Sistine figures he adopts and transforms; and Domenichino followed Bellori's classical theory so closely as to actually anticipate Thorwaldsen in some of his compositions [66]. Domenichino's classicism is exempt from rhetoric: he was for a harmony of temperate tones, a rhythm of everyday acts such as those

shown in the antique bas-reliefs, whose restraint he imitated to the point of appearing "troppo marmoreo, profilato e stentarello" to some of his contemporaries. He influenced all the ethically inspired French painting of the seventeenth century, from Poussin to Le Sueur, and contributed to the movement of reaction against the Baroque. A follower of Poussin, Jacques Stella (1596–1657) of Lyons showed in a painting of *Clelia and Her Companions Crossing the Tiber* [67] that he had taken his models from Domenichino and ancient statues. Domenichino was no isolated phenomenon, because *Diana's Hunt* (Borghese Gallery, Rome) gives us a synthesis of the Italian literary and musical taste of the early seventeenth century.

A curious fact, indeed, one which illustrates the persistence of tradition, is the relative tameness of Italian seventeenth-century literature in comparison with the daring innovations in the arts. Marino, the Italian representative of *secentismo*, develops certain tendencies already apparent in Tasso, and enounces one of the principles of the Baroque in the phrase "È del poeta il fin la maraviglia"; but none of the really essential characteris-

66 DOMENICHINO: *St. Cecilia Refuses to Worship the Idols*. Fresco, 1611–14. S. Luigi dei Francesi, Rome

67 JACQUES STELLA: *Clelia and Her Companions Crossing the Tiber*. Canvas,
1635–37

tics of this style finds a perfect illustration in him. His chief poem, *Adone*, is little more than an inventory of delights and elegances, very close in spirit to Jan Brueghel's overcrowded *Allegories of the Senses*, which were destined to stimulate the languishing appetites of those most melancholy of sovereigns, the kings of Spain, with a display of fine and rare things. Marino's paradisiacal garden, inhabited by Venus and Cupid, is in spirit one of the paradises of Jan Brueghel, who was nicknamed after them. It is divided into five sections, each symbolizing one of the five senses. Adonis, after listening to a learned dissertation on the organ of sight from the lips of Mercury, his guide, enters a garden full of merry dances and games. The arcades are decorated with paintings representing love scenes, and the poet seizes the opportunity to celebrate the greatest painters of the period: Caravaggio, Veronese, Titian, Bronzino, the Carracci. While the pair wanders in the garden, a beautiful peacock comes their way, and the poet tells its mythical story. Similarly, in *The Allegory of Sight* [68] Brueghel displays paintings by the most celebrated artists of his time hanging on the walls or leaning on easels or pieces of furniture, and shows a peacock framed in the window-space. In Marino's poem, Venus then leads Adonis into the garden of the sense of smell, and Mercury expounds upon the flowers and scents that are found there: cassia, amaracus, amomum, anet, spikenard, thyme, serpille, helichrysum, cytisus, sisymbrium, cinnamon, terebinth, myrrh, privet, amaranth, narcissus, hyacinth, crocus—flowers throng Marino's verse as well as Brueghel's painting. In the same way the peacock surpasses all other birds of the garden in beauty, so the passionflower excels all other flowers, and Marino sings its praises in nine stanzas. In the seventh book of the poem, after a discourse on the sense of hearing and a description of its garden, a symphony of forty-four birds, each one described by the poet, is introduced, and the episode concludes with the famous competition between the nightingale and the lutanist derived from Famianus Strada, the same source Crashaw drew upon for "Musicks Duell."

We needn't continue our brief survey of the poem, which is modeled on Tasso and Ovid. It was published in Paris in 1623 and had circulated in manuscript long before then, and it is possible that Brueghel, who painted his *Allegories* in 1618, may have been acquainted with it; but this is not of

primary importance. Both the poet and the painter represent in a very similar way the same moment of taste, and a fashionable subject: catalogues which are almost scientific are turned into poetry; the current notions about the senses and the objects which impress them are arranged into elaborate and dizzy symphonies. Sensuous things display all the splendor of their outward appearance and become almost mystical species, though without losing anything of their terrestrial nature. Marino and Brueghel create an apotheosis of the still life. Man, in this spectacle of things intended for the pleasure of his five senses, almost disappears. Venus and Adonis pass like shadows through Marino's magical gardens; Brueghel took so little interest in man that he asked other painters to paint in those human figures which would have distracted his attention from that universe of objects in which he loved to take shelter. A step further on, we shall find with Marvell that ecstatic love of gardens in which things

68 JAN BRUEGHEL: *The Allegory of Sight.* Wood, ca. 1618

are adored for their own sakes, and their practical purpose, that of minis-
tering to the senses, is nearly lost sight of: the adoring spirit becomes one
with nature,

> *Annihilating all that's made*
> *To a green Thought in a green Shade.*

If Baroque meant only an overcrowding of details, a display of luscious
imagery, then Marino could certainly be termed baroque; but then even
Tasso, for his description of Armida's garden, may be said to belong to the
same category of poets, and indeed Armida has been compared with the
Cleopatras of seventeenth-century artists.[7] There is in that description,
however, a hint which is more indicative of a new turn in matters of taste
than all the other alleged antecedents to be found in Tasso's *Gerusalemme
liberata*. In the sixteenth canto of this poem (stanzas 9 and 10) we read
the following description of the character of Armida's garden:

> *L'arte, che tutto fa, nulla si scopre.*
> *Stimi (sì misto il culto è co'l negletto)*
> *sol naturali e gli ornamenti e i siti.*
> *Di natura arte par, che per diletto*
> *l'imitatrice sua scherzando imiti.*[8]

This passage, which owes not a little to Longinus' *On the Sublime*
—in which, however, the same principle was applied to eloquence—is not
only a first step towards the creation of the "natural" or picturesque garden
that became an English specialty during the eighteenth century.[9] It indi-
cates a revolution in taste that is lightly hinted at in Herrick's delightful
little poem "Delight in Disorder," which followed in the wake of Ben
Jonson's passage in *The Silent Woman* (1609), which in its turn was an
English version of a Latin poem presumably by Jean Bonnefons.[10] Now,
when we read Herrick's poem we are instantly reminded of Bernini's
treatment of drapery, and of a characteristic of baroque art much more
revealing than that mere crowding of details we have examined:

> *A sweet disorder in the dresse*
> *Kindles in cloathes a wantonnesse:*

A Lawne about the shoulders thrown
Into a fine distraction:
An erring Lace, which here and there
Enthralls the Crimson Stomacher:
A Cuffe neglectfull, and thereby
Ribbands to flow confusedly:
A winning wave (deserving Note)
In the tempestuous petticote:
A carelesse shooe-string, in whose tye
I see a wilde civility:
Doe more bewitch me, then when Art
Is too precise in every part.

All this may seem a frivolous mood, in comparison with the deep emotions Bernini's draperies are meant to suggest. The artistic result is, however, of the same kind: a significant movement instead of beautiful stillness. Of the Ponte S. Angelo angels Professor Wittkower writes that their grief over Christ's Passion is reflected in different ways in their wind-blown draperies: "The Crown of Thorns held by one of them is echoed by the powerful, wavy arc of the drapery which defies all attempts at rational explanation. By contrast, the more delicate and tender mood of the Angel with the Superscription is expressed and sustained by the drapery crumpled into nervous folds which roll up restlessly at the lower end" [69 and 70]. The tendency toward what Wittkower calls "dynamic ornamentalization of form" is developed to its utmost limit in the garments of the bronze angels on the altar of the Cappella del ss. Sacramento (1673–74) in St. Peter's: "Parallel with this went an inclination to replace the diagonals, so prominent during the middle period, by horizontals and verticals, to play with meandering curves or to break angular folds abruptly, and to deepen crevices and furrows."[11]

Of the use of such compositional devices to support an emotional tension we find an instance, parallel from a structural point of view, in the variety of rhythms employed by Dryden in his Pindaric ode "Alexander's Feast." On the whole it can be said that the favor enjoyed by the Pindaric ode, first adopted in England by Ben Jonson in his poem in honor of Lucius

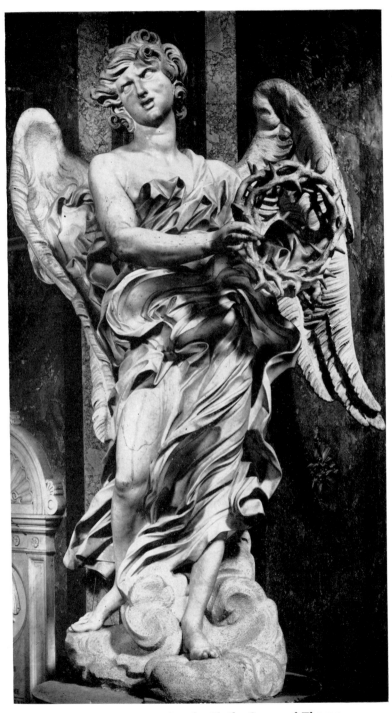

69 GIANLORENZO BERNINI: *Angel with the Crown of Thorns.*
Marble, 1668–71

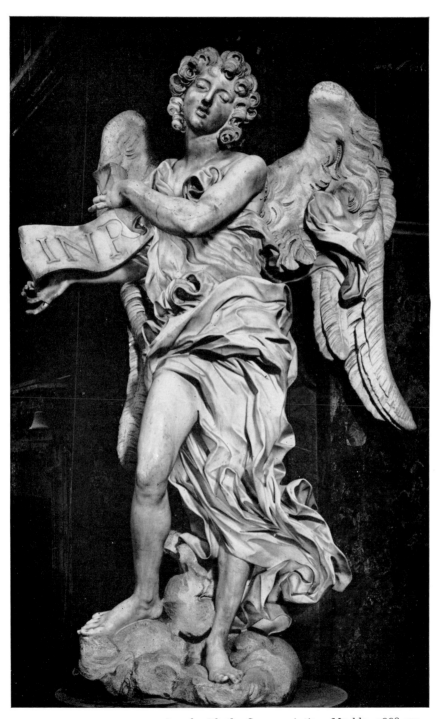

70 GIANLORENZO BERNINI: *Angel with the Superscription.* Marble, 1668–71

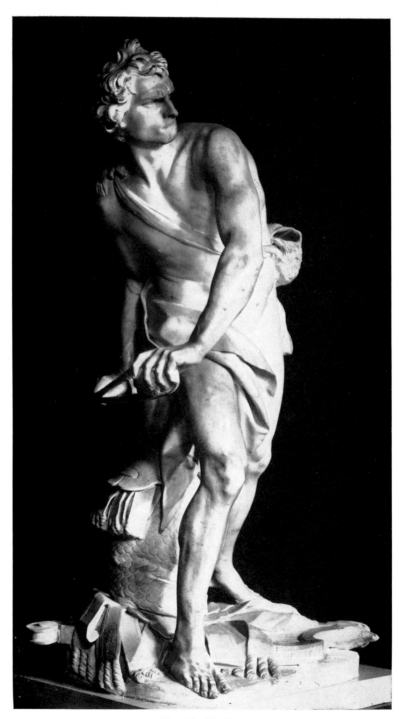

71 GIANLORENZO BERNINI: *David*. Marble, 1623

Cary and H. Morison, then naturalized by Cowley, is to be attributed to its irregularity of rhythm, which allowed for dynamic effects and the expression of the fury of inspiration: "Chez elle un beau desordre est un effet de l'art," (Boileau, *L'Art poétique*, Chant II, l.72). An Italian composition almost contemporary with Dryden's "Alexander's Feast," Francesco Redi's dithyramb "Bacco in Toscana," is another instance of the same tendency.

The freedom of movement implied by the elegant disorder in dress described by Herrick may be contrasted to the idol-like immobility enjoined by the stiff, complicated clothes worn by women in the preceding century "cloth-o'-gold and cuts, and lac'd with silver, set with pearls down sleeves, side-sleeves, and skirts, round underborne with a bluish tinsel."[12] This is, in the field of fashion, a reflection of the same tendency one finds in the higher arts. To quote Wittkower again: "One need only compare Bernini's *David* [71] with statues of David of previous centuries, such as Donatello's or Michelangelo's, to realize the decisive break with the past: instead of a self-contained piece of sculpture, a figure striding through space almost menacingly engages the observer."[13]

Another little poem by Herrick, "Upon Julia's Clothes," reveals a delight in the glittering silk of women's dresses, and this time a pictorial, rather than sculptural, parallel comes to mind:

> *When as in silks my* Julia *goes,*
> *Then, then (me thinks) how sweetly flowes*
> *That liquefaction of her clothes.*
> *Next, when I cast mine eyes and see*
> *That brave Vibration each way free;*
> *O how that glittering taketh me!*

Gerard Terborch (1617–81), a contemporary of Herrick (1591–1674), delighted in reproducing the silver-gray shades of silk and the pulpy softness of velvets [72]: "The light comes mostly from the front and stops at the glossy surfaces of the costumes and other textures."[14]

When the reaction to the Baroque came, and principles of classical beauty were reasserted, it followed as a matter of course that the chief features on which seventeenth-century artists relied for novelty and surprise had to be reversed. Simplicity was opposed to overcrowding, noble

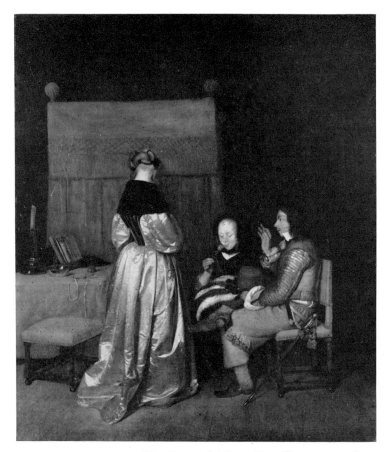

72 GERARD TERBORCH: *The Parental Admonition.* Canvas, ca. 1654–55

calm to passionate movement, order to disorder (or what seemed such), perfect beauty to the unusual and the bizarre, and the straight line to the curve. This last feature, which was the real core of the baroque revolution, we shall consider later on.

As for the unusual and the bizarre, the greatest innovation lay in the managing of the point of view from which objects had to be seen, and of the kind of light in which they had to be seen. Wit in poetry, illusionism in painting, and the *tenebroso* manner initiated by Caravaggio and brought to its extreme consequences by Rembrandt are all so many aspects of the same phenomenon. As *arguzia* or *agudeza* (wit) was, in the words of Sforza Pallavicino, "a marvellous observation condensed into a brief sen-

tence," it is easy to understand why the literary form that most appealed to the mind of a seventeenth-century man should be the epigram, which, by suggesting a foreshortened *tertium quid*, was the poetical counterpart of a false perspective like that of the famous Borromini colonnade in the Palazzo Spada [73], or Bernini's Scala Regia [74] in the Vatican: the former appears to be very long, but as soon as you proceed to walk inside the statue at the end dwarfs into a pigmy, and the different sizes of the columns reveal the trick; in the latter, Bernini, "By placing a columnar order within the 'tunnel' of the main flight and by ingeniously manipulating it, . . . counteracted the convergence of the walls towards the upper landing and created the impression of an ample and festive staircase."[15]

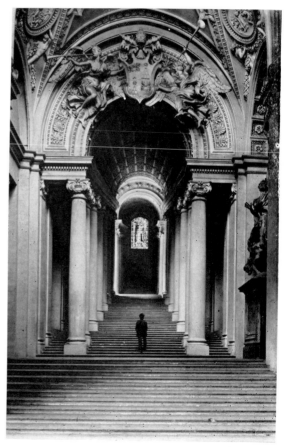

73 FRANCESCO BORROMINI: Colonnade with false perspective, Palazzo Spada, Rome. 1635

74 GIANLORENZO BERNINI: Scala Regia, Vatican Palace, Rome. 1663–66

Bernini's Cornaro and Pio chapels may also be quoted, and the magic effect of the supernatural scene he created around the Throne of St. Peter by the combined powers of sculpture, architecture, and lighting [75]; one hardly need mention the most famous of all illusionistic effects, that of Andrea Pozzo's ceiling of S. Ignazio [76]. What Emmanuele Tesauro says of metaphor in *Il Cannocchiale Aristotelico* reveals the kinship between wit and artistic illusionism: "Metaphor packs tightly all objects into one word:

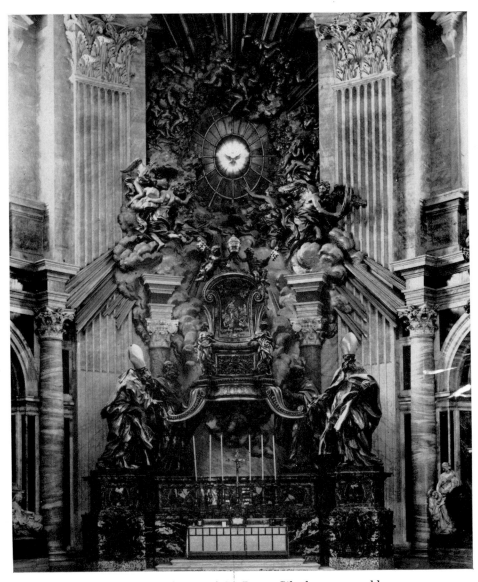

75 GIANLORENZO BERNINI: Throne of St. Peter. Gilt, bronze, marble, and stucco, 1657–66. Apse, St. Peter's, Rome

and makes you see them one inside the other in an almost miraculous way. Hence your delight is the greater, because it is a more curious and pleasant thing to watch many objects from a perspective angle than if the originals themselves were to pass successively before one's eyes."[16]

One understands, then, why only in a period in which this point of view had become widespread could there be a chance of popularity—indeed, of an enthusiasm—for the kind of decoration of church ceilings and cupolas first practiced in the second decade of the sixteenth century by Correggio, in S. Giovanni Evangelista [77] and the Cathedral of Parma. These triumphal flights, among dawn-colored clouds, of angels and saints gyrating in the coil of a celestial maelstrom did not find an immediate following. It was only a century later, in the baroque period, that Giovanni Lanfranco's decoration of the cupola of S. Andrea della Valle after the manner of Correggio (1628) caused a real sensation, and the example of church decoration thus set by the Theatines was followed by the Oratorians with Pietro da Cortona's frescoes in the Chiesa Nuova (1647) and by the Jesuits with Baciccia's decoration of the Gesù (1675) and Andrea Pozzo's formidable *trompe-l'œil* [76] in the Church of S. Ignazio (1691–94), and for a century and a half became the fashionable style of church decoration in Catholic Europe, particularly in Italy and the German countries.[17]

Light playing on certain singled-out points of a scene has a dramatic effect similar to wit, insofar as it creates a tension, and dramatic contrasts. The painter manipulating light can be likened to an alchemist bent on finding the philosophers' stone:

> *I assure you,*
> *He that has once the flower of the sunne,*
> *The perfect* ruby . . .
> *. . . by it's vertue,*
> *Can confer honour, loue, respect, long life,*
> *Giue safety, valure: yea, and victorie,*
> *To whom he will.*[18]

Fromentin, in *Les Maîtres d'autrefois*, saw Rembrandt thus: "Rembrandt at work had the air of an alchemist: secrets were asked to his brush and his burin which came from afar; his principle was to extract from

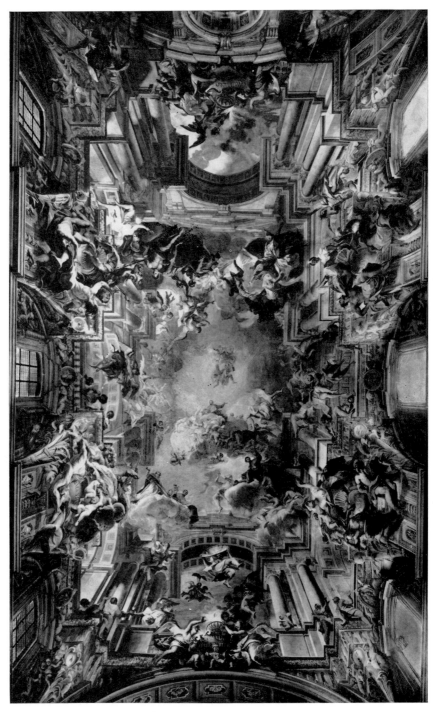

76 ANDREA POZZO: *The Glory of St. Ignatius*. Fresco, 1691–94. Ceiling
of the nave, S. Ignazio, Rome

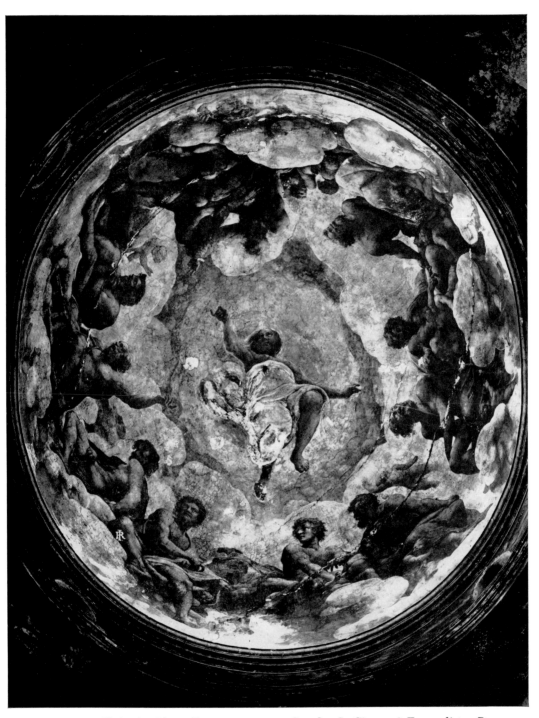

77 CORREGGIO: *Christ in Glory*. Fresco, 1522–24. Cupola, S. Giovanni Evangelista, Parma

things an element above all others; or rather to abstract from all elements except one. Thus in all his works he has behaved like an analyst, like a metaphysician rather than a poet. To see the way in which he treated bodies one may doubt whether the envelopes interested him. He decomposed and reduced everything, color as well as light in such a way that, by eliminating from appearances all that is manifold, condensing what lies scattered, he succeeded in drawing without contours, in painting a portrait almost without visible traits, in coloring without color, in concentrating the light of the sun into a beam. He substituted moral expression to physical beauty, the almost total metamorphosis of things to their imitation. Thanks to this faculty of double sight, to this somnambulist's intuition, he sees deeper than anybody else into the supernatural."[19]

By the magic of light, that supreme elixir, that wit of the sun, Rembrandt made ugliness acceptable to the vision of art. This was his great discovery, which was also Caravaggio's: that nothing is so vulgar and ugly that art cannot redeem it.[20] And this was also, in a way, Cervantes' and Shakespeare's discovery: Don Quixote and Sancho are grotesques in the baroque manner, Falstaff and Caliban could hardly have been exhibited on the classical stage of France, though, considered from another point of view, even Corneille may be defined as baroque[21]—indeed, France had to wait until Hugo's preface to *Cromwell* to conceive of such freedom.

Rembrandt not only dares to show men as they are—that is, on the whole, as far from handsome—but he actually chooses his models from among the most ordinary and unprepossessing of them. He represents the celebrated women of the Bible and of heroic legend as endowed with deplorable anatomies: live flesh, no doubt, but pitifully throbbing with the life of coarse humanity; though certainly he was not pursuing aims similar to those of the authors of *Lo Scherno degli dei* or *Virgile travesti*,[22] or of those followers of Marino who sang the praises of women attractive in spite of their deformities, or even of Shakespeare, when he professes in Sonnet 130 his partiality for a far from beautiful mistress. Rembrandt represents Diana as a flabby, mature matron bathing [78], Bathsheba as a stripped maid servant, Susannah with flesh as white as cheese, her gestures clumsy as she covers her womb and puts on uncouth slippers, and Ganymede being carried off by the eagle as a blubbering urchin.

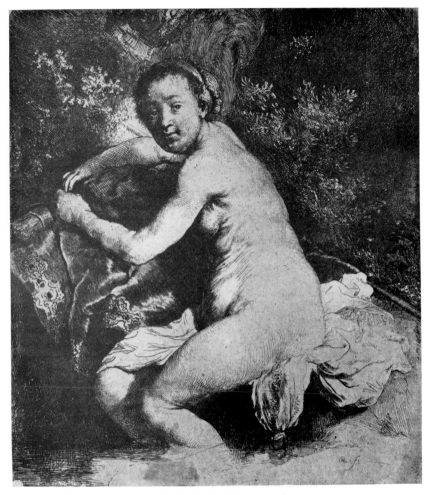

78 REMBRANDT: *Diana at the Bath*. Etching, ca. 1631

Just as he could produce light out of darkness, so that the words of
Sophocles' Ajax could be made his: "Oh, darkness, my light!"; thus, too,
Rembrandt knew how to seize the quintessence of live, passionate, and
suffering humanity in its less attractive specimens, in graceless creatures
and in the very people despised in his own times, the Jews. These human
types, too, claimed admission at the door of art. Caravaggio had perceived
this, and chose his models from among the populace; Rembrandt felt it
even more, and, more daringly still, picked his own up from the haunts of

beggars and the ghetto. To find something corresponding to this in litera-
ture, one must wait until the nineteenth century, when George Eliot, in the
wake of Wordsworth, answered the objection "What a low phase of life!—
what clumsy, ugly people!" in the seventeenth chapter of *Adam Bede*: "But
bless us, things may be lovable that are not altogether handsome, I hope.
. . . Yes! thank God; human feeling is like the mighty rivers that bless the
earth: it does not wait for beauty,—it flows with resistless force, and
brings beauty with it. All honour and reverence to the divine beauty of
form! Let us cultivate it to the utmost in men, women, and children. . . .
But let us love that other beauty too, which lies in no secret of proportion,
but in the secret of deep human sympathy." She had already asked,
apropos of ordinary men, in *The Sad Fortunes of the Rev. Amos Barton*:
"Is there not a pathos in their very insignificance,—in our comparison of
their dim and narrow existence with the glorious possibilities of that
human nature which they share?"

Anticipating George Eliot by two centuries, Rembrandt too felt the
appeal of the many human souls who look out "through dull grey eyes,"
and speak "in a voice of quite ordinary tones." His anticlassical campaign
was animated by an intent of truthfulness to nature. Words used by
Wittkower of Caravaggio could be applied also to Rembrandt: "It is pre-
cisely the antithesis between the extreme palpability of his figures, their
closeness to the beholder, their uncomeliness and even vulgarity—in a
word, between the 'realistic' figures and the unapproachable magic light—
that creates the strange tension. . . ."[23]

Rembrandt did not attempt to improve upon the ugliness he found in
nature (his etching of Diana bathing shows "all the small furrows which
an elaborate, habitual costume—garters, stays, sleeve-bands—leave on the
soft surface of the flesh"),[24] and he also reduced to the level of ordinary
humanity the ideal figures of Italian art, in such a way as to make them
unrecognizable. It has needed the ingenuity of Sir Kenneth Clark to find in
Samson's Wedding Feast traces of Rembrandt's study of Leonardo's *Last
Supper*, to read as in a palimpsest Raphael's *Attila* in *The Night
Watch*. In the etching of *Christ Presented to the People* we recognize the
patterns of both Bandinelli's *Martyrdom of St. Lawrence* (by way of an en-
graving by Marcantonio) and Antonio da Salamanca's engraving of Mi-

chelangelo's monument to Julius II; Rembrandt's self-portrait is modeled on Titian's so-called Ariosto portrait and Raphael's *Castiglione;* the *Sacrifice of Manoah* is based on a lost *Adoration of the Shepherds* by Leonardo, reproduced fairly accurately in a work by his Spanish followers; in the etching of *The Three Crosses* we are astonished to find Pisanello's portrait of Gian Francesco Gonzaga. Such influences, completely assimilated, have an interest that reaches beyond source hunting. Renaissance art had utilized Gothic motifs, submitting them to the selective principle of classical ideals of beauty. Rembrandt follows the opposite course: he appropriates Renaissance motifs and translates them into the language of a period in which the artistic expression of moral and spiritual dignity was independent of physical perfection: the Middle Ages.[25] Like many revolutions, his revolution consisted in a return to the past. In him the poetics of the Middle Ages—of ugliness as a possible content for art—reasserted its validity.

Rembrandt's treatment of classical models is parallel to the use to which baroque architects put the traditional orders. Bernini as a sculptor availed himself of classical models in the same way Rembrandt utilized his studies of Italian masters of the Renaissance. Wittkower has drawn attention to the fact that the *Angel with the Superscription* is derived from the so-called *Antinoüs* in the Vatican. Bernini himself referred to this in his address to the Paris Academy: "In my early youth I drew a great deal from classical figures; and when I was in difficulties with my first statue, I turned to the Antinous as to the oracle." Wittkower comments: "His reliance on this figure, even for the late Angel [with the Superscription], is strikingly evident in a preparatory drawing showing the Angel in the nude. But the proportions of the figure, like those of the finished marble, differ considerably from the classical model. Slim, with extremely long legs and a head small in comparison with the rest of the body, the nude recalls Gothic figures."[26] Here we are made aware of the same return to the taste of the Middle Ages that Sir Kenneth Clark noticed in connection with Rembrandt. The same tendency can be observed in Borromini's Church of the Collegio di Propaganda Fide, where "The coherent 'skeleton'-structure has become all-important—hardly any walls remain between the tall pilasters!—and to it even the dome has been sacrificed. . . . No post-

Renaissance building in Italy had come so close to Gothic structural principles. For thirty years Borromini had been groping in this direction."[27] These are some instances of the revolution brought about by baroque ideals; the modular system, which implied an anthropomorphic conception of architecture, has been abandoned, and architects use the various elements in defiance of classical rules. The same grammar of architectural forms serves entirely different purposes and conveys vastly different ideas in the churches Bernini designed when he was almost sixty years old than it had formerly: S. Andrea al Quirinale, and the churches at Castelgandolfo and Ariccia.[28]

But Bernini never challenged the essence of the Renaissance tradition. It was Borromini who actually threw overboard the classical anthropomorphic conception of architecture. The extent of this revolution can be appreciated by studying Borromini's comparatively short career, from the small but all-important church of S. Carlino alle Quattro Fontane [79], in which he renounced the classical principle of planning in terms of modules (i.e., in terms of the multiplication and division of a basic architectural unit), to the late façade of the Palace of the Collegio di Propaganda Fide [80], in which nothing is orthodox. "The capitals are reduced to a few parallel grooves, the cornice is without a frieze, and the projecting pair of brackets over the capitals seems to belong to the latter rather than to the cornice. The central bay recedes over a segmental plan, and the contrast between the straight lines of the façade and the inward curve is surprising and alarming. No less startling is the juxtaposition of the austere lower tier and the *piano nobile* with its extremely rich window decoration."[29]

The main feature of this revolution, a feature which led to extremely complex schemes and to such marvelous developments as the domes of S. Carlino alle Quattro Fontane [81] and S. Ivo, and to S. Lorenzo and the Capella della ss. Sindone in Turin [82], is the curve. The curve induces movement, it articulates the façade of a church like a fugue,[30] with volutes, concave and convex surfaces, broken pediments: a ceaseless throbbing transforms the solidity of the stone into the mobility of the wave.[31] The curve helps in the creation of an illusory space; the interplay of convex and concave forms causes the small piazza of Pietro da Cortona's S. Maria della Pace to appear much wider than it actually is, a device belonging to

the kind of false perspective employed on the stage.[32] Angels' wings, the sphere, the sun, the cloud, wind-blown draperies and hair, the palm branch —all curved forms are ubiquitous; they are often invested with a symbolical meaning, as in the case of the soap bubble, an emblem of human life, or the egg,[33] the heart,[34] the tennis ball. It is significant, for instance, that the image of man's utter incapacity to resist destiny, or the will of a supernatural power, which most appealed to the seventeenth century was that of a ball used in a game. "It seemed to happen to me that I saw the devils playing tennis with my soul," wrote St. Teresa (*Vida*, XXX); and Solórzano Pereira's *Emblemata* (Madrid, 1651) has an emblem in which God is represented dealing with kings as with tennis balls. John Webster, taking up by way of Book V of Sidney's *Arcadia* Montaigne's sentence "Les dieux s'esbattent de nous à la pelote, et nous agitent à toutes mains" (in its turn indebted to Plautus' *Captivi*, Prol. 22), puts it in the mouth of Bosola in his own *Duchess of Malfi* (V, iv, 63–64): "We are merely the starres tennys-balls (strooke, and banded / Which way please them)."

As could be expected, the predilection for the curve is evident in costume, both in the shape of the garments themselves and in the emphasis on volume: wigs, breeches, sleeves all speak a curvilinear language. One fashion in men's shoes produced an oval hollow at the extremity, the tip of the shoe frequently jutting out in two little horns.[35]

The culmination of the curved figure is the spiral, which the last of the baroque artists, Piranesi, was later to invest with a hallucinatory character in the spiral staircases of the *Carceri*.[36]

The baroque artists used the suggestion of infinity conveyed by the curve as a vehicle of religious sublimity and for the exaltation of terrestrial majesty. While painting offers any number of parallels to this apotheosis of the curve in the frescoed ceilings of baroque churches, and parallels with music may be pointed out in Borromini's architecture,[37] it is not so easy to find illustrations in literature. There is, however, a case in which the correspondence seems all but perfect: Richard Crashaw.[38]

Crashaw learned how to turn surprising *concetti* in Marino's school, but there is nothing either in Marino or in the Jesuit poets whose Latin verse Crashaw studied and imitated to suggest that marvelous energy of soaring imagination which associates the English poet with the masterpieces of

79　FRANCESCO BORROMINI: Façade, S. Carlino alle Quattro Fontane, Rome. 1665–67

80 FRANCESCO BORROMINI: Façade, Palace of the Collegio di Propaganda Fide,
Rome, 1662

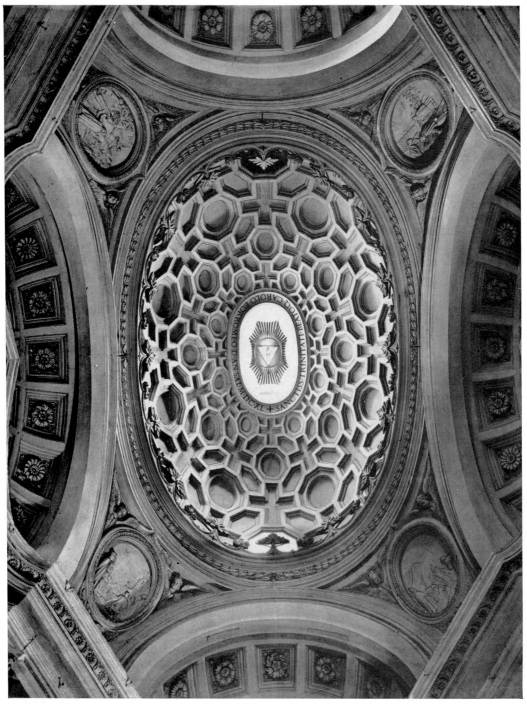

81 FRANCESCO BORROMINI: View into dome, S. Carlino alle Quattro Fontane,
Rome. 1638–41

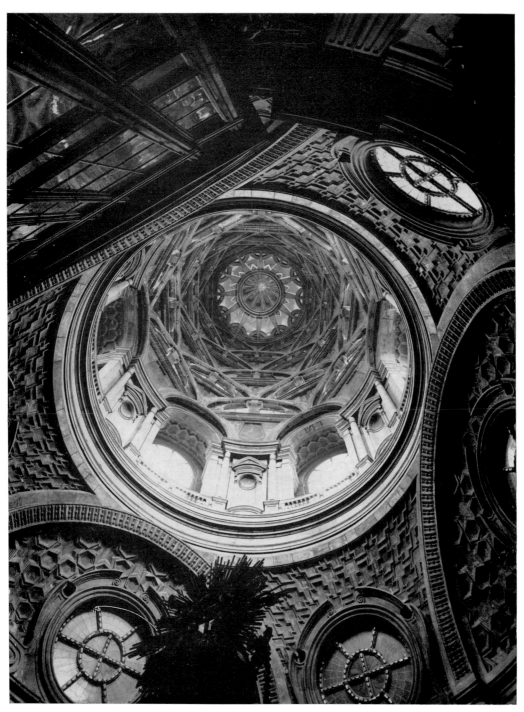

82 GUARINO GUARINI: View into dome, Capella della SS. Sindone, Turin, 1667–90

the visual arts. Of poetic inspiration Crashaw speaks thus in "To the Morning. Satisfaction for Sleepe":

> *. . . nimble rapture starts to Heaven and brings*
> *Enthusiasticke flames, such as can give*
> *Marrow to my plumpe Genius, make it live*
> *Drest in the glorious madnesse of a Muse,*
> *Whose feet can walke the milky way, and chuse*
> *Her starry Throne; whose holy heats can warme*
> *The Grave, and hold up an exalted arme*
> *To lift me from my lazy Vrne to climbe*
> *Vpon the stooped shoulders of old Time;*
> *And trace Eternity.*

Such an inspiration (thus described in a swift succession of mixed metaphors whose incongruity is nevertheless swept away by a frenzied motion, like the disparate elements in an overdecorated baroque altarpiece) can be defined, in the poet's own words, as "a sweet inebriated extasy,"[39] an ecstasy which breaks forth into dithyrambs and hymns of many-hued splendor, now nimble, soaring up in dizzy spirals, now solemn, wrapped in the silken folds of azure singing robes, veiled by clouds of incense. A Rubensian opulence swells the hymn "To the Name above every Name, the Name of Iesvs," as perhaps no other poem of the *Carmen Deo Nostro*. Crashaw's hymn is a dizzy sequel of variations on the Latin text of the "Jubilus de nomine Jesu" attributed to St. Bernard: the English poet envelops the spare structure of the Latin hymn in the folds of his inebriated rhetoric, just as Bernini transformed the classical statue of *Antinous* into the wind-blown *Angel with the Superscription*. And in the ill-welded final portion of the "Hymn to Saint Teresa," the poet's inspiration soars dizzily into an impassioned invocation ("O thou vndanted daughter of desires!"): his yearning for ecstasy is so intense and desperate that he seems almost to have reached it. In the whole course of seventeenth-century literature there is no higher expression of that spiritualization of the senses which is here condensed into a portentous flight of red-hot images. The voluptuous rapture of Lanfranco's and Bernini's ecstatic saints—St. Margaret surprised by the celestial Spouse, St. Teresa pierced by the

angelic archer, the Blessed Lodovica Albertoni in the throes of expiring—
and the paradisal languor of so many saints, martyrs, and blessed women
whose effigies people Italian and Spanish churches and art galleries, those
images we hesitate whether to term holy or profane, become suddenly
clear, as if we had been given a commentary on them and were reading
them in the light of those few lines of a great "minor" English poet, which
transcend them and seem to contain *in nuce* the quintessence of the whole
seventeenth century.

The circular magic of a baroque ceiling, centering on the apotheosis of a
hero or a saint, can be illustrated by Dryden's *rifacimento* of that very
passage of Shakespeare's *Antony and Cleopatra* which we mentioned ear-
lier in connection with mannerist preciosity. There is nothing of Shake-
speare's meticulous concentration on detail in Dryden's passage in the
third act of *All for Love* (emphasis mine):

> *She lay, and leant her cheek upon her hand,*
> *And cast a look so languishingly sweet,*
> *As if, secure of all beholders' hearts,*
> *Neglecting, she could take them: boys, like Cupids,*
> *Stood fanning, with their painted wings, the winds,*
> *That played about her face: but if she smiled,*
> A darting glory seemed to blaze abroad.
> *That men's desiring eyes were never wearied,*
> *But hung upon the object: To soft flutes*
> *The silver oars kept time; and while they played,*
> *The hearing gave new pleasure to the sight;*
> *And both to thought. 'Twas heaven, or somewhat more:*
> *For she so charmed all hearts, that gazing crowds*
> *Stood panting on the shore, and wanted breath*
> *To give their welcome voice.*

Shakespeare's picture is not focused into a single vista, whereas in Dry-
den's fresco we see the darting glory of Cleopatra's smile blazing abroad
from the very center of the scene, and gazing crowds massed along the
margins, much as Tiepolo's onlookers, in the shadow, people the edge of a
ceiling [83] whose center is "heaven, or somewhat more."

Tiepolo is a much later artist than Dryden, but the ceiling decoration of the rococo period continued the baroque tradition. The current opinion that the age of the Rococo is merely a development of the Baroque has been challenged by Philippe Minguet in his *Esthétique du Rococo*.[40] The baroque architects, even when they dissociate structure from ornament, never drown the articulations, because this would defeat their aim of creating architectural tensions. In a baroque interior, spaces never really blend together; they certainly interpenetrate, and in most cases counteract each other, but even when unity is aimed at, heterogeneity prevails. In the Rococo, the limitation of space is, instead, unperceivable: the aim is to create a unity which cannot be decomposed [84]. In a word, Rococo is the invention of decorators: rococo ornaments are flat, they cover a gliding surface with their thin lace; they tend to the infinitesimal, consisting as they do of smaller and smaller elements, of interpenetrating C and S curves, of flamelike shapes which dwindle into little flames and sparks, of flower-like shapes which are reduced to petals and pistils, of watery forms which flow into waterfalls and drops. The C and S curves are perceptible also in compositional schemes of paintings, as in J.-F. de Troy's *Une Lecture de Molière* (1727). The very subject of *The Rape of the Lock*—a spiral lock of hair, a curl—seems to condense into a symbol the essence of a whole century of Rococo. By an inverse metamorphosis the curl, a symbol of the Rococo, becomes humanized in a woman:

> *This Nymph, to the Destruction of Mankind,*
> *Nourish'd two Locks, which graceful hung behind*
> *In equal Curls. . . .* [Canto I, 35–37]

The Rococo renders any attempt at a Pythagorean explanation of its space absurd from the outset; nothing about it can be translated into terms of geometry. It is a feminine style, so feminine indeed that its chief figure, the shell, with its cozy concavity, suggests exactly what Verlaine saw in one of the shells in his poem "Les Coquillages" (from *Fêtes galantes*) when he wrote, "Mais un, entre autres, me troubla." Rococo interior decoration is reminiscent of trimmings on women's dresses, and its character persisted even in early neoclassical decoration, for Horace Walpole said of Robert Adam's Adelphi Buildings: "What are the Adelphi buildings? warehouses

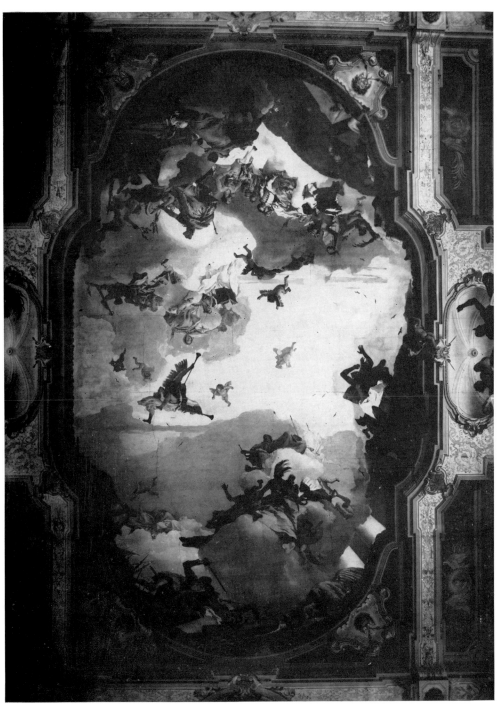

83 GIOVANNI BATTISTA TIEPOLO: *Apotheosis of the Pisani Family.* Fresco, completed 1761–62. Ceiling of the ballroom, Villa Pisani, Stra

laced down the seams, like a soldier's trull in a regimental old coat."[41] One feels tempted to liken the succession of styles from the Renaissance to the Baroque and the Rococo to the emphasis one might give to the various parts of a woman's body in turn, from the head and shoulders to the waist and flanks, and finally to the lower portion of it. Reason finds little nourishment in Rococo, but imagination, on the contrary, revels in it.

How, then, is this artistic style to be reconciled with the literature of the Age of Reason? The gulf seems at first unbridgeable, and certainly if one takes Addison and Johnson as representative authors, one may easily see in their style a counterpart of English Palladianism, but hardly a link with Rococo. There is, however, an element in Swift—magnifying and dwarfing used with a satirical aim in *Gulliver's Travels*—that almost foreshadows that aspect of the Rococo to which Minguet, using a Voltairian term, has referred as the "complexe de Micromégas."[42] A common feature of rococo decoration is the abolition of normal limits for a given motif, which can be made as big or as small as one likes: an element, either figurative or abstract, may be repeated in a diminishing series. Minguet has pointed out the hybridism of cartouches, in which architectural elements mix with branches, shells, and human and animal figures of different sizes. He has compared rococo decoration to the style of Marivaux, who was fond of bizarre connections and a mixture of different tones and shades, and has referred to Georges Poulet's definition of the literary manner inaugurated by Marivaux: "du rien qui se réfléchit à l'intérieur de rien, des reflets dans un miroir,"[43] an aerial play almost destitute of action.

The artist who inaugurated the new rococo style of interior decoration, who exploited *chinoiserie, singerie,* and the *décor frais et léger* of the Italian masks, was Watteau, the painter of *fêtes galantes,* and his name has been frequently coupled with that of Marivaux. He is the boudoir reduction of Rubens. The curve of Rubens is that of the cloud and the wave, the curve of Watteau is that of the shell, which is stamped emblematically in his treatment of draperies: "ravissante rocaille des plis," as the Goncourts remarked.[44]

But the smooth gliding from one subject to another, the flow made up of the scintillation of innumerable little waves—main features of rococo decoration—are mirrored in the dialogues of Diderot and in the style of his

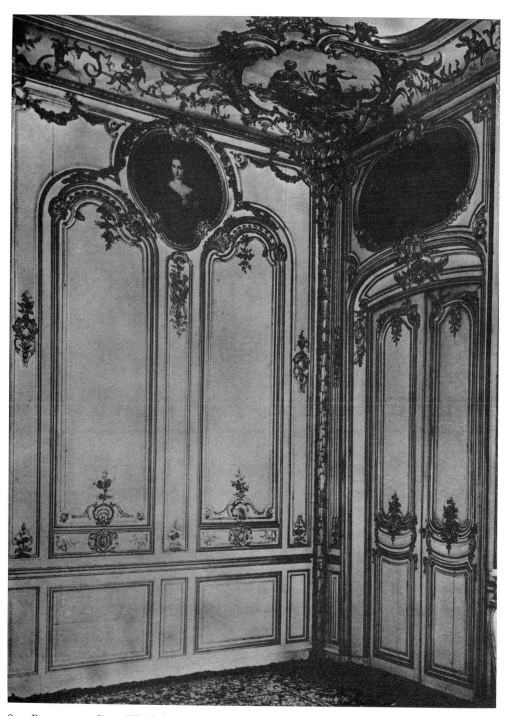

84 Rococo paneling, Hôtel de Seignolay, Paris. Ca. 1745

master, Sterne, who influenced also other French writers, such as Mlle. de Lespinasse. In *Le Neveu de Rameau*, digressions and subsidiary conversations are inserted incidentally into the main dialogue, imaginary as well as real scenes are recorded, the speaker apostrophizes himself. In the *Supplément au Voyage de Bougainville*, the first and second interlocutors report bits of conversation in their repartees, and the first one sketches the scene of a quarrel between an actor and his wife; the author himself intervenes in the dialogue—the strangest trait of all, since the first interlocutor is introduced as the author of the *Père de famille*, i.e., Diderot himself, who in this case is split into two characters. *Jacques le fataliste* is a novel which is really not a novel at all; its model is, of course, *Tristram Shandy*. On the one hand, Sterne broke the frame of the traditional narrative by discarding the idea that the subject must be an important one, just as the Dutch painters, by taking everyday life as the theme of their canvases, helped to disestablish the *grand goût* of historical painting: for him, for the first time in literature, a girl with a green silk bag was more important than the Cathedral of Notre-Dame. Details from everyday life were introduced even into heroic painting. By the end of the century Hubert Robert did not scruple to show, in a view of Roman buildings, a clothesline hanging from the horse of Marcus Aurelius.

Sterne went even further, he repudiated all subjects as a pretence, an impurity, and in this foreshadowed not only Joyce, but also the modern idea that the supreme triumph of imagination consists in a form of art which represents nothing; on the other hand he was the supreme master of the arabesque in the rococo manner. Events assume the lightness of the arabesque also in Voltaire's *Contes*, and in that fireworks display of Oriental enormities, inspired partly by Voltaire himself, partly by *The Arabian Nights*, Beckford's *Vathek*.

These parallels by no means exhaust the close relationship among the various arts during the eighteenth century. We have already spoken earlier of Pope and the art of the English garden, and we may add here that Pope's pruning Homer of all coarse or unseemly details finds an echo in Capability Brown's removal of all imperfections from a landscape; that landscape gardening and Thomson's *The Seasons* both took their cue from Claude Lorrain, as has been so many times pointed out;[45] that the coupling

of the names of Hogarth and Fielding, Joseph Highmore and Richardson is almost a commonplace; and that the conventional treatment of trees and rocks in Gainsborough has been likened by Roger Fry to the poetic diction fashionable at the time.[46]

The vestal fire of classicism, kept alive in England thanks to the Palladian style in architecture that had become the outward expression of the upper class (buildings inspired by the temple had their counterpart in Reynolds' deification of noble women as Juno, Minerva, Venus, etc.), blazed anew with the momentous discoveries of Herculaneum and the message of Winckelmann.

The disavowal of the curve brought about an exclusive taste for straight lines. But the predilection for the curve had not been so self-conscious as the adoption of the straight line was to be. Aesthetics and morals combined in the new cult, and many an artist and writer, conforming to the neoclassical creed, might have repeated with Spinelli in Thomas Mann's short story *Tristan:* "There are periods in which I simply cannot do without the Empire style, in which it is to me unconditionally necessary in order to reach a modicum degree of well-being. It is obvious that one feels in one mood among soft furniture, comfortable to the point of voluptuousness, and in another in the midst of these straight-lined tables, chairs, and curtains. . . . This splendor and hardness, this cold and astringent simplicity, this self-contained strength imparts to me composure and dignity. In the long run that style has as a consequence, an inner purification and restoration: it lifts me up ethically, without any doubt."[47]

The baroque period had delighted in *technopaignia* like George Herbert's "Easter-wings," and indulged in such heraldic fantasies as the church (never executed) that Pietro da Cortona planned in honor of the Chigi pope, Alexander VII, with superimposed cupolas imitating the mountains of the Chigi coat of arms, so that the building would have resembled a Hindu temple [85],[48] or Borromini's S. Ivo, whose shape was an allusion to the bee in the Barberini coat of arms. Neoclassical inventions took a less imaginative and more geometrical turn, as could be expected from a return to the anthropomorphic canons of architecture.

At the beginning of the nineteenth century Thomas de Thomon's plan for the new center at Poltava was conceived according to the hierarchy of

85 PIETRO DA CORTONA: *Church inspired by the Chigi arms*. Project,
period of Pope Alexander VII, 1655–67

the Russian Empire, with the number of columns in the front of the houses proportioned to the ranks of the residents. The governor's house had six columns, with a triangular pediment separated from the entablature by an attic, and this colonnade was flanked by two smaller porches of two columns each; the house of the vice-governor had six columns but no smaller porches, and no attic between the pediment and the entablature; the house of the commander in chief, a smaller one, had six columns but a balustrade without pediment; the house of the head of the police four columns; and the postmaster general's only a porch of two columns, whereas the houses of clerks, merchants, and ordinary citizens were distinguished by simpler architectonic devices.[49]

My giving of this instance is not intended as a caricature of neoclassicism, to which, on the contrary, I am rather partial, but only to show how easy and comparatively uninteresting it may be on the whole to draw a parallel between the arts in a period so self-conscious about its aesthetic principles.[50]

Telescopic, Microscopic, and Photoscopic Structure

WE HAVE so far been able to ascertain a coordination of modes and expressions which implies a deep structural affinity, an underlying order in the arts and letters well into the eighteenth century. This order was chiefly manifest in architecture: thus we have seen the golden section echoed also in literary and pictorial compositions of the Renaissance; we have seen that the fascination of the curve inspired not only baroque architects, but poets and painters as well; we have noticed that Pope's *The Rape of the Lock* had for its theme a *rocaille* object, a curl, a motif which at about the same time was to become a feature of Watteau's conception of interior decoration.

But by the end of the eighteenth century architecture seems to have lost its power as a leading art. As the century progresses we are aware of a gradual infiltration of literary elements into architecture: buildings were planned whose purpose was to convey ideas of the sublime and the picturesque, the two new categories of the beautiful about which thinkers and literary men were writing. Fonthill Abbey tries to translate the poetic emotion of sublimity into stone. During the Renaissance and the *grand siècle* of Louis XIV, architecture used to project its geometrical law on the surrounding landscape: hence the formal garden, and Le Nôtre's regular park. But with Capability Brown the roles were inverted; architecture came to be envisaged as part of a picturesque composition whose principal component was nature. Brown's buildings (he was also an architect) were theatrical paraphernalia, Nash's were conceived like stage settings: they were intended to convey an idea of stateliness, as in Regent's Park, no

matter how careless they might be in some details. With Nash the building became not unlike the wing on a stage, just for show. This was even more the case in America, in the neoclassicism of the Louisiana plantation houses, which displayed colonnaded fronts behind which an ordinary house was hidden. The garden gained on the house to such an extent that it entered into it: in the Regency period large French windows were opened on the ground floor, designed almost to cancel any gap between interior and exterior, and to allow people to step over from the real carpet to the grassy one.

Moreover, there rose in France at about the middle of the eighteenth century a group of architects (Ledoux, Boullée, Lequeu) who considered architecture as a succession of forms which developed, and tried to hasten this process themselves by inventing revolutionary forms. Those forms accentuated the geometrical features of architecture: pure cylinders and spheres were offered as ideal shapes for buildings, but this predilection was not dictated merely by a love of pure volumes. The eruption of cubic volumes which took place in France between 1760 and 1790 (as a rule only on paper) was generally camouflaged by picturesque exteriors, and claimed to serve symbolical purposes. Ideas of sublimity and fitness to the personalities of the inhabitants were responsible to a large extent for the unusual shapes. The idea of the severity of the law, of restriction of freedom, had to be conveyed by the very aspect of a prison (Ledoux's Prison at Aix-en-Provence [86]), a monument to an astronomer had to suggest his calling by its shape (Boullée's cenotaph for Newton [87]), and so on. Together with this literary intrusion went another disturbing element, studied by Sedlmayr.[1] The merits of asymmetry had been already stressed as early as 1685, with Louis le Comte's praise of the qualities of Chinese gardens, particularly the element of surprise, which in this connection received in England the preposterous name of *sharawadgi*.[2] The principle enforced by Leon Battista Alberti, that there should be such a harmony between the various parts of a building that nothing could be added or taken away except for the worse, was jeopardized by the new taste for asymmetry: hence the "loss of the middle," which according to Sedlmayr represents a definite break in the tradition. Art becomes eccentric in every sense of the word.

86 CLAUDE-NICOLAS LEDOUX: *Prison d'Aix*. Project of ca. 1770

87 ETIENNE-LOUIS BOULLÉE: *Newton Memorial*. Project of 1784

The taste for ruins is an outspoken refusal to see architecture as the expression of a permanent law of harmony: instead, it was invested with the capricious character of the English garden, and valued as an expression of the picturesque. Sedlmayr sees Goya as the first artist who drew inspiration from the world of the illogical. But Piranesi's *Carceri* also take us away from those harmonious symmetries which had been the dominant mode of European art previous to the eighteenth century. In the *Carceri*, as Marguerite Yourcenar has pointed out, it is impossible to discern an organic plan, we never have the impression of being in the axis of the building, but only on a radius vector; we feel as if we were in a continually expanding, centerless world.[3]

Architecture ceased, then, to speak that language of forms which had been proper to it up until, and including, the baroque and rococo styles. Its language became one of destination, and different historical styles were applied according to the character of a building: whether a town hall, a palace, a church, a museum, or a parliament; in a word, architecture ceased to stand for itself, as an art controlled by inner rules, and became subservient to external purposes.

Thus architecture can no longer be taken as a guide in pursuing the parallel between the arts in the nineteenth century. The very fact that the nineteenth century has been often criticized for not possessing a style of its own is a confirmation of the thesis that architecture is a reliable point of reference in the study of the underlying structure of all the arts of a given period. The situation of the arts henceforth could be dramatically represented by the words of Ulysses' famous speech in Shakespeare's *Troilus and Cressida* (I, iii, 109ff., 135ff.):

> *Take but degree away, untune that string,*
> *And hark what discord follows!*
>
> ·　·　·
>
> *This chaos, when degree is suffocate,*
> *Follows the choking.*

or by the concluding lines of the *Dunciad:*

> Physic *of* Metaphysic *begs defence,*
> *And* Metaphysic *calls for aid on* Sense!

See Mystery *to* Mathematics *fly!*
In vain! they gaze, turn giddy, rave, and die.

. . . .

Nor human *Spark is left, nor Glimpse* divine!
Lo! thy dread Empire, CHAOS! is restor'd;
Light dies before thy uncreating word:
Thy hand, great Anarch! lets the curtain fall;
And Universal Darkness buries All.

If we apply this last passage to the state of the arts from the beginning of the nineteenth century on, we shall find that it fits to a surprising extent, once we have made a few necessary substitutions: we shall then see Painting asking support from Literature, and vice versa, and Architecture calling on both for aid, but in vain. Death was certainly not the result, not at least in that century, which on the contrary strikes us as instinct with a feverish vitality; but if we consider the state of the arts today, we may feel much less sure whether the final outcome may not be just this, and may wonder whether the great Anarch, Chaos, is not on the point of letting the curtain fall.

If architecture, with the nineteenth century, ceased to be the leading art, is music to be considered the artistic expression which best represents the tendencies of the period? It has been justly said that the analogies between music and literature are the most fraught with danger and diffi-cult to ascertain;[4] and certainly the names of writers and artists that come to mind for comparison in this respect are few: E. T. A. Hoffmann and De Quincey among writers, Whistler among painters, Mallarmé among poets, are instances so rare and distant from one another as to appear almost exceptions. It is, however, in the nineteenth century that music was pro-claimed the highest form of art by Schopenhauer (*Die Welt als Wille und Vorstellung*, Bk. III, §52), and hailed by Pater (*The School of Giorgione*) as the art to whose condition all the other arts constantly aspire. Ortega y Gasset, in *The Dehumanization of Art*, has said that after Beethoven all music became melodramatic; but even if one grants this sweeping state-ment, no convincing parallel could be made with the other arts (Schopen-hauer, in fact, recognized music as standing quite apart from her sister

arts, insofar as music does not express ideas but the will itself, its objectivation), apart from the general conclusion that music, like painting, became permeated by literature and psychology during the nineteenth century, since operatic music underlines the passions and the themes of a libretto.

Many critics have studied the reasons for this break with tradition, a break which is universally recognized. Ortega y Gasset has spoken of lack of stylization. But the fact that we are unable to find a common denominator for the styles of, say, a Waldmüller and a Delacroix, does not allow us to conclude that the nineteenth century, as has so often been maintained, lacked style; rather, it should induce us to try to find the characteristics of the century elsewhere.

If we reflect that the more uniformity of style there is, the less room remains for expression of the individuality of the single artist; that that freedom which in previous centuries was possessed only by the very great artists became during the nineteenth century accessible also to minor ones; that a certain uniformity of manner is surely still to be found at the beginning of the century in David's school, whereas in the sixties and seventies we are confronted with the greatest variety of artistic expressions, particularly in painting, we shall conclude that the heart of the matter lies in the development of personality which has taken place with the advent of the romantic era. The critic who seems to have come closest to solving the problem of detecting the structures underlying the development of the arts and letters in the nineteenth century is Rudolf Zeitler, in his recent volume *Die Kunst des neunzehnten Jahrhunderts.*[5]

Zeitler, in fact, starts from that well-known feature of the romantic era, the development of the individual, and its natural consequences, introversion and psychological outlook: hence the yearning for what is beyond and unknown, something vague and indefinite, the rejection of traditional rules, the response to calls of various kinds, and, in a later phase, the withdrawal to a material reality which is close at hand—these, in brief, are in general outline the attitudes of artists and writers during the century.

In the *Lyrical Ballads* (1798), that manifesto of English romanticism which covers also the main aspects of European romanticism, Coleridge, as is well known, proposed to deal with the supernatural, whereas Words-

worth aimed at giving the charm of novelty to everyday things. This division of the field between the two poets foreshadows the twofold attitude of nineteenth-century artists, among whom Zeitler distinguishes two great classes: dualists and monists.

In Anglo-Saxon countries, particularly, there is a distinct aversion to generalizations of the kind known to art historians as "typologies." Wölfflin's famous characteristics of Renaissance and Baroque, and the later category of mannerism, are looked on with no less distrust and suspicion than they aroused in Benedetto Croce. We must, however, bear in mind that the contribution of Croce's sound philosophy to art criticism has amounted to next to nothing, whereas Wölfflin's questionable categories have done excellent service as working hypotheses.

Zeitler has called attention to the dualistic structure of a number of paintings of the early nineteenth century. A foreground formed by everyday circumstances, or in any case related to the phenomenal world, serves as a runway for a yearning, a dream, which is projected into a distance full of mystery, a magical beyond: it may be only a vista from a window, or the faraway ship seen by the shipwrecked sailors of the *Méduse*. The painting falls into two planes, like El Greco's *The Burial of Count Orgaz* (one may say that all religious paintings of the past contain a heavenly counterpart to an earthly one, but in most of them there is hardly any distinction of treatment in the representation of human beings and of divinity, whereas in El Greco that distinction is most conspicuous). But there is a better example still: Hieronymus Bosch's painting [88], in the Doges' Palace, representing the attraction to the empyrean through a cylinder as dark as a cave, whose exit opens into infinity, into that "immense essential light" of which Ruysbroeck speaks in the *The Adornment of the Spiritual Marriage*. The romantics use this very same structure for the expression not of an actually religious aspiration, but of a dream, an expectation, a hope beyond the sphere of everyday events. The elements of escape are no longer offered by the divine, but by nature: their vision, to use Geoffrey H. Hartman's term,[6] though with a somewhat different connotation, is no longer mediated through faith, but is the result of an unmediated experience, a direct sensuous intuition.

London as Wordsworth sees it from Westminster Bridge in his famous

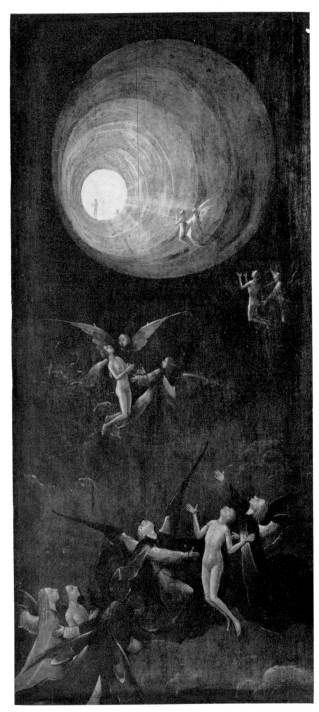

88 HIERONYMUS BOSCH: *The Ascent into the Empyrean*. Wood. 1505–16

sonnet, quoted by Zeitler, appears like a mirage, steeped in supernatural serenity:

> *Ne'er saw I, never felt, a calm so deep!*
> *The river glideth at his own sweet will:*
> *Dear God! the very houses seem asleep;*
> *And all that mighty heart is lying still!*

The rush of the flowing river is the frame of reality; the magic city lies beyond, bathed in the morning light. Similarly, in a view of Rome by the Danish painter Eckersberg [89], the city appears in the distance through the arches of the Colosseum. Zeitler gives another instance, this time from architecture: the sense of a far-off space achieved by Christian Fredrik Hansen in the apse of the Church of the Virgin at Copenhagen [90], through the use of a constructional device which prevents the onlooker

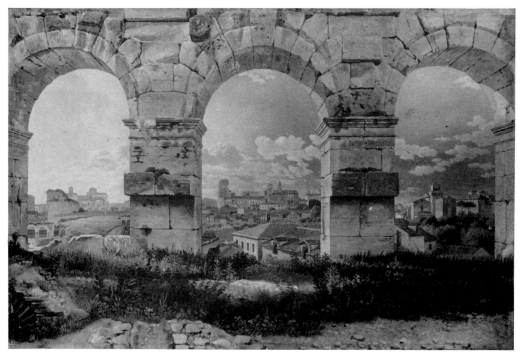

89 CHRISTOFFER WILHELM ECKERSBERG: *View Through Three Arches of the Colosseum*. Canvas, 1815

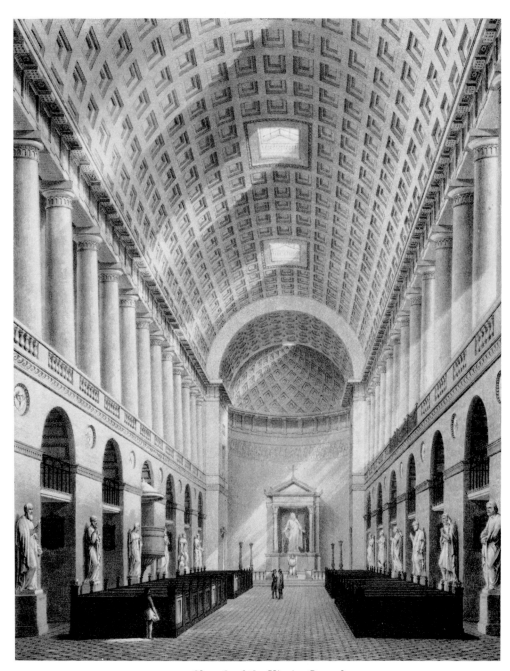

90 CHRISTIAN FREDRIK HANSEN: *Church of the Virgin, Copenhagen.*
1811–29. (Lithograph.)

from seeing the limit between the nave where he stands and the apse, so that therefore he cannot estimate the distance between his position and the wall of the apse. This duality between the "here" and the "there" is the theme of Keats's "Ode to a Nightingale." The poet listens in the shade, among the flowers he can smell but not see; the foreground is the embalmed darkness, but also the place "where men sit and hear each other groan," the invisible bird sings in a vague vicinity, and his song evokes past ages and fairylands and a world of ease and happy immortality. In Wordsworth's "The Solitary Reaper" the dualistic note is sounded both in the sense of space (the evocation of the Arabian desert and of the farthest Hebrides) and of time ("Perhaps the plaintive numbers flow / For old, unhappy, far-off things, / And battles long ago. . . . The music in my heart I bore, / Long after it was heard no more"). This dualistic aspect of paintings, poems, and church interiors might also be termed "telescopic" structure.

The yearning for another world does not, however, always take this shape. There is a form of exoticism which represents to itself as actually present the land of the heart's desire. Such is the case with Joseph Anton Koch, who gives us a vision of an enchanted world: in his landscapes everything, no matter whether near or far, is treated with the same miniaturist's precision, and there is no season or time of day, but an eternal climate which ignores death and decay. In poetry, Keats's "To Autumn" conveys a similar impression of an ideal climate and no definite time of day, a compound of whatever enchanting features of the season the poet can recollect. Such is the case with two French painters who in many respects are poles apart from Koch, Delacroix and Gustave Moreau: they bring immediately before our eyes in the one instance visions of passion and dynamic intensity, in the other scenes of languor and exotic preciosity. They are not visionaries, but rather voyeurs. If we use here a term which has a psychopathological connotation, there is some justification for doing so, because these artists are highly representative of the two periods of romantic sensibility which existed at the beginning and at the end of the century respectively.[7] All the literary exoticists like Gautier (*Mademoiselle de Maupin*, etc.) and Flaubert (*Salammbô*, etc.) belong to this same category.

Interiority and psychological interpretation prevail in the portraits: men are no longer represented in their social personalities, as expressions of a class or a rank; they no longer look the viewer in the face.[7a] Madame de Senonnes, in the portrait by Ingres [91], looks beyond him; compare this with Bronzino's Lucrezia Panciatichi [92], who appears very conscious of her social status. Or if they turn their eyes in the onlooker's direction, they show faces ravaged by interior conflicts, the mirrors of intense interior life (*Self-Portrait* by Caspar David Friedrich [93]), not of behavior towards other men.

Psychological inquisition invades what was in the first part of the century the most respected type of pictorial composition: historical painting.[8] Painters are not so much interested in representing action as, rather, the reactions revealed in the faces of the historical characters; in this way a typically modern element permeates scenes of the past, and this element jars against the meticulous, archaeological study of historical costume, making it next to impossible for the onlooker to reach the state of "suspension of disbelief." Zeitler quotes as an instance *The Crusaders on Jordan* by Friedrich Lessing, but there are even more conspicuous and unprepossessing examples, such as *Phèdre* [94] by Alexandre Cabanel, in which the attitude of the protagonist seems to anticipate that of a film star.

Few were the artists who continued the old tradition of painting action without a meticulous study of costume and without psychological accuracy in the modern sense: Fuseli in painting (a belated mannerist) and in poetry Kleist, for his *Penthesilea*, are rare exceptions; they treated classical themes with the fury of the *Stürmer und Dränger*, looking forward to modern expressionism.

The intrusion of a definite psychological bias did not necessarily follow a melodramatic course; even its opposite, an exaggerated restraint, may betray a modern outlook. Take Landor's "The Death of Artemidora":

> *"Artemidora! Gods invisible,*
> *While thou art lying faint along the couch,*
> *Have tied the sandal to thy slender feet,*
> *And stand beside thee, ready to convey*

Thy weary steps where other rivers flow.
Refreshing shades will waft thy weariness
Away, and voices like thy own come near,
And nearer, and solicit an embrace."

 Artemidora sigh'd, and would have press'd
The hand now pressing hers, but was too weak.
Iris stood over her dark hair unseen
While thus Elpenor spake: He look'd into
Eyes that had given light and life erewhile
To those above them, but now dim with tears
And wakefulness. Again he spake of joy
Eternal. At that word, that sad word, joy,
Faithful and fond her bosom heav'd once more,
Her head fell back: and now a loud deep sob
Swell'd through the darkened chamber; 'twas not hers.

In *Virgil Reading from the Aeneid* Ingres, representing the episode of Virgil reading aloud the passage of the *Aeneid* which refers to Marcus Claudius Marcellus, the intended successor of Augustus who had untimely died, shows the poet's audience, composed of the Emperor, Livia (who was rumored to be partly responsible for Marcellus' death), and Octavia, who has swooned at the narration [95]. The swooning of the young woman seems hardly to concern the other two. Livia in particular maintains her pose unruffled, and Augustus remains impassibly statuesque; in fact the whole group puts one in mind of figures in a wax museum. In this case Ingres followed Winckelmann's ideas concerning the expression of emotion in Greek art: the sculptor of the *Apollo Belvedere* had to register on the face of the god his indignation against the serpent Python killed by his arrows, and at the same time his contempt of his victory over the monster; indignation is hinted at in the slightly swelling nostrils, and contempt in the lifting of the lower lip and consequently of the chin. "Now," Winckelmann asks, "are these two sensations capable of altering beauty? No, because the glance of this Apollo is serene, and his forehead is perfectly calm."[9]

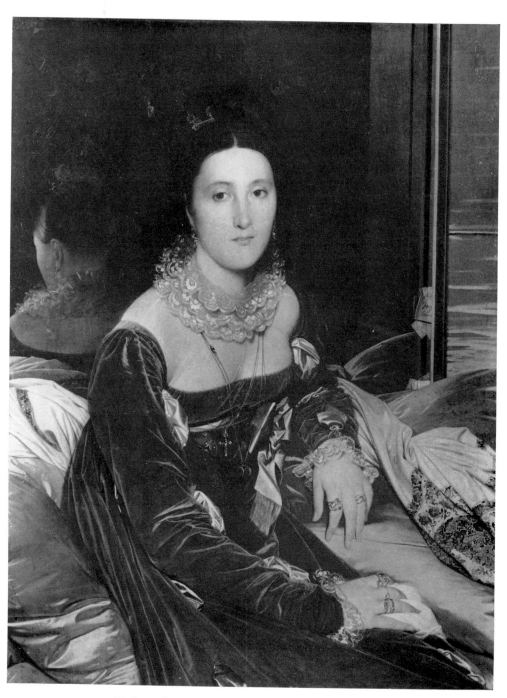

91 J.A.D. INGRES: *Madame la Vicomtesse de Senonnes*. Canvas, 1816

92 BRONZINO: *Lucrezia Panciatichi.* Wood, ca. 1540–50

93 CASPAR DAVID FRIEDRICH: *Self-Portrait*. Black crayon on paper, ca. 1810

94 Alexandre Cabanel: *Phèdre*. Canvas, 1880

95 J.A.D. INGRES: *Virgil Reading from the Aeneid.* Canvas, 1819

Degas was more successful in obtaining a "suspension of disbelief" in his *Semiramis Founding a Town* [96]. Neither historical costume nor the expression of emotions is obtrusive in this painting. The painter's attitude is, in fact, not unlike that of Piero della Francesca in his Arezzo frescoes [97], and Degas has been able to follow his model not only in the composition (the grouping of Semiramis, her women, and the two attendants with the horses reproduces that of the Queen of Sheba kneeling at the bridge, the onlookers, and the men attending the horses nearby, only in a reversed order), but also in spirit.

The statuesque ideal which was present to Ingres in *Virgil Reading from the Aeneid* has been present also to Nicolas Poussin, but in him the expression of emotions is contrived according to certain physiognomical patterns whose masklike appearance affords enough stylization to avoid a jarring effect of modernity. In fact, we are not aware of any jarring note in painters of the previous centuries (for instance, Rubens) who represented historical or Biblical events without any pretence at historical accuracy. Stylization is, however, to be distinguished from stylishness, the slick elegance which causes Leighton's and Alma-Tadema's reconstructions of the classical world to strike us as the last word in dandified Hellenism, attitudinizing to such an extent that it has been said of Leighton's figures [98]: "If only someone would pinch them or make them sneeze and jump."[10]

While painters tried to vie with writers in the psychological interpretation of the human beings represented in their canvases, writers tried to achieve pictorial effects in their descriptions. This tendency becomes obsessive with Flaubert and the Parnassians; Nathalie Sarraute's remarks in this respect are much to the point: "The task set us by Flaubert and the Parnassians is one of fabricating mental pictures, and no doubt the hostility that Flaubert's style has so frequently encountered comes from the effort he demands of us as well as from its results. For our recollections of triremes and ivory horses dashing through foam are, alas, both flat and conventional. They are like paintings of dubious quality; their beauty of form and their brilliance give us the same sort of pleasure. Only subjective description, one that is distorted and purged of all impurities, can keep us from making it adhere to a preexistent necessarily conventional picture."[11] If Cabanel's *Phèdre* makes us think of the ravings of a film star, Flaubert's

descriptions of the classical world may stir in us only memories of Thomas Couture's *The Romans of the Decadence* [99] or Bryullov's *Last Days of Pompeii* (1833) or worse, while Gautier's descriptions are supposed to vie in gorgeous and somber effects with the spectacular John Martin.[12]

Although Gautier exulted over the fact that "une foule d'objets, d'images, de comparaisons, qu'on croyait irréductibles au verbe, sont entrés dans le langage et y sont restés, la sphère da la littérature s'est élargie et renferme maintenant la sphère de l'art dans son orbe immense,"[13] the close alliance of the sister arts in the nineteenth century on the whole was fertile in imperfect sympathies, particularly in the fields of historical painting and the historical novel.

There is, however, another area in which their collaboration proved more congenial, the field which coincides with what Zeitler calls "monism." He has noticed the appearance of a monistic structure in painting in about 1830. This monistic structure—we may call it "microscopic"—is common to most Biedermeier painting, and finds a counterpart in the minute descriptions adopted by the novelists (Balzac, for example), in which all the items forming an interior are inventoried regardless of narrative economy or the reactions of the characters. The *horror vacui* of nineteenth-century architecture, particularly of Victorian architecture (but see also the Grand Staircase of the Paris Opera House, built in 1861–74 by Charles Garnier), and the stuffiness of mid-Victorian interior decoration are paralleled not only in the most typical poems of the Spasmodic School, choked with detail and emotionally supercharged, but also in the poems of major poets like Browning (see, e.g., "The Englishman in Italy") and Tennyson ("The Palace of Art"), and in a later poet who combines the Victorian taste for overcrowding with a wealth of metaphysical imagery, Francis Thompson ("A Corymbus for Autumn"). The same parallel is clear in paintings like Holman Hunt's *The Awakening Conscience* (1852–54), where mirrors aid in the multiplication of objects (Ruskin, in *Modern Painters*, spoke of this picture as an example of "painting taking its proper place beside literature"), and in his *The Hireling Shepherd*, or in William Bell Scott's *Iron and Coal*, where we can read a whole article on "Garibaldi in Italy" in a newspaper dated March 11, 1861, which occupies the lower right-hand corner of the painting.

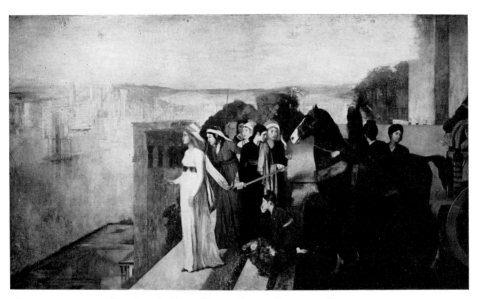

96 EDGAR DEGAS: *Semiramis Founding a Town*. Canvas, 1861

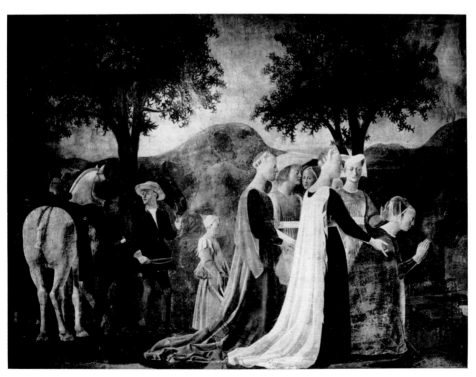

97 PIERO DELLA FRANCESCA: *The Queen of Sheba and Her Retinue*.
Fresco, 1453/4–65. S. Francesco, Arezzo

The difference between the microscopic attitude of a mid-century painter and the contemplative outlook of a painter whom Zeitler considers a dualist can be appreciated by comparing John Brett's *The Stonebreaker* [100] and Venetsianov's *Sleeping Shepherd's Boy* [101]. In both cases a peasant boy is shown in the foreground, a subject to which no painter before the nineteenth century (unless perhaps Le Nain or Murillo) would have felt attracted. One cannot say that Venezianov paints the grass and flowers of the foreground carelessly, but the dominant notes in this painting are the perfect stillness of the sleeping boy and the infinite stretch of the Russian plain: the scene breathes religious awe, causing this common boy to appear not only a brother of Wordsworth's humble folk, but also a not-so-distant kin of the mythical creatures of Giorgione. No such impression is made by Brett's *The Stonebreaker:* the foreground is so crammed with detail that our eye is not led back to wander on Box Hill shimmering on the border of the skyline. Of course the kind of remark which comes naturally in the face of this tour de force of minutiae is one like Ruskin's: "If he can make so much of chalk flint, what will he not make of mica slate, or gneiss?" Ruskin wrote also: "Here we have, by the help of art, the power of visiting a place, reasoning about it, and knowing it, as if we were there. . . . I never saw the mirror so held up to Nature, but it is Mirror's work, not Man's."[14]

For an art historian like Werner Hofmann, who, despairing of finding in artistic processes a clue to the maze of nineteenth-century art, thinks he is on safer ground examining the subject matter of the paintings, the extreme wealth of the nineteenth-century artistic production is reducible to a few constant themes: in these themes, according to Hofmann, the century between Goya and Cézanne finds its real unity.[15] From this point of view, it is a comparatively easy task to show how, in the course of this century, mundane reality takes the place which in other centuries had been reserved for religious subjects; the everyday event receives a symbolical dimension. The museum is invested with the solemnity of a sanctuary, the religion of progress celebrates its rites in the universal exhibitions, the Crystal Palace and the Bayreuth Opera House become substitutes for the church. There is a constant effort to replace the old symbols by new ones.

A comparison of Courbet's *Atelier* and Ingres's *Apotheosis of Homer*

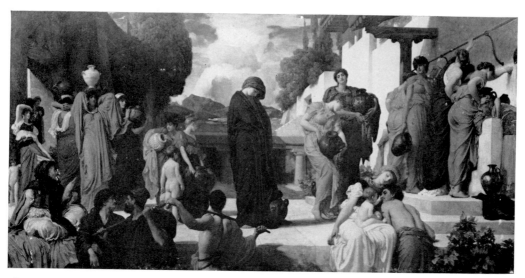

98 FREDERIC LORD LEIGHTON OF STRETTON: *Captive Andromache*. Canvas, ca. 1887

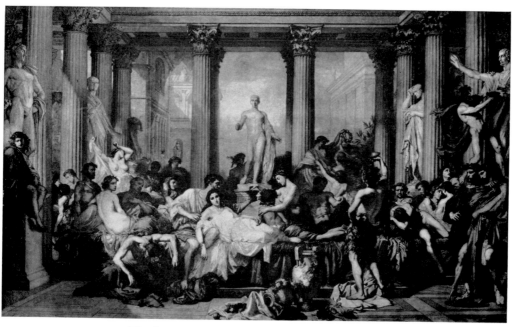

99 THOMAS COUTURE: *The Romans of the Decadence*. Canvas, 1847

throws light on the contrast between the new spirit and the traditional contents. The *School of Athens* and the *Dispute Concerning the Holy Sacrament* are still present in Ingres's exquisitely drawn but theatrical and lifeless composition, whereas in Courbet's painting one has the confused impression of a crowd in a waiting room, in which, little by little, we succeed in distinguishing the various social classes; while the naked woman near the painter, who is busy with a landscape, is not a model, as we might have thought at first, but the bearer of a symbol: a muse, a mother, the matrix of all fecundity. Although there are many portraits in the crowd, including Baudelaire's, the general impression is of an anonymous crowd.

The crowd, the mass, is one of the favorite subjects of the realist school of painting; but rather than men partaking of the same entertainment (as in Manet's *Music at the Tuileries*, or Monet's *Grenouillère*), they are men involved in a collective act of violence (Delacroix's *Liberté guidant le peuple*) or in a collective tragedy (Géricault's *Radeau de la Méduse*), or, as in Goya's *Pilgrimage of S. Isidro* [102], men staring in a hopeless stupor, in the absence of an aim, or, as Hofmann suggests, because of the absence of God. Thus the subject of a collectivity without history crops up at the beginning of the nineteenth century as an expression of anxiety, as if Goya had foreseen, a century ahead, the desperate final conclusion of modern man: Beckett's *Waiting for Godot*. The parallel between this representation of the masses in painting and the main trend in the nineteenth-century novel is striking. We can follow this trend from Manzoni's *I Promessi sposi*, where the sympathy of the author lies with the victims, the oppressed, and the humble, those obscure sacrifices of downtrodden communities which are ignored by the professional historian, to Tolstoy's *War and Peace*, with its insistence on the anonymous crowd, on the acts which history fails to record. For Tolstoy only unconscious activity bears fruit: the same democratic creed that George Eliot embodied in *Felix Holt* (Vol. I, Chap. xvi).

However, the study of form and technique by far exceeds in interest the examination of subject matter; its importance in the development of nineteenth-century painting is not inferior to that of the study of materials and engineering processes for the appreciation of architecture. We watch,

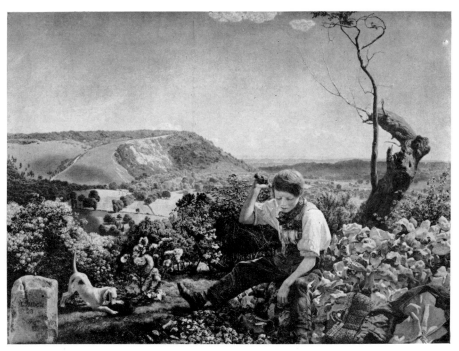

100 JOHN BRETT: *The Stonebreaker*. Canvas. 1857–58

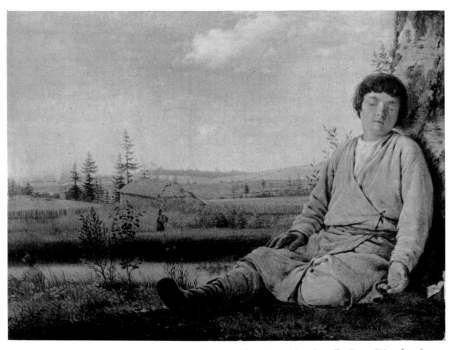

101 ALEKSEI GAVRILOVICH VENETSIANOV: *Sleeping Shepherd's Boy*. Wood, 1820

indeed, a parallel development in these two fields throughout the century: out of the bone heap of historical styles exhumed, blended, and mixed together, there arose gradually, as the sole reliable basis, mere structure, the work of the engineer; in the same way, out of the bone heap of traditional contents, the painter found a last hope in pure technique, thus reaching in the end that nonrepresentational standpoint in which art is still entrenched nowadays.

The invention which completely unhinged the traditional structure of painting was photography. This new way of fixing the appearance of the external world may be considered responsible for the new patterns of pictorial composition which became current after the middle of the century, for the preference given to fragments rather than to grand compositions, for the interest in glimpses of humble life, peasants, nameless folk, and landscapes with no special distinction to recommend them, seen as in a snapshot. A section of a landscape (Courbet's *Landscape near La Source bleue* [103]), a fleeting motion (Degas's *Mlle La La at the Cirque Fernando* [104]), an effect of lighting (Monet's series of paintings of Rouen Cathedral at various times of day) are instances chosen at random out of a number of others. This kind of structure may be called "photoscopic."

A few comparisons may help us to realize the change which came about, from the point of view of the earlier painters, as a consequence of the influence of photography. Take Hobbema's *The Avenue, Middelharnis* [105] and Ivan Shishkin's *The Ryefield* [106]: the former is composed according to the old rule of symmetry, the latter has the haphazard look of a snapshot. Goya's *View of the Pradera of S. Isidro* [107] and Ford Madox Brown's *An English Autumn Afternoon* [108] offer a contrast of a different kind: there is a certain symmetry in Brown's picture, but the eye of the painter rests impartially on everything, like the eye of a camera, whereas Goya concentrates his attention on certain parts of the scene, and deals with others summarily. *A Bridge in a French Town* by Stanislas Lépine [109] accepts the view as it would offer itself to the camera, whereas Van Wittel's *View of the Isola Tiberina* [110] and Hubert Robert's *The Old Bridge* [111] though both including also a foreground, are the work of a selecting mind.[16]

While in the first portion of the nineteenth century painters were

steeped in literature, and writers tried to emulate painters, the impact of impressionism caused painting to draw inspiration no longer from literature but from photography. Painting took the lead henceforward, and embarked on a series of experiments which were taken up by the other arts. We may perhaps say that when Architecture was a guide, she behaved like a wise virgin, whereas Painting, in the last hundred years, has shown herself a foolish virgin, to judge from the present state of the arts.[17]

"After the first Art Nouveau flourish of unshackled imagination," writes Nikolaus Pevsner in *An Outline of European Architecture,* "the basic principles [of architecture] were rediscovered. This happened—a very hopeful sign—not only in architecture, but also in painting and sculpture. Cubism and then abstract art were the outcome, the most architectural art

102 GOYA: *Pilgrimage of S. Isidro* (detail). Canvas, 1821–22

103 GUSTAVE COURBET: *Landscape near La Source bleue.* Canvas, 1872

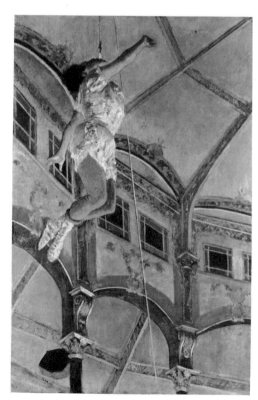

104 EDGAR DEGAS: *La La at the Cirque Fernando.* Canvas, 1879

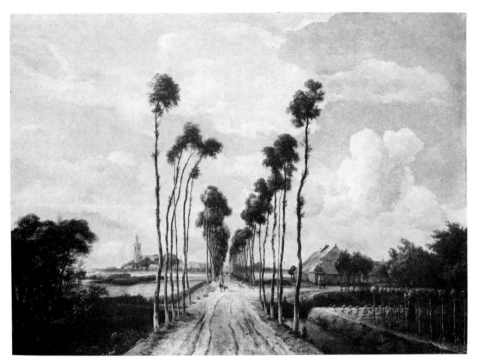

105 MEINDERT HOBBEMA: *The Avenue, Middelharnis.* Canvas, 1689

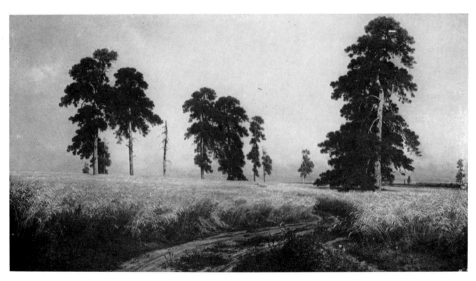

106 IVAN IVANOVICH SHISHKIN: *The Ryefield.* Canvas, 1878

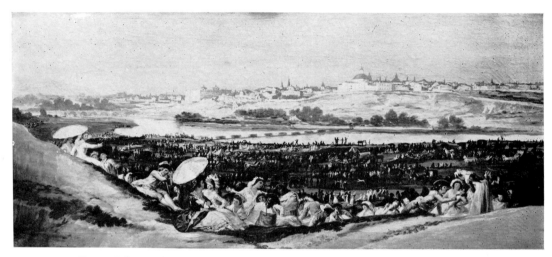

107 GOYA: *View of the Pradera of S. Isidro.* Canvas, 1788

108 FORD MADOX BROWN: *An English Autumn Afternoon.* Canvas, 1852–54

109 STANISLAS LÉPINE: *A Bridge in a French Town.* Canvas, ca. 1870

110 GASPAR VAN WITTEL: *View of the Isola Tiberina*. Canvas. 1690–1700

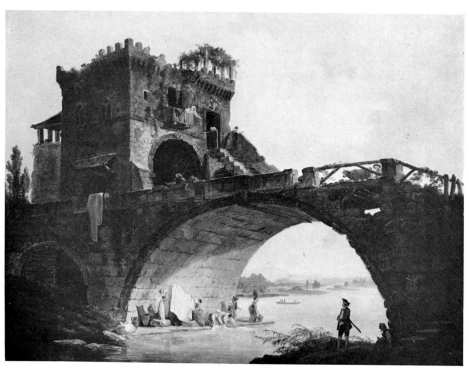

111 HUBERT ROBERT: *The Old Bridge*. Canvas, prob. 1775

that had existed since the Middle Ages. . . . For over a hundred years no style in that sense had existed. . . . Can we not take it then that the recovery of a true style in the visual arts, one in which once again building rules, and painting and sculpture serve, and one in which form is obviously representative of character, indicates the return of unity in society too?" In a later edition of the book he adds: "When building activity got going again after the six or seven years' pause of the First World War and its immediate aftermath, the situation was like this: a new style in architecture existed; it had been established by a number of men of great courage and determination and of outstanding imagination and inventiveness. . . . Their daring appears almost greater than that of Brunelleschi and Alberti; for the masters of the Quattrocento had preached a return to Rome, whereas the new masters preached a venture into the unexplored."[18]

Whatever the merits of the both technical and imaginative originality of such architects as Wright, Perret, Garnier, Loos, Hoffmann, Behrens, Gropius, Mies van der Rohe, and Le Corbusier, it must be admitted that many of them were primarily concerned with the element of surprise. Apollinaire had said: "It is by the important place given to surprise that the new spirit distinguishes itself from all the artistic and literary movements which have preceded it"—not knowing, or not remembering, that Marino had written in the seventeenth century that the aim of the poet was to astonish: "E' del poeta il fin la maraviglia." But in concentrating on the "surprise" element, most architects neglected to consider the relation of these buildings to their surroundings.

This has been deplored by Peter Collins in his remarkable book on *Changing Ideals in Modern Architecture, 1750–1850,* and he lays the fault at the door of the influence of painting and sculpture on architectural design.[19] With the invention of abstract sculpture and abstract painting, architecture came to be considered as "the creation of sculpture big enough to walk about inside,"[20] and, on the other hand, architects such as Le Corbusier made no mystery of the fact that abstract painting was the basis of their architectural creativity. Painting and sculpture now "lead to the idea of a building as simply an object in space, instead of as part of a space. They thus accentuate the evil . . . of considering architecture as something isolated from its environment, and from the other buildings

among which it must find its place. This danger did not exist before 1750, because painting and sculpture were still thought of largely as architectural decoration. . . . Today it is rare for an abstract painter or sculptor to actually create a work of art with a specific environment in mind (other than the blank wall of an art gallery). . . ."[21]

But not only is the rule of fitting a building to its surroundings ignored; in direct antagonism to the practice of preceding ages, particularly the nineteenth century, which stressed the relation of style to purpose, churches are built nowadays in shapes invented for industrial constructions, such as dikes, hangars for planes, viaducts. "What it [architecture] cannot be," writes Pevsner, "is irresponsible, and most of to-day's structural acrobatics, let alone formal acrobatics imitating structural acrobatics, are irresponsible. That is one arguement against them."[22]

Frivolity is the chief characteristic of the first style that represented a clean break from the mimetic nineteenth-century academical practice. In one of the best surveys of *art nouveau* that has been written recently, that of Robert Schmutzler, we read: "Horta thus adapted to an elegant town house features that make us think of riveted metal plates on cargo ships or of a factory's machine rooms. Horta was not unreceptive to this contrasting effect, as we shall see elsewhere: in the same way, he also banished all artificial decoration from his own house . . . such as lamps that electric blossoms and pleated frills transform into a glass bouquet; instead of this, he treated his ceiling like the vault of a subway station and coated his walls with brightly glazed tiles."[23] The example of Gaudí, the creator of a public park in Barcelona which is like a pixieland, with elfin grottoes that look as if modeled in plasticine, is well known.

In *art nouveau* the links between the various arts were so close[24] that no end of parallels can be drawn. The name of Aubrey Beardsley will occur at once to anyone reading this passage from Laforgue's *Moralités légendaires:* "Persée monte en amazone, croisant coquettement ses pieds aux sandales de byssus: à l'arçon de sa selle pend un miroir; il est imberbe, sa bouche rose et souriante peut être qualifiée de grenade ouverte, le creux de sa poitrine est laqué d'une rose, ses bras sont tatoués d'un coeur percé d'une flèche, il a un lys peint sur le gras des mollets, il porte un monocle d'émeraude. . . ."[25]

The reaction to realism brought about a return of certain romantic features, particularly attempts at a synthesis of literature, painting, and music to be achieved on the level of ornament: swirling weeds and arabesques pervade architecture, painting, and sculpture, and in literature find a belated counterpart in the sophisticated style of Ronald Firbank, who defined himself as "a dingy lilac blossom of rarity untold." Two famous stanzas of Fiodor K. Sologub's lyric "Playing with Light Love" try to reproduce through assonance and alliteration the languid arabesques of *art nouveau* paintings (Khnopff, Toorop, Klimt):

> *Ee dvá gloobókiye bokála*
> *Eez tónko-zvónchevo stiklá*
> *Ty k sviétloy cháshi podstavlyála,*
> *Ee piénoo sládkooyoo leelá,*
>
> *Leelá, leelá, leelá, kachála*
> *Dva tyélno-áliye stiklá,*
> *Belyéy leelyéy, alyéye lála,*
> *Belá bylá ty ee alá.*[26]

Effects of impressionist painting were aimed at by Verlaine and some of his English followers, by Arthur Symons, for instance, whose "Impression," from his *Silhouettes*, may serve as an example:

> *The pink and black of silk and lace*
> *Flushed in the rosy-golden glow*
> *Of lamplight on her lifted face;*
> *Powder and wig, and pink and lace.*

This kind of *ut pictura poesis* is, after all, common to many ages. As Ariosto in verse and Aretino in prose tried to emulate Titian, the former in his descriptions of naked beauties, the latter in his landscapes, thus Symons and Davidson adopted the subject matter of Degas, Seurat, and other painters of the period: the demimonde, cabarets, music halls, ballet dancers, and the rest. The same motifs were widespread throughout Europe in the early part of the twentieth century from France (R. Radiguet, *Le Bal du Comte d'Orgel*, 1924) to Russia (Yuri Karlovich Olesha).

Instances of deliberate attempts at expressing in words what impressionist painters conveyed with their brushes have been noticed in Proust (for example, the description of water lilies in the ponds formed by the Vivonne, in *Swann's Way*, recalls Monet's *Nymphéas*)[27] and in Henry James.[28] Other instances are frequent in the works of Virginia Woolf, particularly in *The Waves*; a number of these have been pointed out by Peter and Margaret Havard-Williams, to whose essay[29] I refer the reader for further details. Here are a few:

"Sharp stripes of shadow lay on the grass, and the dew dancing on the tips of the flowers and leaves made the garden like a mosaic of single sparks not yet formed into one whole. . . ."

"The sun laid broader blades upon the house. . . . Everything became softly amorphous, as if the china of the plate flowed and the steel of the knife were liquid."

"The sun fell in sharp wedges inside the room. Whatever the light touched became dowered with a fanatical existence. A plate was like a white lake. A knife looked like a dagger of ice. Suddenly tumblers revealed themselves upheld by streaks of light. Tables and chairs rose to the surface as if they had been sunk under water and rose, filmed with red, orange, purple like the bloom on the skin of ripe fruit. . . . A jar was so green that the eye seemed sucked up through a funnel by its intensity and stuck to it like a limpet."[30]

These and similar passages are to be found in the nine prologues of *The Waves*, which are hung at intervals throughout the novel like as many impressionist paintings translated into words. The early portion of the first quotation ("a mosaic of single sparks . . .") reminds us of pointillism. To quote the Havard-Williamses: "This ability to perceive objects in terms of paint constitutes an analogy in itself, and shows how intimately the psychology of artistic creation is connected, for Virginia Woolf, with contemporary developments in the visual arts, for the techniques of Impressionism and Post-Impressionism depend greatly on the simplification of form and the intensification of colour."

On the other hand, Virginia Woolf offers in *To the Lighthouse* one of the few examples of a successful application of musical technique to literature. As Harold Fromm has remarked, "she was aware that the only

significant similarities worth achieving between music and literature are emotional"; through her use of leitmotifs she has been able to produce "the extraordinary emotional effects that we have come to experience in Wagner"; she uses also other musical devices—"the three movements of the novel as a whole, the outer movements cyclical, like Franck and Chausson symphonies, making use of the same themes, the inner movement violently contrasting with the outer ones, not only in length, but in its occupation with impersonal Nature, as opposed to psychological Reality." Fromm concludes:[31] "On close re-examination of the novel we find that it sustains a pitch of excitement for which few, if any, parallels can be cited in English literature. It is essentially a musical experience and does not communicate ideas; it communicates a meaning which transcends meaning."

The technique of the stream of consciousness, though having different origins (Stendhal hinted at it, Tolstoy applied it in Anna Karenina's interior monologue preceding her suicide, and finally William James gave it a scientific foundation), is related to impressionism in painting, as the Russian critic Chernyshevski, saw clearly enough. As in the case of the church ceilings of Correggio, which found success only in an age more prepared to receive his innovation, one might say that the technique of the stream of consciousness could develop only in an age initiated to impressionism, though the idea of the stream of consciousness had dawned before on a few isolated geniuses.

Spatial and Temporal Interpenetration

THE general panorama offered by the first half of our century is one of such a variety of experiments that it would be easy to lose oneself among them. However, parallel lines of development can be observed in the various arts. There has been an anti-art with the Dada movement, an anti-architecture with Le Corbusier, an anti-novel in France with Robbe-Grillet and the *nouvelle vague*. The same problems face writers, sculptors, and architects. To give expression to the sense of nothingness, of the void, has been attempted—to quote only a few names—by Rothko in painting, Antonioni in the film, Kafka in the novel, Beckett on the stage.[1] Cézanne told Emile Bernard to "see in nature the cylinder, the sphere, the cone." Picasso has represented a figure both *en face* and *en profil* in the same view; architects have spoken of a fourth dimension. Giedion (on whom Picasso's paintings doubtless had an influence) sees the history of architecture as a progression from the bidimensional to the three-dimensional and so on, without knowing, of course, that a parody of pluridimensionality had already been written in the Victorian era by Edwin A. Abbott, in *Flatland.*

Interpenetration of planes in painting, sculpture, and architecture; interpenetration of words and meanings in the language of Joyce; an attempt, in Lawrence Durrell's *The Alexandria Quartet*, at a "stereoscopic narrative" obtained by means of "passing a common axis through four stories"[2] ("to intercalate realities . . . is the only way to be faithful to Time, for at every moment in Time the possibilities are endless in their multiplicity"[3]). In the films of Alain Robbe-Grillet (*Last Year at Marienbad*

and *L'Immortelle*), as Bruce Morrissette has remarked, "two or more characters appear twice in different parts of a panoramic camera movement, creating a strange effect of continuity between two moments of time and two spatial locations which on a realistic level could not be proximate . . . a willingness to accept, in fiction, some of the same formal liberties and absence of conventional justifications that prevail in modern pictorial style (from abstract to op) and musical compositional methods (from serial to chance)."[4] Quotations which seem to float like alien bodies in the sentences of Ezra Pound's *Cantos* and Eliot's *The Waste Land;*[5] collage in the paintings of Braque, Max Ernst, and others. "The noises of waves, revolvers, typewriters, sirens, or airplanes," explained Erik Satie, the musician contemporary with the Cubists, in commenting on his ballet *Parade,* subtitled *Ballet Réaliste,* "are in music of the same character as the bits of newspapers, painted wood grain, and other everyday objects that the Cubists frequently employ to localize objects and masses in Nature."[6] Picasso's career could be put side by side with Joyce's, in the manner of Plutarch's *Parallel Lives of Greeks and Romans.* The painter also started with spirited imitations of traditional styles: he could be as civilized as Ingres,[7] as primitive as an African sculptor, as solemn as an archaic Greek, as subtle in color effects as Goya. In both painter and writer we find the general contraction of the historical sense and that intoxication with the contemporaneity of all historical styles[8] which can be compared to the experience of drowning, a giddy simultaneous rehearsal of one's whole life. Picasso's *Les Demoiselles d'Avignon* [112] attempted, long before Joyce, the elaboration of a new language through the fusion of unreconcilable manners. The left-hand figure in that picture speaks the language of Gauguin, the central section is conceived according to the flattened planes of Iberian sculpture, the right-hand portion betrays the influence of African masks with their saw teeth and sharp spines; whereas Cézanne is responsible for the hatching filling the space between the figures. But this contamination of styles is by no means confined to Joyce and Picasso; Picasso is not alone among modern painters in his ability to be at the same time Raphael and Cimabue. Incidentally, a trait common to Joyce, Picasso, and another representative genius of our time, Stravinsky,[9] is that while they have derived from many sources, nearly everybody since has derived

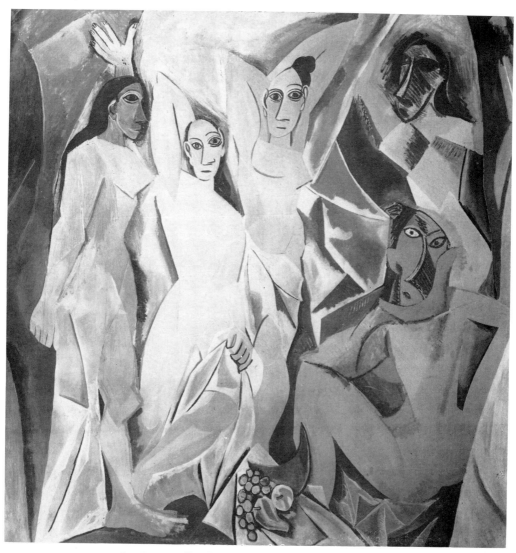

112　PABLO PICASSO: *Les Demoiselles d'Avignon*. Canvas, spring 1907

from them. Ezra Pound could be both Chinese and Provençal, and T. S. Eliot could write sententious Elizabethan English as well as musical comedy songs, as he demonstrated in "Sweeney Agonistes." *The Waste Land* is an even more composite product than *Les Demoiselles d'Avignon*. Viewed as pastiches, all these works of art take us back to the atmosphere of the circus and to the performances of the tightrope walker:[10] there is a deliberate masquerading and prancing, with the constant danger of losing one's balance and falling from the flying trapeze into the void, or merely into the sawdust of the arena. There lurks behind all these experiments the suspicion that the artist is just "shoring fragments against his ruins."[11] There is no proper succession governing the episodes of *Ulysses* but rather simultaneity and juxtaposition, just as in cubist paintings the same form reappears, mixing with others, the same letter of the alphabet or the same profile popping up here and there in a perpetual rotation whose final result is immobility [113, 114, and 115]. All this helps to give the structure of the book the appearance of the spatial and temporal interpenetration aimed at by futurists and cubists.

However, the juxtaposition of different languages was for Joyce only a first step toward the creation of an ultrasonic language, a language that falls on deaf ears as far as common mortals are concerned. In *Finnegans Wake* Joyce, having completely freed himself from the tyranny of mimesis,[12] has made a Dublin publican, Earwicker, the recipient of the whole past history of mankind, and a universal linguist in his dream language as well, which on an incomparably larger scale repeats the experiment of Lewis Carroll's "Jabberwocky"[13] "C'est"—remarks J.-J. Mayoux in "L'hérésie de James Joyce"—"une langue de *lapsus*, très exactement, c'est à dire de *glissements*."[14] The demon of association, conjured up by Lewis Carroll for fun, has received from Joyce the chrism of psychoanalytical science; the artist has dived into the night of dream psychology, revealing a phantasmal world that might have been one of the discarded alternatives at the beginning of things. But this is exactly what Picasso has done with forms in his escape from the accepted patterns of beauty.[15] Behind the world of forms as it exists, just as behind the world of words with which we are familiar, there is an infinity of unrealized possibilities that God or nature, or whatever you like to call the supreme vital principle, has rejected. By a

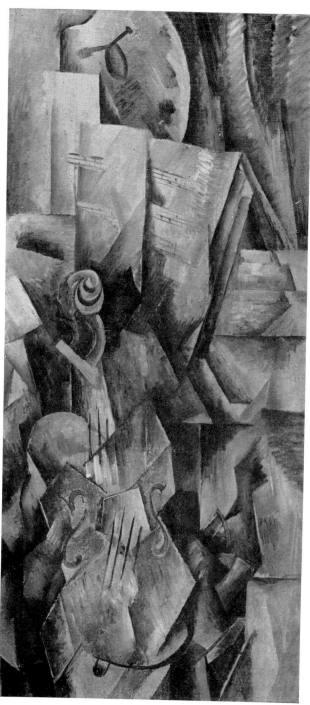

113 GEORGES BRAQUE: *Violin and Palette.*
Canvas, 1910

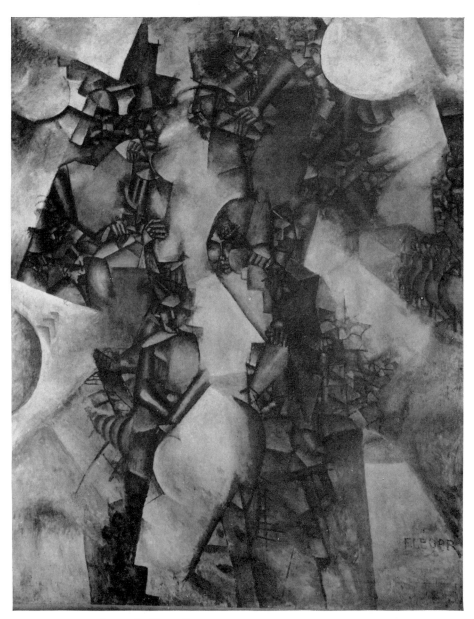

114 FERNAND LÉGER: *La Noce*. Canvas, 1911

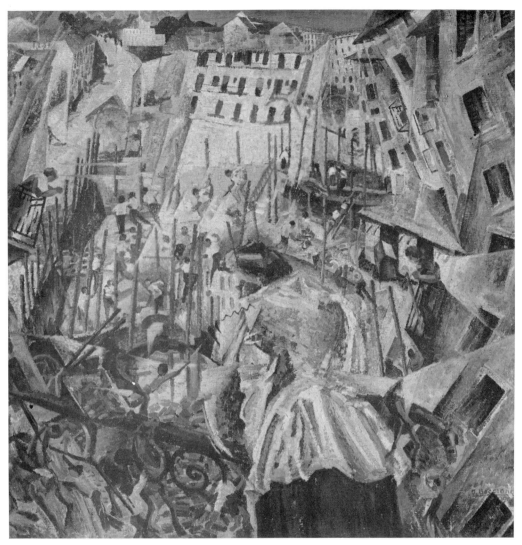

115 UMBERTO BOCCIONI: *The Street Enters the House.* Canvas, 1911

perversion of the process described by Michelangelo in his famous sonnet "Non ha l'ottimo artista alcun concetto," Joyce and Picasso have searched in the marble block for all the unlikely and illegitimate forms hidden within its entrails; theirs has been an anti-creation in the same sense that the gospel preached by the Antichrist was an inverted gospel. No wonder Mayoux says of Joyce's work: "Le néant, l'esprit du néant pénètre tout," and calls him "fils spirituel du Mallarmé du *Coup des dés;* chercheur d'absolu, enchanteur maléfique, puissant et stérile, engendreur de fantômes et d'incubes."

To take the relatively simple instance from *Finnegans Wake* that Edmund Wilson examines first: "Amengst menlike trees walking or trees like angels weeping nobirdy aviar soar anywing to eagle it!"; the last seven words represent the sentence "Nobody ever saw anything to equal it" telescoped into an ornithological simile. Picasso, repeating a process which can be traced to Giuseppe Arcimboldi, represents a lady's hat like a fish, giving an ichthyological turn to the hat, just as Joyce reads an ornithological content into a plain sentence. Salvador Dali sees a lady's hat like a shoe, and imagines Mae West's face utilized as a room, with her lips as a sofa and nose as a fireplace; he telescopes Velázquez' infanta into the summit of a Hindu temple, whose shape the infanta's farthingale has recalled. Picasso sees a stork with forks for legs, a shovel for wings, a nail for beak, and the blade-shaped head of a screw for a comb; out of an old weathered bicycle seat and a rusty handle bar he makes an impressive bull's head; a toy motor car becomes the muzzle of a monkey. No doubt Freud's influence has to be taken into account in these developments of suggestions which we find first in Rimbaud and Lautréamont and later in Raymond Roussel, the author of *Impressions d'Afrique* and *Locus Solus.*

In spite of its shortcomings, the chief of which is its monotony, *Finnegans Wake,* according to Wilson, has succeeded in one respect: "Joyce has caught the psychology of sleep as no one else has ever caught it, laying hold on states of mind which it is difficult for the waking intellect to re-create, and distinguishing with marvelous delicacy between the different levels of dormant consciousness."[16]

No such delicacy can be found in the fashionable offshoots of Dali's surrealism, which also purports to be based on dream psychology. In *The*

Secret Life of Salvador Dali we read of a masquerade at the Coq Rouge which had as its theme "A surrealist dream": at a certain moment a huge slaughtered ox was brought into the ballroom, its belly kept open with crutches and stuffed with a dozen gramophones, and Gala, Dali's wife, appeared in the role of *cadavre exquis*, carrying on her head a doll representing a real baby with its entrails eaten by ants and its brain clawed by a phosphorescent lobster. Most of Dali's compositions are actually such *cadavres exquis*, and what else but a *cadavre exquis*[17] is Joyce's ornithological sentence we read a moment ago, and a thousand others? And Gertrude Stein's famous sentence "Toasted susie is my icecream" is similarly a *cadavre exquis* of the first magnitude.[18]

In his *The Dehumanization of Art* Ortega y Gasset observes a change of perspective in most modern artists: "From the standpoint of ordinary human life things appear in a natural order, a definite hierarchy. Some seem very important, some less so, and some altogether negligible. To satisfy the desire for dehumanization one need not alter the inherent nature of things. It is enough to upset the value pattern and to produce an art in which the small events of life appear in the foreground with monumental dimensions. Here we have the connecting link between two seemingly very different manners of modern art, the surrealism of metaphors and what may be called infrarealism. Both satisfy the urge to escape and elude reality. Instead of soaring to poetical heights, art may dive beneath the level marked by the natural perspective. How it is possible to overcome realism by merely putting too fine a point on it and discovering, lens in hand, the micro-structure of life can be observed in Proust, Ramón Gómez de la Serna, Joyce. . . . The procedure simply consists in letting the outskirts of attention, that which ordinarily escapes notice, perform the main part in life's drama."[19]

The same mesmerized attention to magnified minutiae that we find in Salvador Dali we come across in many a modern writer as well. William Empson's critical method as expounded in *Seven Types of Ambiguity* (1930), by exploring all possible meanings of the words and thus opening strange vistas through the pages of a classic, has imparted to these words a tension, a dramatic irony, not unlike a surrealist effect (as when, for instance, Dali combines two figures of women in seventeenth-century

Dutch costumes in such a way that they form together the head of Voltaire: a well-known optical trick of the end of the nineteenth century, frequently combined with erotic and macabre details, e.g., bodies of naked women forming a skull). Empson's love of misprints, which he finds illuminating because they suggest buried meanings, can also be paralleled with the deliberate surrealist cult for solecism in the forms of things (wet watches, limp cellos, telephone receivers used as grills, etc.). When Empson remarks that "the practice of looking for ambiguity rapidly leads to hallucinations," he seems to be formulating the very process of surrealist inspiration, as illustrated, for instance, in Raymond Roussel's *Comment j'ai écrit certains de mes livres*. Another aspect of this mesmerized attention to minutiae is offered by the hairsplitting analyses of structural criticism, an extreme and indeed preposterous instance of which is Roland Barthes' *Système de la Mode*,[20] where the analysis of clothes takes the form of a minute survey of the tailoring language. It is in fiction, however, that we are likely to find obvious parallels with surrealist technique. William Sansom's *The Body* offers a number of illustrations of experiments which are verbal counterparts of the techniques of Dali, Max Ernst, and Eugène Berman. Take, for instance, this scene, which is uncannily like a hallucination in the manner of Max Ernst: "But in that house there was a third figure—and this I saw suddenly through the French windows. I stopped, stooped rigid—searched for this figure which suddenly I knew was there, but could not exactly see. A second before I seemed to have seen it. Then again I caught it—in the detached glass windscreen of a car propped against the sundial there stood reflected, motionless, the figure of a man. Dark and glassy in the windscreen lay reflected blue of the sky and a picture of the façade of the house above—though mostly of the verandah rail just above that garden room itself. The figure was standing with its hands on its sides, right against the white curled iron and creepered rail; it wore a dressing gown; its face seemed to stare directly down into mine; it was Bradford."[21]

This second passage illustrates Sansom's attention to magnified minutiae: "In the fresh morning air, in the still room without fire or light, in that motionless new grey daylight I sat and stared at the blacklead. After a few minutes, long minutes, I remember my eyes moving nearer to my

boots. Nothing stirred—but in the stoneset solitude I suddenly grew conscious of my living body. Inside those black boots there were feet and toes and on the toes greyish-yellow hairs. There was a corn on one toe, a patch of hard skin along the side of the other foot. Inside the boot, inside the sock, there was life. And in this knowledge I understood clearly how all the time, motionless in a motionless room, my body was slowly, slowly falling to pieces. A gradual, infinitesimal disintegration was taking place. Nothing could stop it. Pores that once had been young were now drying up, hairs were loosening in their follicles, there was an acid crusting the backs of my teeth and my stomach. And what horrors persisted in the unseen entrails, among all those unbelievable inner organs? My fingernails were growing, phlegm accumulated itself on the membranes of my throat and nose—all the time steadily, relentlessly, a quiet change was taking place, the accelerating decadence of forty-five years."

From Henry Green (though, generally speaking, the counterpart of Green's writing is to be found rather in abstract art), we take this vision reminiscent of Dali; while the last portion seems to be in the manner of Meredith: "He looked down on a girl stretched out, whom he did not know to be Merode, whose red hair was streaked across a white face and matted by salt tears, who was in pyjamas and had one leg torn to the knee. A knee which, brilliantly polished over bone beneath, shone in this sort of pool she had made for herself in the fallen world of birds, burned there like a piece of tusk burnished by shifting sands, or else a wheel revolving at such speed that it had no edges and was white, thus communicating life to ivory, a heart to the still, and the sensation of a crash to this girl who lay quiet, reposed."[22]

Desolate landscapes [116] of a kind which surrealist paintings have vulgarized are a salient feature of Eliot's *The Waste Land:*

> *A rat crept softly through the vegetation*
> *Dragging its slimy belly on the bank*
> *While I was fishing in the dull canal*
> *On a winter evening round behind the gashouse*
> *Musing upon the king my brother's wreck*
> *And on the king my father's death before him.*

White bodies naked on the low damp ground
And bones cast in a little low dry garret,
Rattled by the rat's foot only, year to year.

Another trait Eliot has in common with the surrealists, particularly Max Ernst with his fondness for collage, is the practice of quoting a classic in an apparently unrelated context; in the passage we have just read, we find a quotation from *The Tempest* and, in the lines that follow, a conglomeration of quotations from Marvell's "To his Coy Mistress," Day's *The Parliament of Bees*, a modern Australian ballad, and Verlaine. Picasso's quotations are more cryptic. In his *Girls by the Seine* the pattern of Courbet's famous painting of the same title can be dimly descried, like a wire contrivance supporting a firework. Georges Braque's quotation [117] of the portrait of Simonetta Vespucci by Piero di Cosimo [118] has partly reversed the color pattern, making the profile of the girl black against a white, moonlike face, whereas in the earlier painting the white profile is outlined against a black cloud. In Max Ernst's *Une Semaine de bonté* the sphinx appears at the window of a nineteenth-century train compartment, within which a lion-faced gentleman wearing a bowler is seated, and one sees the naked legs of a corpse. In one of Hans Erni's photomontages one of the Magi as painted by a fifteenth-century Swiss artist, Konrad Witz, appears against the background of a sanatorium, a modern corridor with a view on Swiss mountains.

In the fifth section of *The Waste Land* we come across another surrealist landscape:

Who are those hooded hordes swarming
Over endless plains, stumbling in cracked earth
Ringed by the flat horizon only
What is the city over the mountains
Cracks and reforms and bursts in the violet air
Falling towers
Jerusalem Athens Alexandria
Vienna London
Unreal

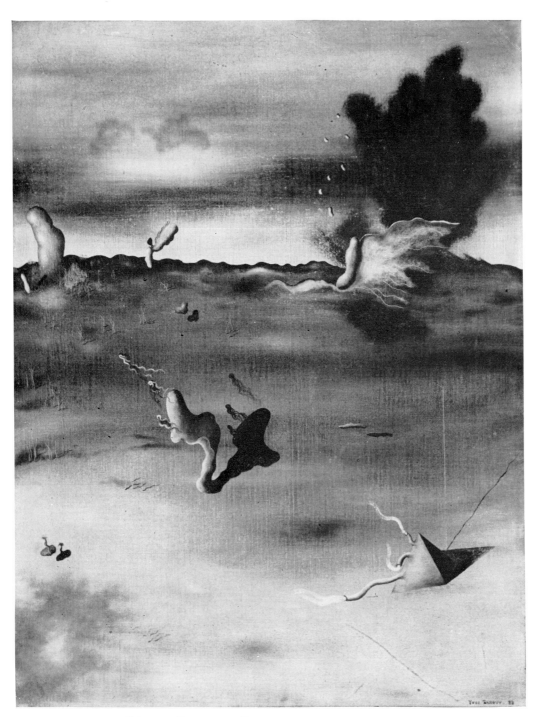

116 YVES TANGUY: *Peinture*. Canvas. 1928

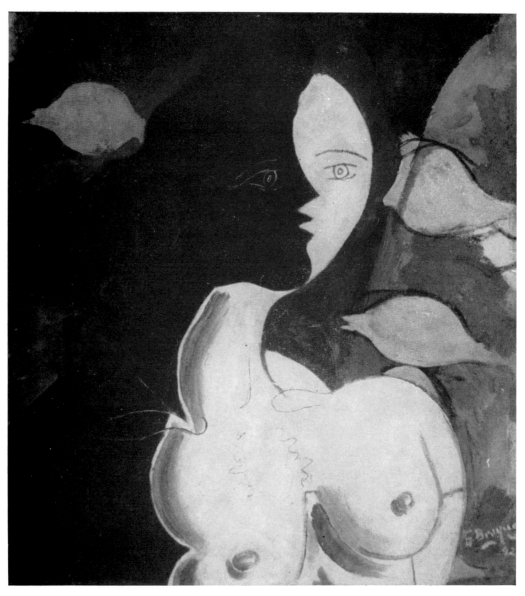

117 GEORGES BRAQUE: *Face et Profil.* Canvas, 1942

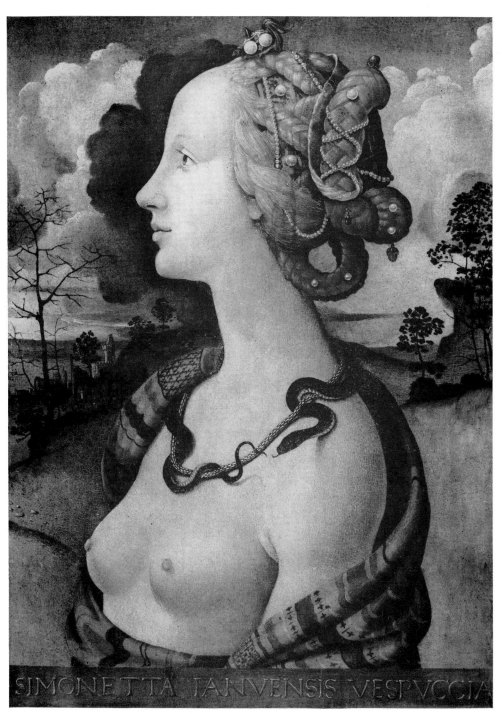

SIMONETTA IANVENSIS VESPVCCIA

118 PIERO DI COSIMO: *Simonetta Vespucci*. Wood, ca. 1480

Then there comes to the foreground a figure which reminds us of Dali's *Cauchemar de violoncelles mous* [119]:

> *A woman drew her long black hair out tight*
> *And fiddled whisper music on those strings.*[23]

The chaotic landscape described in the next passage bears the mark of sterility and is peopled with nightmares, again a typical surrealist treatment:

> *And bats with baby faces in the violet light*
> *Whistled, and beat their wings*

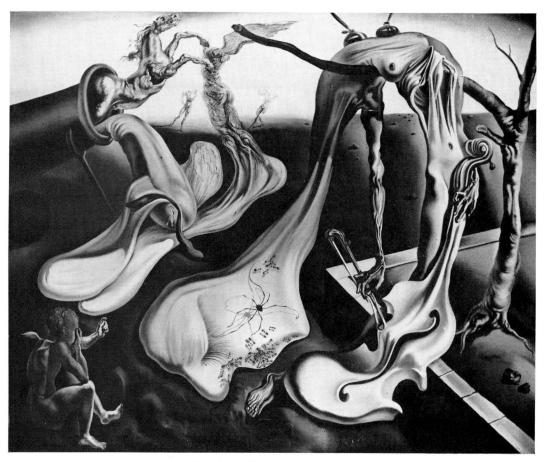

119 SALVADOR DALI: *Cauchemar de violoncelles mous.* Canvas, 1940

And crawled head downward down a blackened wall
And upside down in air were towers
Tolling reminiscent bells, that kept the hours
And voices singing out of empty cisterns and exhausted wells.[24]

The revolt against the traditional perspective that had prevailed in European painting since the Renaissance[25] produced the well-known intersections of time and space in cubism: Picasso's simultaneous presentation of the side and front view of a face. A parallel to this revolutionary change is to be found in the dislocation of the time sequence in fiction,[26] the most conspicuous example of which is William Faulkner's *The Sound and the Fury*.[27] In 1939 Sartre hailed in Faulkner's novel the introduction of the fourth dimension into literature, and then himself produced, in *Le Sursis* (1945), a narrative based on the technique of the Americans Dos Passos and Faulkner. This technique has since been popularized, for instance by Anouilh in *L'Alouette*.

In few modern writers can the parallel with painting be followed so closely as in Gertrude Stein. Her tricks of repet'tion and childlike sentences belong to the same current of innovation which made Matisse discard the traditional syntax of painting in favor of a return to infantile vision, an extreme sequel to Wordsworth's address to the "best Philosopher . . . Eye among the blind." The close contact of Gertrude Stein with avant-garde painters, particularly Matisse and Picasso, is well known, as is Picasso's contact with Apollinaire and Max Jacob; at the time of *The Making of Americans* Gertrude Stein stated that she was doing in writing what Picasso was doing in painting. On the other hand, one of Matisse's nudes [120] might easily be a fit illustration for these lines from a poem by Gertrude Stein:

> *If you hear her snore*
> *It is not before you love her*
> *You love her so that to be her beau is very lovely*
> *She is sweetly there and her curly hair is very lovely*
> *She is sweetly here and I am very near and that is very lovely*
> *She is my tender sweet and her little feet are stretched*
> > *out well which is a treat and very lovely.*

Matisse's synthetic childlike simplicity is also present in this passage from *Ida:*

"Ida returned more and more to be Ida. She even said she was Ida.

"What, they said. Yes, she said. And they said why do you say yes. Well she said I say yes because I am Ida.

"It got quite exciting."[28]

And just as the man in the street wonders whether Matisse can draw, so the press where Gertrude Stein had *Three Lives* printed sent to inquire whether she really knew English.

For Donald Sutherland, "it can be said that the difference between Gertrude Stein and Proust is the difference between Cézanne and the impressionists. The complexities of accident, light, and circumstance are reduced to a simple geometrical structure, a final existence addressed to the mind."

He continues: "Allowing certainly for his analytical gift and his splendors of construction, the presented continuity in Proust is a continuity of perception, of registration, like the surface of an impressionist painting; while in *The Making of Americans* the continuity is one of conception, of constant activity in terms of the mind and not the senses and emotions, like the surface of a cubist painting. . . .

"As the three-dimensional abstractions of Cézanne were flattened into the two dimensions of cubism, so the biographical dimension of *Madame Bovary* was flattened into the continuous present of *The Making of Americans.* As in straight narrative art the story functions as a plane, the continuous present of interior time was for Gertrude Stein a flat plane of reference, without concern for depth. Solids and depth concerned both Flaubert and Cézanne, but not at this time Gertrude Stein or Picasso. The change to plane geometry was an advance in simplicity and finality, to absolute elementalism. It contains some interesting motifs for future writing and painting, as for example the use of the letters of the alphabet, the simple juxtaposition of heterogeneous objects, the use of a concrete recognizable object in the midst of abstractions. But the main similarity between cubism and this period of Gertrude Stein's writing is the reduction

of outward reality to the last and simplest abstractions of the human mind. . . .

"'A Curtain Raiser' happens to correspond to the extremely simple and dry and tense cubist drawings done by Picasso at the same time (1913). . . . Gertrude Stein said much later that her middle writing was painting, and this is true even when no objects are mentioned [*Everybody's Autobiography*, p. 180].

"She seriously created, in the midst of our world, which was falling

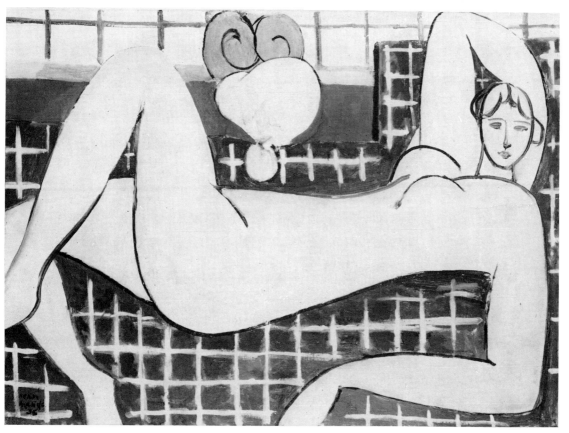

120 HENRI MATISSE: *The Pink Nude.* Canvas, 1935

away under habits and memories and mechanisms of words and ideas, a new reality. The elements of that reality were implicit in the life of the 20th century—the intense isolation of anyone and anything, the simple gratuity of existence, the fantastic inventiveness, and the all but total lack of memory—but it was Gertrude Stein who made that implicit reality most distinct and positive and completely real to the reading mind, as Picasso made it clear to the eye . . . Gertrude Stein and Picasso have isolated quality and movement, and made them articulate, she in words, and he in line and color. . . . They are . . . classical in their insistence on an absolute present free of progress and suggestion, and their use of the flat plane."[29] Gertrude Stein herself, in *The Autobiography of Alice B. Toklas*, has moreover acknowledged a similarity of aim with Juan Gris [121]:

"Gertrude Stein, in her work, has always been possessed by the intellectual passion for exactitude in the description of inner and outer reality. She has produced a simplification by this concentration, and as a result the destruction of associational emotion in poetry and prose. . . . Nor should emotion itself be the cause of poetry or prose. They should consist of an exact reproduction of either an outer or an inner reality.

"It was this conception of exactitude that made the close understanding between Gertrude Stein and Juan Gris.

"Juan Gris also conceived exactitude but in him exactitude had a mystical basis. As a mystic it was necessary for him to be exact. In Gertrude Stein the necessity was intellectual, a pure passion for exactitude. It is because of this that her work has often been compared to that of mathematicians and by a certain French critic to the work of Bach."[30]

Next to the mannerism of repetition, which finds illustration in Gertrude Stein, comes the mannerism of telegraphic language, with suppression of parts of speech, elliptical constructions, and so on. Before Pound advocated economy of speech by the suppression of articles and pruning of adjectives, the Italian futurists had given abundant instances of this, and Marinetti in the 1912 *Technical Manifesto of Futurist Literature* declared:

"Syntax was a kind of monotonous cicerone. We must suppress this intermediary, so that literature may directly become one thing with the universe. After free verse, here we have at last loose words. . . .

"Get yourself ready to hate the intellect, by reawakening in yourselves

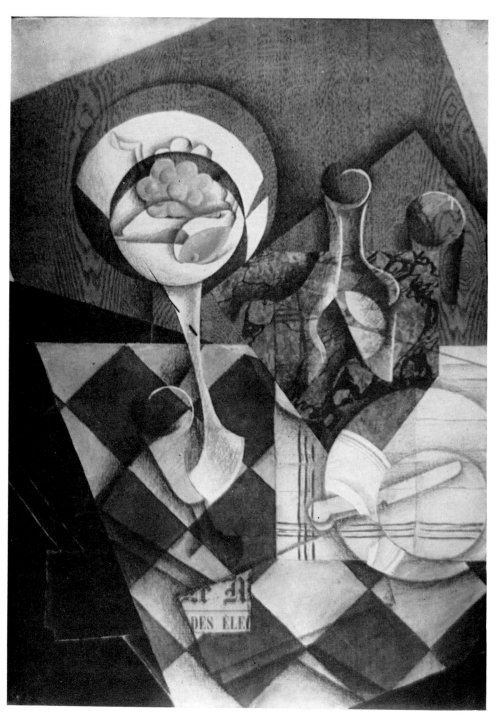

121　JUAN GRIS: *Still Life with Fruit Dish*. Oil and *papier collé* on canvas, 1914

divine intuition, through which we shall overcome the apparently irreducible hostility which separates our human flesh from the metal of engines."[31]

Another Italian who belonged for a time to the futurist movement, Ardengo Soffici, assuming in his *First Principles of Futurist Aesthetics* (1920) that the function of art consists in refining and sharpening the sensibility, concluded that the artistic language was tending to become a slang which needed only the slightest hints to be understood; therefore the modes of expression could grow more and more concise and synthetic, taking on a more intimate and abstract character to the point of becoming a conventional script or cipher. The artist and the public would find satisfaction no longer in working out a detailed representation of lyrical reality, but in the sign itself that stands for it. Therefore a few colors and lines in painting, a few forms and volumes in sculpture, a few words in poetry would be able to set in motion wide repercussions, infinite echoes. A meeting of two colors on a surface, a single word on a page would give an ineffable joy. He foresaw the ultimate destiny of art in the abolition of art itself through a supreme refinement of sensibility such as would render its manifestations useless. One need only look at Piet Mondrian's compositions or listen to Webern's music to see how well the Italian futurist movement coincided with the trend of abstract art. Apollinaire's *Calligrammes* (1918) and Soffici's *Chimismi lirici* (1915, second edition 1920) were already a form of abstract art, violent dissociations of the sentence from any subject matter, its reduction to a mere pattern for the eye and patter for the ear. Similar devices were used by Gertrude Stein: mysterious initials, mistakes and corrections in the midst of sentences, "cryptograms." E. E. Cummings' poems (in which Ezra Pound's ideas about the appearance of the words on the printed page and William Carlos Williams' theory that "the poem, like every other form of art, is an object" reach their extreme development)[32] put one in mind of the achievements of Mondrian, Kandinsky, and Klee in painting: they elaborate a free technique in which the very signs take the place of imagery. Cummings' *technopaignia* are indeed poetry and painting at the same time, a new application of the Alexandrian principle *ut pictura poesis*, as can be seen in the following instance, which I choose not because of its particular merits but for its brevity:

> *the*
> *sky*
> *was*
> *can dy lu*
> *minous*
> *edible*
> *spry*
> *pinks shy*
> *lemons*
> *greens coo l choc*
> *olate*
> *s.*
>
> *un der,*
> *a lo*
> *co*
> *mo*
> *tive s pout*
> *ing*
> *vi*
> *o*
> *lets*[33]

But the closest approach to Mondrian is represented by Gertrude Stein's set of statements abstracted from reality, by her celebrated poem "A rose is a rose is a rose is a rose," and by "Are there Six or Another Question":[34] she "developed a sense—past rhythm, past movement, past vibration—of sheer happening as an absolute."

The nearest the art of fiction comes to abstract art is in the novels of Henry Green.[35] He applies to prose an essentially poetic technique which has derived many hints from Hopkins and Auden: for instance, the concentration on a few significant features, the abolition of the article, the telegraphic language. The very titles of his novels are models of concision: *Living, Party Going, Nothing, Concluding*—single words in the middle of a page, almost taking on the function of a dot of color in an abstract painting. A passage from *Living* may remind one, on the other hand, of Chagall: "Here pigeon quickly turned rising in spirals, grey, when clock in the church tower struck the quarter and away, away the pigeon fell from

this noise in a diagonal from where church was built and that man who leant on his spade."[36] The very atmosphere of Green's novels, the substitution of a much subtler arabesque of conversations and inconclusive episodes (not without a certain resemblance to Ronald Firbank's elegant distortions) for a plot in the current sense of the word, the flattening of personal traits in the characters, so that they may be molded upon the arabesque and become almost indistinguishable from the pattern itself, the placing of the story almost outside a definite time and space (as in *Concluding*), and in some cases (in *Nothing,* for instance) the nearly total absence of descriptive passages—all these features contribute to the impression of abstract art. Occasionally, as in the following passage from *Back,* a faint echo of Gertrude Stein mingles with a surrealist sense of the macabre: "But as it was he went in the gate, had his cheek brushed by a rose and began awkwardly to search for Rose, through roses, in what seemed to him should be the sunniest places on a fine day, the warmest when the sun came out at twelve o'clock for she had been so warm, and amongst the newest memorials in local stone because she had died in time of war, when, or so he imagined, James could never have found marble for her, of whom, at no time before this moment, had he ever thought as cold beneath a slab, food for worms, her great red hair, still growing, a sort of moist bower for worms."[37]

Henry Green's novels seem to belong to the kind of *divertissements* "translating everything into subtlety and elegance"[38] which are typical of every mannerist phase in the history of literature and art.[39]

On a lower artistic level, the same characteristic is to be found in Christopher Fry's plays. The artist seems to give himself up to private juggling in a world whose sole significance is as a storehouse of possible patterns.[40] As an Italian follower of Laforgue, Aldo Palazzeschi, had put it as early as 1910 in the conclusion of a poem, "Lasciatemi Divertire (Canzonetta)," in which he indulged in verbal clowning:

> *i tempi sono cambiati,*
> *gli uomini non dimandano più nulla*
> *dai poeti:*
> *e lasciatemi divertire!*

The purpose of art as stated by Green in *Pack My Bag*, quoted below, is very near that outlined by Soffici in his *First Principles of Futurist Aesthetics:* "Prose is not to be read aloud but to oneself alone at night, and it is not quick as poetry but rather a gathering web of insinuations which go further than names however shared can ever go. Prose should be a long intimacy between strangers with no direct appeal to what both may have known. It should slowly appeal to feelings unexpressed, it should in the end draw tears out of the stone."[41]

It is not difficult to see how closely this aiming at the greatest possible rarefaction of style coincides with the aim of abstract art. "A gathering web of insinuations," an intimacy able to "draw tears out of the stone": there are people who can be intensely moved by a geometric pattern of Malevich or Mondrian; Plato himself had acknowledged the spell of pure geometric figures. Schoenberg worked in the same direction in the musical field, and a parallel can be drawn, as Melchiori draws it, between Green's later novels (*Nothing* and *Doting*) and Schoenberg's final stage in the atonal method, the affirmation of an abstract classicism based on pure form, the perfect and perfectly empty musical construction of the hero of Thomas Mann's *Doctor Faustus*. But such abstract reflections of the modern world—the remark is again Melchiori's—have a peculiar poignancy, due perhaps to despair: for these artists are tightrope walkers, and the surrounding void endows their juggling with an aura of tragedy.

Klee's abstract art indicated to Rainer Maria Rilke the solution of a problem with which he was absorbed: the relation between the senses and the spirit, the external and the internal. Herman Meyer, who has studied Rilke's affinity to Klee, both in attitude and in the means of expressing it in art, has drawn a parallel between Klee's abstract art and Rilke's symbolic language in the *Duino Elegies*.[42] The symbol does not develop out of elements derived from reality, but is a message in cipher. Such are, for instance, in the tenth elegy, the figures of stars used as signs; here there is a close analogy with Klee's enigmatic language in cipher. Rilke has described this process of abstraction in a letter to the painter Sophy Giauque, in speaking of Japanese poetry: "Le visible est pris d'une main sûre, il est cueilli comme un fruit mûr, mais il ne pèse point, car à peine posé, il se voit forcé de signifier l'invisible."[43]

I have refrained, except for a few hints, from drawing parallels between modern music and the other arts, partly because, as I have already had occasion to say, similarities between music and literature are often deceptive.[44] As Edmund Wilson aptly remarked apropos of the supposed musical character of *Finnegans Wake:* "Nor do I think it possible to defend the procedure of Joyce on the basis of an analogy with music.[45] It is true that there is a good deal of the musician in Joyce: his phonograph record of *Anna Livia* is as beautiful as a fine tenor solo. But nobody would listen for half an hour to a composer of operas or symphonic poems who went on and on in one mood as monotonously as Joyce has done in parts of *Finnegans Wake,* who scrambled so many motifs in one passage, or who returned to pick up a theme a couple of hours after it had first been stated, when the listeners would inevitably have forgotten it."[46]

Parallels between the visual arts and literature, on the contrary, seem to me very appropriate: here the fields are closer, and this can be argued—as we have seen—from cases of painters who are also good writers and writers who can draw. But whereas, as I said at the beginning, parallels of this sort seem to be almost obvious in past ages, they are not so obvious in modern art, because the "énormité devenant norme" and the "sauts d'harmonie inouïs" are violently striking when expressed on a canvas or in metal and stone; on the printed page they are not so staggering. Even a page of *Finnegans Wake* is more accessible than most abstract painting; one can guess why that page was written, but the first reaction to most modern painting is precisely to wonder why it has been done at all.[47] The Victorians, as we know, could enjoy "Jabberwocky" but they would have packed Mondrian, Malevich, and Kandinsky off to the lunatic asylum, and would have seen no difference between Klee's pictures and those made by mad criminals. I feel, however, that there is a close relationship between the development of art and literature also in the modern period, one may even say, chiefly in the modern period, when creation goes hand in hand with an overdeveloped critical activity debating problems which are common to all the arts.

Notes

Notes

I. "UT PICTURA POESIS"

1. *Two Cheers for Democracy* (London: Edward Arnold, 1951), p. 101.

2. (London: Faber and Faber, 1958.)

3. (University of Chicago Press, 1958.)

4. Earlier essays on the same subject: A. Fontaine, *Les Doctrines d'art en France; peintres, amateurs, critiques de Poussin à Diderot* (Paris: H. Laurens, 1909); A. Lombard, *L'Abbé Du Bos; Un Initiateur de la pensée moderne (1670–1742)*, (Paris: Hachette, 1913); W. Folkierski, *Entre le classicisme et le romantisme* (Cracow: Académie polonaise des sciences et des lettres, 1925); Rensselaer Lee, "Ut Pictura Poesis: The Humanistic Theory of Painting," *Art Bulletin*, XXII:4 (December 1940); B. Munteano, "Le Problème de la peinture en poésie dans la critique française du XVIIIᵉ siècle," *Atti del quinto Congresso Internazionale di Lingue e Letterature Moderne* (Florence: Valmartina, 1955), pp. 325–38; J. Seznec, *Essais sur Diderot et l'antiquité* (Oxford: Clarendon Press, 1957).

5. See Ian Jack, *Keats and the Mirror of Art* (Oxford: Clarendon Press, 1967).

6. *Timber, or Discoveries*, in *Critical Essays of the Seventeenth Century*, ed. J. E. Spingarn (Oxford: Clarendon Press, 1908), I, 29. *The Merchant of Venice*, V, i, 83–88.

7. In *Œuvres complètes de Diderot*, ed. J. Assézat and M. Tourneux (Paris: Garnier, 1875), I, 374. On the popularity of emblems with writers see my *Studies in Seventeenth-Century Imagery* (2nd edn.; Rome: Edizioni di Storia e Letteratura, 1964), pp. 205–31.

7a. Giulio Romano was responsible for the decorations of the funeral of Federigo Gonzaga, Duke of Mantua (June 28, 1540). Cf. *Winter's Tale*, V, ii, 95ff.

8. Cited in Isabel W. U. Chase, *Horace Walpole: Gardenist* (Princeton University Press, 1943), pp. 100–101.

9. See Ian Jack, *Keats and the Mirror of Art*.

10. E. Wind, *Humanitätsidee und heroisiertes Porträt in der englischen Kultur des 18. Jahrhunderts* (Vorträge der Bibliothek Warburg, Leipzig, 1930–31). Queen Christina of Sweden had also been represented as Minerva, in a painting by D.-K. Ehrenstrahl (portrait bust with allegorical figures of Sculpture, Poetry, and Painting in the Nationalmuseum, Stockholm), as well as in medals by E. Parise (1650) and by G. F. Tavarini (after 1665), and in a statue by Millich. See *Queen Christina of Sweden. Documents and Studies*, ed. Magnus von Platen (Stockholm: Norstedt, 1966), pp. 354ff. Owing to the Queen's unprepossessing appearance, such a Minerva would have had very little chance in the judgment of Paris.

11. *L'Art religieux après le Concile de Trente* (Paris: Colin, 1932), chiefly pp. 383ff.

12. *Untersuchungen zur Iconologie des Cesare Ripa* (Hamburg: Procter, 1934); Italian trans., offprint from *Bibliofilia*, Vol. XLI (Florence: Olschki, 1939).

13. Chester F. Chapin, *Personification in Eighteenth-Century English Poetry* (New York, 1955), p. 56; cited by J. H. Hagstrum, *The Sister Arts*, p. 145.

14. Ibid., p. 290.

15. See Ian Jack, *Keats and the Mirror of Art*, pp. 110–11, 129.

16. See Raymond Escholier, *Delacroix; peintre, graveur, écrivain* (Paris: Floury, 1927), II, 84–87.

17. *Theory of Literature* (New York: Harcourt Brace, 1959), pp. 134–35.

18. *Literature through Art, A New Approach to French Literature* (New York: Oxford University Press, 1952), p. 223.

19. *Barockthemen, Eine Auswahl von Verzeichnissen zur Ikonographie des 17. und 18. Jahrhunderts* (Budapest: Verlag der Ungarischen Akademie der Wissenschaften, 1956; Berlin: Henschelverlag Kunst und Gesellschaft, 1956).

20. *Theory of Literature*, p. 127.

21. *La Correspondance des arts; éléments d'esthétique comparée* (Paris: Flammarion, 1947).

22. Comanini, *Il Figino ouero del Fine della pittura* (Mantua, 1591), pp. 28–53, 135, 244; cited by Benno Geiger, *I dipinti ghiribizzosi di Giuseppe Arcimboldi, pittore illusionista del Cinquecento* (Florence: Vallecchi, 1954), pp. 82–85.

23. Batteux's treatise is little more than a collection of commonplaces: imitation of nature is the most common object of the arts, which differ only in the media employed to achieve that imitation. Batteux speaks of painting and music in only a cursory way.

24. *Œuvres complètes de Diderot*, ed. Assézat and Tourneux, I, 385.

25. See P. Collins, *Changing Ideals in Modern Architecture, 1750–1950* (London: Faber and Faber, 1965), pp. 273–74.

26. I have been unable to see Thomas Munro, *The Arts and Their Interrelations* (New York: The Liberal Arts Press, 1949); Calvin Brown, *Music and Literature; A Comparison of the Arts* (Athens: University of Georgia Press, 1948). Among more recent works, a correct view of the relations among the various arts is found in Wylie Sypher's *Four Stages of Renaissance Style; Transformations in Art and Literature 1400–1700* (New York: Doubleday, 1955).

27. *La Correspondance des arts*, pp. 97ff., 210.

28. Souriau, with the traditional carelessness of the French in foreign languages, writes "Pintelli," ibid., p. 107.

29. Ibid., p. 108.

30. *Peinture et Société, Naissance et destruction d'un espace plastique, de la renaissance au cubisme* (Paris: Gallimard, 1965), p. 133.

31. Vasari had already remarked (*Le Opere di Giorgio Vasari*, con nuove annotazioni e commenti di Gaetano Milanesi [Florence: Sansoni, 1906]), VII, 727: "insegna la lunga pratica i solleciti dipintori a conoscere . . . non altramente le varie maniere degli artefici, che si faccia un dotto e pratico cancelliere i diversi e variati scritti de' suoi eguali, e ciascuno i caratteri de' suoi più stretti famigliari amici e congiunti." ("Long practice teaches the diligent painters how to distinguish . . . the various styles of the artists in the same way in which a learned and experienced registrar knows the various and different hands of his equals, and everybody knows the characters of his close friends and relatives.")

32. Benedetto Croce, *Estetica come scienza dell'espressione e linguistica generale teoria e storia* (3rd edn., rev.; Bari: Laterza, 1908), Part I, Chap. IX, p. 78.

II. TIME UNVEILS TRUTH

1. *Style in Costume* (London: Oxford University Press, 1949).

2. (London: Kegan Paul, 1924.)

3. R. L. Pisetzky, *Storia del costume in Italia* (Milan: Istituto Editoriale italiano, 1964) III, 18.

4. *Style in Costume*, p. 6.

5. *Les Trésors de Palmyre. Curieux, collectionneurs, amateurs d'art, etc.* (Paris: Plon, 1938), p. 239.

6. *On Art and Connoisseurship* (London: Bruno Cassirer, 1942), pp. 260–61.

7. *Le memorie di un pittore di quadri antichi* (San Casciano, Val di Pesa: Società Editrice Toscana, n.d. [c. 1932]), pp. 108, 135. The figure of Diana in the painting

reproduced here is clearly derived from that of the same goddess in the center of Domenichino's *Diana's Hunt* in the Borghese Gallery, Rome.

8. Cited by Collins in *Changing Ideals in Modern Architecture*, p. 257.

9. See M. Praz, *The Romantic Agony* (London: Oxford University Press, 1933; and later editions), Chapter IV, "The Belle Dame sans Merci." (All citations hereafter are from the 1951 edition.)

10. *Changing Ideals in Modern Architecture*, p. 259.

11. Translated from Winckelmann, *Opere* (Prato: Giachetti, 1830), VI, 520ff.

12. *The Australian Ugliness* (Harmondsworth: Penguin Books, 1960), p. 191.

13. See *The Romantic Agony*, pp. 291–93, 399.

14. *Theory of Literature*, pp. 128–29.

15. Matila C. Ghyka, *Le Nombre d'or, Rites et rythmes pythagoriciens dans le développement de la civilisation occidentale* (Paris: Gallimard, 1931), I, 109.

16. *English Landscaping and Literature, 1660–1840* (London: Oxford University Press, 1966), p. 37.

17. Hannah More to her sister, 31 December 1782. *Memoirs of the Life and Correspondence of Mrs. Hannah More* (London: Seeley and Burnside, 1834), I, 267.

18. *Studies in Iconology* (New York: Oxford University Press, 1939), pp. 176–77.

19. I am quoting from my essay, "Donne's Relation to the Poetry of His Time," in *The Flaming Heart* (New York: Doubleday, 1958), pp. 201, 203.

20. *William Blake, Poet and Painter, An Introduction to the Illuminated Verse* (University of Chicago Press, 1964), pp. 140 and 20.

21. See *Letters of Dante Gabriel Rossetti*, ed. Oswald Doughty and J. R. Wahl (Oxford: Clarendon Press, 1965), II, 526ff.

22. The identity of the pose would seem, however, due to chance, if we were to accept for Rossetti's oil painting the date 1864, given by the painter. Courbet's *La Jo, Femme d'Irlande* (here reproduced in his own identical copy dated 1856, in the Metropolitan) was originally painted at a single sitting at Trouville in 1865 when Courbet borrowed from Whistler the Irish girl who was the American painter's model. Courbet had possibly met her at Whistler's studio in Paris when Whistler was working on *The White Girl*, for which Jo posed. The 1865 date is supported by a letter of Courbet of that year in which he mentions "a superb red-haired girl" whose portrait he had started (P. Borel, *Le Roman de Gustave Courbet* [Paris, 1922], p. 99, n. 1; Charles Sterling and Margaretta M. Salinger, *French Painting; A Catalogue of the Collection of the Metropolitan Museum of Art*, II: XIXth Century [Greenwich, Conn.: New York Graphic Society, 1966], pp. 128–29.) However, *Lady Lilith* (of which there exist replicas dated 1867) was not painted until 1866. Rossetti wrote to his mother in August of that year: "I have been working chiefly on the Toilette picture [i.e., *Lady Lilith*] and at the one with the gold sleeve [*Monna Vanna*], both of which I think you know" (see H. C. Marillier, *Dante Gabriel Rossetti, An Illustrated Memoir of His Art and Life* [2nd edn., abridged and rev.; London: Bell, 1901], pp. 77, 99, 105; and *Letters*, II, 602). Rossetti's visits to France took place much earlier than 1867, when Courbet's painting was shown at his exhibition at the Rond-Point du Pont de l'Alma. But Whistler traveled to and from London between 1859 and 1884, and Rossetti might have heard of Courbet's painting from him.

23. *Histoire du romantisme* (Paris: Charpentier and Fasquelle, 1895), p. 130.

III. SAMENESS OF STRUCTURE IN A VARIETY OF MEDIA

1. Vladimir Ja. Propp, *Morphology of the Folktale*, ed. with an intro. by Svatava Pirkova-Jakobson (Bloomington, Ind.: Ind. U. Research Center in Anthropology, Folklore, and Linguistics, 1958).

2. *L'Arte e le Arti* (Pisa: Nistri-Lischi, 1960), pp. 18, 37, 43, 45, 46, 49, 105.

3. Ibid., p. 39.

4. In a different sense, Petrarch defined poetry as "remembrance of things experienced and proved" (*Lettere senili*, II, 3). Petrarch had in mind the example of the great classical authors, and defined poetical activity accordingly.

5. M. Arnold in his introduction to Volume I of *The Hundred Greatest Men* (London: Sampson Low, 1879).

6. In "Wordsworth and Constable," *Studies in Romanticism*, V (Spring 1966), 121–38.

7. Coleridge, *Shakespeare Criticism*, ed. T. M. Raysor (London: Everyman Edition, 1960), II, 106; as cited by Storch, "Wordsworth and Constable," p. 134.

8. See, however, what is said about the sonnet "Westminster Bridge" and about "The Solitary Reaper," Chap. VI, pp. 159f, 163.

9. *The Unmediated Vision, An Interpretation of Wordsworth, Hopkins, Rilke, and Valéry* (New Haven: Yale University Press, 1954).

10. By Ath. Georgiades, quoted by Matila C. Ghyka, *Le Nombre d'or, Rites et rythmes pythagoriciens dans le développement de la civilisation occidentale*, I, 69–70. The conclusion of Ghyka's study of Pythagoreanism (I, 32–33) is worth quoting: "Intercaler le terme moyen dans un syllogisme, monter une chaîne de syllogismes en 'sorite' et jeter ainsi un pont entre deux îlots de la connaissance, relier par l'éclair de la métaphore juste deux images baignant dans le flot du rythme prosodique, joindre par l'eurythmie basée sur l'analogie des formes les surfaces et les volumes architectoniques, comme le dit le même Platon dans le *Théétète* et le *Timée*, et comme le détaille très clairement Vitruve . . . toutes ces opérations sont parallèles, 'analogues' à la création de l'harmonie musicale que les pythagoriciens choisissent de préférence comme modèle ou comme exemple." See, however, the remarks on Ghyka's theories in Souriau, *La Correspondance des arts*, p. 232, n. 1.

11. Bk. VI, Chap. 2: "Ut sit pulchritudo quidem certa cum ratione concinnitas universarum partium in eo, cuius sint ita ut addi aut diminui aut immutari possit nihil, quin improbabilius reddatur." Cf. Aristotle, *Poetics*, VIII, 4: ". . . the component incidents must be so arranged that if one of them be altered or removed, the unity of the whole is disturbed and destroyed. For if the presence or absence of a thing makes no visible difference, then it is not an integral part of the whole" (translated by W. Hamilton Fyfe [Loeb Classical Library edn., 1927], p. 35).

12. Hans Kayser, *Die Nomoi der drei altgriechischen Tempel zu Paestum* (Heidelberg: Lambert Schneider, 1958), has deciphered the hymns of the temples of Paestum; by examining the relationships of height, width, and depth among the various elements he elicits the notes of male and female hymns according to destination and cult. See also, by the same author, *Akróasis, Die Lehre von der Harmonik der Welt* (Basel: Benno Schwabe, 1946).

13. See what Jacob Burckhardt (*Griechische Kulturgeschichte* [Stuttgart: Alfred Kröner, n.d.], II, 298) has to say about the ancient Greek tragedy: "As for the structure of the performance, in the later tragedy there have gradually appeared secrets which one could neither see nor notice in the theatre itself, which nevertheless must have had their meaning. Certain tragedies of Sophocles and Euripides so divide themselves quantitatively, according to the number of lines of the parts in dialogue, that the middle is a principal scene, in relation to which the other scenes equally on one side ascend, on the other fall out, so that they approach the middle symmetrically, like the figures of a pediment. This no man's eye has been able to see, and no man's ear to hear, and it is nevertheless pointed out; there are things which for the present have not yet been made clear to us, which however show us the supreme skill of the poets."

14. Ghyka, *Le Nombre d'or*, I, 64, quotes the work of the Norwegian archaeologist F.-Macody Lund, *Ad Quadratum; A Study of the Geometrical Bases of Classic & Medieval Religious Architecture* (Eng. edn.; London: Batsford, 1921).

15. M. Schneider, *Singende Steine* (Kassel and Basel: Bärenreiter-Verlag, 1955);

see also Jurgis Baltrušaitis, *Les Chapiteaux de Sant Cugat del Vallès* (Paris: Ernest Leroux, 1931).

16. *Dante and the Legend of Rome* (London: Warburg Institute, 1952), p. 74.

17. See Rocco Montano, "Dante's Style and Gothic Aesthetic" in *A Dante Symposium, In Commemoration of the 700th Anniversary of the Poet's Birth* (1265–1965), ed. W. De Sua and G. Rizzo (Chapel Hill: University of North Carolina Press, 1966), pp. 11–34, on "the essence of the Gothic aesthetic" which "is the same strong intellectualism which characterized the theological speculation of the age" (p. 16). Prof. Montano stresses the fact that "starting with the beginning of the 12th century until the first half of the 14th century the Western world knew one of the most rich and intense developments of studies on logic in its whole history. . . . Theology was now a rigorous intellectual construction" (pp. 26–27). "We have the extremely complex organization of thought of the medieval *Summae*. Gothic art is the result of this latter attitude. It shows the same rigorous structure, the intellectual force, the complexity of organization, the multiplicity of elements which we find in the great constructions of St. Thomas and St. Albertus Magnus. . . . This art is fully consistent with the aesthetic ideals which supported the literary production of the age. The search, also here, is for the extreme articulation of elements, the subtlety and intricacy of forms, the great number of correspondences, the strenuousness and ingenuity of the construction. The work was always the result of an extreme intellectual tension and of a characteristic, profound ambition to create something difficult, subtle, high" (p. 28). And again: "The ambition of the time was toward height, arduousness, culmination together with multiplicity and concatenation of elements" (p. 31).

18. *Gothic Architecture*, Pelican History of Art (1962).

19. There is nevertheless a connection (studied by Panofsky in *Gothic Architecture and Scholasticism* [Latrobe, Pa.: Archabbey Press, 1951]) between Gothic architecture and scholasticism. Gothic architecture has been defined by Frankl as "a visual logic." "St. Thomas Aquinas to some extent equated perception with reason—'*nam et sensus ratio quaedam est*'—from which one can conclude that he saw an analogy between the current systematic scholastic method and Gothic architecture. Panofsky gives convincing proofs that a whole series of scholastic terms can also be fruitfully used to describe Gothic works built between about 1140 and 1270. Certainly the same, or at least a similar, form of thought governed both the scholasticism and the Gothic style of these four or five generations" (Frankl, op.cit., p. 263). I find, however, that the proof Sergio Bettini (*Le pitture di Giusto de'Menabuoi nel Battistero del Duomo di Padova* [Venice: Neri Pozza, 1960], p. 43) produces of the close connection between Gothic architecture and scholasticism is somewhat forced. He says: "In Villard de Honnecourt's sketch book one finds for instance the plan of an ideal *chevet* of a Gothic church, which he and another master, Pierre de Corbie, had drawn *inter se disputando*—as one reads in the slightly later caption which accompanies the drawing. Here we see then two architects of high Gothic who discuss a *quaestio* no doubt in the manner of schoolmen, because there is a third master who refers to the discussion using the specific scholastic verb *disputare* instead e.g. of *colloqui, deliberare,* or such like. Certainly Giusto de'Menabuoi before getting to work must have disputed a good deal in this manner—be it merely, perhaps, with himself." There is a definite contrast with Frankl's point of view in what Bettini says apropos of French high Gothic architects, who "were chosen, rather than for strictly technical capacities, *propter sagacitate ingenii,* and planned their cathedrals like scholastic *summae.*"

20. Willi Drost, *Romanische und gotische Baukunst* (Potsdam: Akademische Verlagsgesellschaft Athenaion, 1944), p. 5. Panofsky, *Gothic Architecture and Scholasticism*, p. 21.

21. *Die Kunst des Mittelalters;* the passage is translated from the Italian edition, *L'Arte del Medivero* (Turin: Einaudi, 1961), p. 82.

22. H. Janitscheck, *Die Kunstlehre Dantes und Giottos Kunst;* W. Hausenstein *Giotto;* Rosenthal, *Giotto in der mittelalterlichen Geistesentwicklung;* cited by Enzo Carli, "Dante e l'arte del suo tempo," *Dante,* ed. V. Parricchi (Rome: De Luca, 1965), p. 164. However, Dante could benefit by the literary tradition of the ancient world (Lucretius, Virgil), whereas such guides in the technique of painting were not available to Giotto; hence there is some ground in Saverio Bettinelli's contention that in that period letters were far ahead of the arts. See Giovanni Previtali, *Giotto e la sua bottega* (Milan: Fabbri, 1967), p. 13. Previtali finds, however, a parallel between the Allegories in the Lower Church of St. Francis at Assisi and passages of *Paradise,* XXX, 42, XXXI, 3–4, 130–35: "Here the firm stance of the figures, the rationality of the spatial connexions, the perspicuous display of the simple enough allegories, are a visual, peculiarly Giotto-like transposition, of ideas and fantasies somehow close to Dante's."

23. "Chaucer and the Great Italian Writers of the Trecento," in *The Flaming Heart.*

24. Contrary to what Paul Frankl maintains in *Gothic Architecture,* see above, p. 65.

25. Es bleibt kein Pflug stehen um eines Menschen willen, der sterbt. (Literally: "No plow comes to a stop for one man's sake who dies.")

IV. HARMONY AND THE SERPENTINE LINE

1. E. Panofsky, *Renaissance and Renascences in Western Art,* Gottesman Lectures of the University of Uppsala, Vol. VII (Stockholm: Almqvist & Wiksell, 1960), Part I, pp. 39–40, 110–13.

2. Curtis Brown Watson, *Shakespeare and the Renaissance Concept of Honor* (Princeton University Press, 1960), p. 63.

3. See, among others, Rocco Montano, op.cit., who maintains (p. 14) that the opposition to the Middle Ages did not stem from an attitude of revolt against Christian transcendentalism, but against the intellectualism of the scholastic dialectics. "The same reaction . . . took place in the world of art and poetry: it was not a turn toward secularism, but a revolt against intellectualism" (p. 15).

4. Castiglione, *Il libro del Cortegiano,* ed. G. Preti (Turin: Einaudi, 1960), p. xiii.

5. Stoll, *Shakespeare and Other Masters* (Cambridge: Harvard University Press, 1940); as cited by Watson, *Shakespeare and the Renaissance Concept of Honor,* p. 362.

6. "Shakespeare and the Stoicism of Seneca," *Elizabethan Essays* (London: Faber and Faber, 1934), pp. 33–54.

7. Wittkower, *Architectural Principles in the Age of Humanism,* Studies of the Warburg Institute, Vol. XIX (1949; new edn., London: Alec Tiranti, 1952); quotations here and below are from the latter edition, pp. 24ff., 15, 25, 97.

8. Quoted (in Italian) ibid., p. 89, n. 2.

9. Ibid., p. 93.

10. *Il Cortegiano,* Bk. II, Chap. xli. English translation from *The Book of the Courtier . . . done into English by Sir Thomas Hoby Anno 1561,* intro. by Walter Raleigh (London: D. Nutt, 1900), p. 152. "È adunque securissima cosa nel modo del vivere e nel conversare governarsi sempre con una certa onesta mediocrità, che nel vero è grandissimo e fermissimo scudo contro la invidia" (Preti, pp. 169–70).

11. Bk. II, Chap. vii. Hoby, p. 111. ". . . Non solamente ponga cura d'aver in sé parti e condizioni eccellenti, ma il tenor della vita sua ordini con tal disposizione, che 'l tutto corrisponda a queste parti, e si vegga il medesimo esser sempre ed in ogni cosa tal che non discordi da se stesso, ma faccia un corpo solo di tutte queste bone condizioni; di sorte che ogni suo atto risulti e sia composto di tutte le virtú, come dicono i Stoici esser officio di chi è savio; benché però in ogni operazion sempre una virtú è la principale; ma tutte sono talmente tra sé concatenate, che vanno ad un

fine e ad ogni effetto tutte possono concorrere e servire" (Preti, p. 120).

12. Cf. Leonardo da Vinci, *Trattato della pittura:* "Ciascun colore pare più nobile ne' confini del suo contrario che non parrà nel suo mezzo." ("Each color looks more noble on the border of its contrary than in its middle portion.")

13. Bk. II, Chap. vii. Hoby, pp. 111–12. ". . . come i boni pittori, i quali con l'ombra fanno apparere e mostrano i lumi de'rilevi, e cosí col lume profundano l'ombre dei piani e compagnano i colori diversi insieme di modo, che per quella diversità l'uno e l'altro meglio si dimostra, e'l posar delle figure contrario l'una all'altra le aiuta a far quell'officio che è intenzion del pittore" (Preti, p. 120).

14. See Maurice H. Goldblatt, "Leonardo da Vinci and Andrea Salai," Sec. One, Part II, in *The Connoisseur*, CXXV (May 1950), 71–75.

15. H. Wölfflin, *Die klassische Kunst, eine Einführung in die Italienische Renaissance* (3rd edn.; Munich: Bruckmann, 1904). (*Classic Art,* tr. Peter and Linda Murray [London: Phaidon, 1952].)

16. As can be seen, for instance, in Charles Bouleau, *Charpentes, La géométrie secrète des peintres* (Paris: Aux Editions du Seuil, 1963).

17. Wittkower, op.cit., p. 110.

18. *Ad Vitruvium*, I, ii, 3; cited in Wittkower, op.cit., p. 121.

19. This has been tried, though, by Professor George Duckworth in the case of the *Aeneid*, which, according to his complicated mathematical operations, would appear to be written with the golden section in mind.

20. See A. Vallone, "Un momento della critica dantesca nel tardo Cinquecento," in *Filologia e letteratura,* Vols. VIII–IX (1962–63); V. Limentani, "La fortuna di Dante nel Seicento," in *Studi secenteschi* (1964); L. Martinelli, *Dante* (Palermo: Palumbo, 1966), in the series *Storia della critica,* ed. G. Petronio.

21. See M. Praz, *Studies in Seventeenth-Century Imagery,* Chap. II.

22. See M. Praz, "Milton and Poussin," in *Seventeenth-Century Studies Presented to Sir Herbert Grierson* (Oxford: Clarendon Press, 1938), pp. 192–210; and also "Tasso in England," in *The Flaming Heart,* pp. 308–47.

23. See *The Flaming Heart,* pp. 326–30.

24. Cf. "L'Origine de la lettre de Poussin sur les modes d'après un travail récent," a report by Paul Alfassa on a thesis of A. Blunt, in *Bulletin de la Société de l'Histoire de l'Art Français* (1933), pp. 125–43.

25. In fact, for Poussin art was not an imitation of nature or of an idea, but an imitation of history in the Virgilian sense: recollection and promise. See R. Zeitler, "Zwei Versuche über Poussin," in *Friendship's Garland, Essays Presented to M. Praz on His Seventieth Birthday* (Rome: Edizioni di Storia e Letteratura, 1966), I, 221.

26. Wittkower, op.cit., pp. 124ff.: "The Break-away from the Laws of Harmonic Proportion in Architecture."

27. See Paolo Portoghesi, *Bernardo Vittone, Un architetto tra illuminismo e rococò* (Rome: Edizioni dell'Elefante, 1966), p. 28.

28. David Hume, "Of the Standard of Taste," *Essays Moral, Political, and Literary,* and Gaudet, *Éléments et théorie de l'architecture,* as cited in Wittkower, op.cit., pp. 132–35.

29. The nowadays widespread notion that mannerism represented an anti-Renaissance movement has been qualified by Mario Salmi in his article "Rinascimento, classicismo e anticlassicismo," published in the magazine *Rinascimento,* XVII (December 1966). Salmi shows that this notion has its origin in a false idea of the Renaissance, which did not, in fact, adhere to a rigid classicism, as the work of Donatello the very "initiator of the Renaissance in sculpture" (p. 16) shows clearly enough. Remarks to the same effect can be found in Sir Kenneth Clark, *A Failure of Nerve, Italian Painting 1520–1535,* H. R. Bickley Memorial Lecture (Oxford: Clarendon Press, 1967), particularly p. 5: "But throughout the period [i.e., the Renaissance] there is plenty of evidence for what has been called the tragic insufficiency of hu-

manism, and this is true of the field where the classical values of humanism were thought to have shown themselves more confidently. Almost all the great artists of the fifteenth century turned away at some point from the belief in human perfection, ideal proportion or rational space." Clark gives the examples of Donatello and Mantegna.

30. Wittkower, op.cit., pp. 75ff.

31. See Paolo Portoghesi and Bruno Zevi, *Michelangiolo architetto* (Turin: Einaudi, 1964), pp. 316ff.

32. The merits of the *linea serpentinata* had already been stressed by Quintilian, apropos of figures of speech. See J. Shearman, *Mannerism* (Harmondsworth: Penguin Books, 1967), pp. 84–85, where the relevant passage is quoted with reference to the *Discobolus* of Myron: "A similar impression of grace and charm is produced by rhetorical figures, whether they be figures of thought or figures of speech. For they involve a certain departure from the straight line and have *the merit of variation from the ordinary usage.*"

33. See for instance *Joseph* panel by Lorenzo Ghiberti (Gates of Paradise, Baptistery, Florence) where the circular building in the middle gives the impression of a spectacle being progressively revealed on a revolving platform.

34. The difference between a mannerist composition and a traditional one is evidenced by a comparison between Pontormo's *Joseph in Egypt* and Andrea del Sarto's *Joseph in Egypt* panel, executed in the same period (1517–18) for the same room of Pier Francesco Borgherini's house in Florence.

35. *Mannerism—Style and Mood, An Anatomy of Four Works in Three Art Forms* (New Haven and London: Yale University Press, 1964), p. 15.

36. See Alfred Einstein, *The Italian Madrigal* (Princeton University Press, 1949), II, 715. Although Gesualdo's compositions belong to the beginning of the seventeenth century, "his music shows the same centrifugal qualities which we have seen in Rosso and Pontormo. Gesualdo seems equally anxious to break through the stylistic systems of his day, like them he never constructed a new system, but built his madrigals out of the fragments of what he had destroyed, fragments put together with consummate skill into a delicate structure" (Rowland, op.cit., p. 23).

37. For instance, Donald L. Guss, *John Donne, Petrarchist, Italianate Conceits and Love Poetry in the Songs and Sonets* (Detroit: Wayne State University Press, 1966), sees Donne as belonging to the current of witty, courtly Petrarchism represented in Italy by Serafino Aquilano, Cariteo, and Tebaldeo.

38. *Metaphysical, Baroque, and Précieux Poetry* (Oxford: Clarendon Press, 1953), p. 10.

39. "Baroque in England," *Modern Philology*, LXI:3 (February 1964), 169–79.

40. See Chap. III. The stress on accessory elements which we have noticed already in medieval poets like Chaucer is one of the traits that mannerism has in common with the late Middle Ages, and represents a continuation and revival of some aspects of this period. This characteristic has been exhaustively illustrated by Georg Weise, "Manierismo e letteratura," *Rivista di letterature moderne e comparate*, XIII: 1–2 (June 1960), with special regard to certain oxymora and forced antitheses developed by fifteenth- and sixteenth-century Petrarchists. These are, however, stock phrases and commonplaces rather than structural characteristics.

41. John Shearman, *Mannerism*, considers Bembo and his school as mannerists, because of the artificial character of their stylistic ideal (p. 38: "Bembo argued that it was right for every man to write in his own language, but he did not mean the spoken language, which he despised for its corruptness, but a dead language revived, the language of classics"). But on that score Milton ought to be termed a mannerist also, which would manifestly lead to a definition of mannerism so wide as to be practically useless as an historical category. In fact, Prof. Shearman, by denying on one

side what modern critics have considered the distinctive traits of mannerism (anxiety and instability, and an opposition to Renaissance ideals; see pp. 19, 135, 171), and on the other including within the frame of mannerism all kinds of preciosity and artificiality, has cast a net of such loose mesh as to enable any fish to swim in and out. His definition of mannerism fits both the style of Bembo and that of Serafino, against which Bembo reacted (p. 176): "The elegant stylizations of Mannerist literature are related not only to the classicizing tendencies of *Bembismo*, but also to the courtly forms of the fifteenth century: the Petrarchism established long before Bembo, the contorted word-play of the sonnets of Serafino dell'Aquila. . . ." He thinks (p. 146) that Ariosto's variety in the *Orlando Furioso* has much in common with mannerist art. It would no doubt be attractive to see in Ariosto's interweaving of multiple narratives a phenomenon parallel to the delight in variegated surfaces and polychrome compositions (the mosaics of *pietre dure*, the cabinets composed of various materials: wood, metal, tortoise shell, semiprecious stones, etc.), or to musical polyphony, or to Pirro Ligorio's composite architecture, all of which are characteristic aspects of mannerist art. But the interweaving of multiple narratives was already there in Ariosto's sources, the medieval romances of the Arthurian cycle, where one constantly comes across the formula "Mes a tant laisse li contes a parler de . . . et retorne a . . .": the fractioning of the narrative was a consequence of the plurality of actions. Boiardo in his *Orlando Innamorato* had introduced a selective rule of art into this time-hallowed method by adopting the technique of suspension: he shifts to a new subject at the very moment when he has stimulated the reader's curiosity, and Ariosto has taken this tantalizing device from him (see Pio Rajna, *Le fonti dell'Orlando Furioso* [2nd edn., corrected and augmented; Florence: Sansoni, 1900], pp. 143ff). Was Boiardo also a mannerist, then? And are we to include also the authors of *Lancelot, Tristan,* and *Palamedes* in the category? For Professor Shearman the dramatic genre of *pastorali* (p. 91) is a typical mannerist invention, because of its total artificiality and its technique of "three or four concurrent affairs interwoven and resolved in a polyphonic manner" (p. 92). But here again, the same characteristics are to be found in the Hellenistic romances of Longus and Heliodorus, and if this is mannerism, it is not mannerism in the peculiar form it assumed in the sixteenth century. In conclusion, Professor Shearman's point of view favors a universal scheme like that contemplated by E. R. Curtius in *European Literature and the Latin Middle Ages* (New York: Pantheon [Bollingen Series], 1953)—according to which there are moments of mannerism, i.e., of preciosity of style for its own sake, in almost all phases of European literature, including antiquity—and anticipated by Walter Friedländer in *Hauptströmungen der französischen Malerei von David bis Cézanne* (Bielefeld and Leipzig: Velhagen & Klasing, 1930). On the other hand, Shearman's parallel for Tasso's *Aminta* (p. 92): "It is like a bronze by Giovanni Bologna: tiny, polished, exquisitely interlaced yet balanced and gracefully at ease," conveys no more than a vague impression, like the hackneyed comparison of Mozart to Watteau. Hardly less vague is the equation (p. 101) between Luca Marenzio's madrigals and Bronzino's paintings: both are polished and passionless.

42. "Fair warrior of mine, why so often do you arm yourself with wrath and pride against me, who in acts and words behave so reverently and humbly toward you? If you derive a little advantage out of my harm, or some little pleasure out of my pain, I will smart and die without regret, because I only care for myself for your sake. But if my life can promote your honor through my relentless works, do not make havoc of it. If you don't grant me a longer span of life, your story I am spinning with my life's thread will be nipped in the bud." The same theme is treated by Sir Philip Sidney in *Astrophel and Stella*, Sonnet 40: "Yet noblest Conquerours do wreckes avoid. / Since then thou hast so farre subdued me, / That in my heart I offer still to thee, / O do not let thy Temple be destroyd."

43. Milton took over from Della Casa the use of the run-on line in his sonnets, so that his "rhythm is staccato and irregular. It makes great play with the phrase-unit or sentence-unit which begins in the middle of one line and ends in the middle of another, thereby cutting across the metrical unit" (Patrick Cruttwell, *The English Sonnet*, in the series "Writers and Their Work," pub. for the British Council [London: Longmans, 1966], p. 31). It must, however, be kept in mind that Milton's adoption of the run-on line was suggested by Tasso's remark on Della Casa's sonnet "Questa vita mortal" ("Lezione sopra un sonetto di Monsignor Della Casa," in *Prose diverse*, ed. C. Guasti [Florence: Successori Le Monnier, 1875], II, 126), to the effect that "the breaking of the lines, as it is taught by all the masters, greatly contributes to gravity: and the reason is that the breaking of the lines slackens the course of the oration, and causes tardiness, and tardiness is proper to gravity: therefore tardiness both of motions and words is ascribed to magnanimous men, who are very grave." But it is not in the sonnets only that a serpentine element is noticeable in Milton's style. This has been remarked by William Empson ("The sliding, sideways, broadening movement, normal to Milton"; *Some Versions of Pastoral* [London: Chatto and Windus, 1935], p. 162), by C. Ricks ("The more closely one looks at the style, the clearer it seems that Milton writes at his very best only when something prevents him from writing with total directness"; *Milton's Grand Style* [Oxford: Clarendon Press, 1963, pp. 147–48), and by A. Bartlett Giamatti ("This allusive, elusive technique allows Milton full scope for his vast literary resources, and sources, and for the breadth of verbal ambiguity needed to maintain multiple perspectives, and the suspense, necessary for a successful account of the Fall"; *The Earthly Paradise and the Renaissance Epic* [Princeton University Press, 1966], p. 297).

44. Georg Weise, in "Manierismo e letteratura, II," *Rivista di letterature moderne e comparate*, XIX: 4 (December 1966), identifies with mannerism the unprecedented vogue for oxymora in the lyric poetry of the mid-sixteenth century (Wyatt, Barnes, and others in England, Desportes in France, etc.). Admittedly the antithetical device based on witty contraries is already in use in the Middle Ages, and Petrarch greatly contributed to its establishment; its recrudescence in the Cinquecento was certainly favored by the dialectical bias of mannerism. In the Middle Ages, also, are found the roots of another literary form which is usually connected with mannerism, "euphuism," a style which can be traced to Cicero, Seneca, and, among later writers, Boccaccio and Guevara; but Professor Weise makes a distinction between parallelism and balance as employed by Lyly after academic models, and the antithetical manner of the later followers of Petrarch. The only passage of *Euphues and His England* in which he detects a mannerist handling of oppositions occurs in R. W. Bond's edition of the *Complete Works of John Lyly* (Oxford: Clarendon Press, 1902), II, 84f., and in M. W. Croll and H. Clemons' edition of *Euphues: The Anatomy of Wit; Euphues and His England* (London: Routledge, 1916), p. 291. We quote from the latter: "She was ready of answer, yet wary: shrill of speech, yet sweet; in all her passions so temperate as in her greatest mirth none would think her wanton, neither in her deepest grief sullen . . . : oftentimes delighted to hear discourses of love, but ever desirous to be instructed in learning; somewhat curious to keep her beauty, which made her comely, but more careful to increase her credit, which made her commendable. . . ." There is a close similarity of style between this passage and the passage we quote from Sidney's *Arcadia*. For J. Shearman (*Mannerism*, p. 39), *Euphues* "is directly linked in style with *Bembismo*," and therefore to be considered a mannerist work. See note 41 of this chapter.

45. For further remarks on Sidney's style see M. Praz, *Ricerche anglo-italiane* (Rome: Edizioni di Storia e Letteratura, 1944), pp. 63–78.

46. Aretino wrote in one of his letters: "I believe our beloved messer Jacopo Sansovino will decorate your room with a Venus so true to life as to fill with lust the

mind of whomsoever gazes at her." Parmigianino executed for Aretino a *Madonna of the Rose* who, with her divine child, looked rather like Venus with Cupid, owing to her gesture and the comeliness of her limbs.

47. J. J. Dwyer, *Italian Art in the Poems and Plays of Shakespeare* (Colchester: Benham, 1946). See M. Praz, *Machiavelli in Inghilterra ed altri saggi* (2nd edn.; Florence: Sansoni, 1962), pp. 189–91.

48. Such as P. de Witte ("il Candido"); Von Achen, who visited Florence; and prints by Sadeler, Cort, and Goltzius. See G. Briganti, *La maniera italiana* (Rome: Editori Riuniti, 1961), p. 61.

V. THE CURVE AND THE SHELL

1. See Frances A. Yates, "The Allegorical Portraits of Sir John Luttrell," *Essays in the History of Art Presented to Rudolf Wittkower*, ed. D. Fraser, H. Hibbard, M. J. Lewine (London: Phaidon Press, 1967), pp. 149–60.

2. See E. K. Waterhouse, *Painting in Britain, 1530–1790*, Pelican History of Art (1953), p. 16.

3. See Frances A. Yates, "Queen Elizabeth as Astraea," *The Journal of the Warburg and Courtauld Institutes*, X (1947), 27–82.

4. Spain merely reinforced this taste in the second half of the century, when Italy became a Spanish dominion politically. See R. L. Pisetzky, op.cit., III, 217–23.

5. *Dialogo del Gentiluomo vinitiano* (Venice, 1566). He advises a young man to wear "buoni habiti più tosto gravi che pomposi."

6. Rudolf Wittkower, *Art and Architecture in Italy, 1600–1750*, Pelican History of Art (1958), pp. 100, 129.

7. Ferruccio Ulivi, *Il Manierismo del Tasso e altri studi* (Florence: Olschki, 1966). Ulivi, however, considers Tasso a mannerist and finds affinities with Tintoretto, though for Tasso's delight in describing semiprecious stones in the *Sette giornate del mondo creato* he might be considered closer to Jacopo Zucchi (see Chap. IV, p. 105). But in his use of the idea of pleasure in pain, evidenced in the episodes involving Olindo and Sofronia or Clorinda and Tancredi in the *Gerusalemme liberata*, and Silvia and the satyr in *Aminta*, Tasso heralds already the ambiguous sensibility of the baroque, and even of the romantic, period; actually his yearning for the unknown, the *non so che*, the exotic, and his sense of the solitude of man, are romantic traits. Tasso's *ductus* lacks homogeneity: he reminds us now of Tintoretto and now of Bartholomaeus Spranger; perhaps a psychoanalytical critic would find the reason for this variety of moods in the fact that Tasso was a schizophrenic.

8. "Art, which does everything, remains hidden. There is such a mixture of culture and negligence, that you imagine that the ornaments and the arrangements are only natural. It seems as if nature were playing at imitating her own imitator, art."

9. See E. Malins, *English Landscaping and Literature, 1660–1840*. Robert Castell, in *The Villas of the Ancients* (London, 1728), reported that Pliny had a garden in which hills, rocks, cascades, rivulets, woods, and buildings were thrown into such an "agreeable disorder" as to please the eye from several points of view, "like so many beautiful landskips" (p. 117).

10. Here are the two poems: "Semper munditias, semper, Basilissa, decores, / Semper compositas arte recente comas, / Et comptos semper cultus, unguentaque semper, / Omnia sollicita compta videre manu / Non amo. Neglectim mihi se quae comit amica / Se det, et ornatus simplicitate valet. / Vincula ne cures capitis discussa soluti, / Nec ceram in faciem: mel habet illa suum. / Fingere se semper non est confidere amori; / Quid quoque saepe decor, cum prohibetur, adest?" from *Publii Virgilii Maronis Appendix*, ed. J. C. Scaliger [Lyons, 1573]; Ben Jonson, *Epicœne or The Silent Woman*, I, i, 91–102: "Still to be neat, still to be drest, / As, you were

going to a feast; / Still to be pou'dred, still perfum'd: / Lady, it is to be presum'd, / Though arts hid causes are not found, / All is not sweet, all is not sound. / Giue me a looke, giue me a face, / That makes simplicitie a grace; / Robes loosely flowing, haire as free; / Such sweet neglect more taketh me, / Then all th'adulteries of art. / They strike mine eyes, but not my heart."

11. *Art and Architecture in Italy*, p. 100.

12. Shakespeare, *Much Ado About Nothing*, III, iv, 19ff. Such stiff dresses, indeed, that Brantôme tells us that when the niece of Francis I of France was married to the Duke of Cleves at twelve years of age, she had to be carried in the arms of an assistant to the nuptial ceremony, being unable to walk, so great was the weight of her jewels and of the gold and silver cloth of her garment.

13. *Art and Architecture in Italy*, p. 98.

14. Jakob Rosenberg, Seymour Slive, E. H. ter Kuile, *Dutch Art and Architecture, 1600–1800*, Pelican History of Art (1966), p. 128.

15. Wittkower, *Art and Architecture in Italy*, p. 127.

16. *Il Cannocchiale Aristotelico* (Venice, 1655), p. 310. See Praz, *The Flaming Heart*, pp. 207ff.

17. See Marie Christine Gloton, *Trompe-l'œil et décor plafonnant dans les églises romaines de l'âge baroque* (Rome: Edizioni di Storia e Letteratura, 1965).

18. Ben Jonson, *The Alchemist*, II, i, 46–52.

19. E. Fromentin, *Les Maîtres d'autrefois* (Paris: Garnier, 1939), p. 313.

20. Although, in the case of Caravaggio, people at the time were shocked to find prominence given to realistic details, such as the dirty feet in the *First St. Matthew* and the *Madonna di Loreto*, or the swollen body in the *Death of the Virgin*; and not only in his own time, since Berenson too, in his *Caravaggio, His Incongruity and His Fame* (London: Chapman and Hall, 1953), shows his disgust at such features.

21. See Jean Rousset, *La Littérature de l'âge baroque en France* (Paris: Corti, 1953), pp. 204ff., particularly p. 217: "Le héros cornélien est un personnage d'ostentation, qui se construit à la manière d'une façade baroque, disjoignant l'être et l'apparence comme l'architecte baroque disjoint la structure et la décoration et donne à celle-ci la primauté."

22. Though a satirical intent is obvious in such details as, in the etching of the *Good Samaritan*, the dog crouching while intent on a natural function: that very dog which, in an engraving of Michelangelo's *Ganymede* by Nicole Barbizet, is represented as only barking.

23. *Art and Architecture in Italy*, p. 29.

24. Kenneth Clark, *Rembrandt and the Italian Renaissance* (London: Murray, 1966), p. 12.

25. Ibid., p. 186.

26. Wittkower, *Art and Architecture in Italy*, p. 111.

27. Ibid., p. 145.

28. Ibid., p. 116.

29. Ibid., p. 150.

30. On the character of the rhythmical progression of baroque buildings, Matila C. Ghyka, *Le Nombre d'or*, I, 89, writes: "Ici aussi nous pouvons poser à première vue qu'en réalité la projection, même oblique, même répétée, d'un ensemble rythmé sur un plan ou sur plusieurs plans successifs, donne encore une image rythmée. . . . Ceci s'applique tout spécialement aux cascades musicales baroques, celles, par exemple, d'un édifice comme l'abbaye de Melk; l'orchestration magistrale de ces volumes 'chante' de quelque part que l'on approche l'immense symphonie de pierre, et ceci s'applique à bien d'autres abbayes 'baroques' d'Autriche ou d'Allemagne, de même qu'à leur 'archétype,' l'abside de Saint Pierre de Rome par Michel Ange." See also *Baroque, Italie et Europe centrale*, by Pierre Charpentrat (Fribourg: Office du livre,

1964), p. 9: "Depuis longtemps nombre d'historiens et de critiques, particulièrement en Allemagne, parlent de 'musique baroque.' C'est en pleine Italie baroque en effet que se lève la grande génération des Corelli, des Vivaldi, des Scarlatti, nés en 1653, 1678 et 1685. J.-S. Bach et Haendel ont quinze ans en 1700: ils sont exactement contemporains des architectes qui ont donné un visage à l'Allemagne du XVIII^e siècle, et en particulier du plus grand d'entre eux, Balthasar Neumann. Parallèlisme qui ne se limite pas à la chronologie, si l'on admet que l'influence de Vivaldi joua en l'occurrance un rôle comparable à celui que joua à plusieurs reprises, dans le développement de l'architecture baroque germanique, l'influence des maîtres du Seicento."

31. For a detailed study of the development of the curve in Borromini, see Paolo Portoghesi, *Borromini, Architettura come linguaggio* (Rome: U. Bozza, 1967), chiefly pp. 48–49, where Borromini's project for S. Eustachio is compared with Palladio's Church of the Redentore: "The main difference between the two naves lies in the treatment of the corner . . . Palladio had adopted a square pilaster in the point of intersection of the two orthogonal points of perspective . . . Borromini does not accept the separation of the orthogonal points and blends them into a *continuum* by bending one of the minor intervals into a curve . . . A research destined to have its most significant stages in the Oratorio dei Filippini, in the church of S. Maria dei Sette Dolori and in the chapel of the Magi at Propaganda Fide."

32. Wittkower, *Art and Architecture in Italy*, p. 159.

33. See Father Georgius Stengelius' *Ova Paschalia sacro emblemate inscripta descriptaque* (Munich, 1634), in which all the emblems are egg-shaped, and the conceits all derive from the egg.

34. One of the favorite emblems of the seventeenth century, when the cult of the heart of Jesus was revived by Jean Eude and Marguerite Alacoque. See M. Praz, *Studies in Seventeenth-Century Imagery*, pp. 151ff. Antonius Wiericx's plates of *Cor Iesu amanti sacrum* were the most popular ones, and appear in several devotional books.

35. R. L. Pisetzky, op.cit., III, 355, plate 158: A typical man's attire included knee trimmings descending in concentric, almost cabbage-shaped flounces down the calves. Sashes, ribbons, lace contribute to the effect of abundance and restlessness. Honeycombed ruffs recall the myriad geometrical decorations, conveying a sense of infinity, of the inside of the cupolas designed by Borromini and Guarino Guarini (Giedion has seen a relation between Guarini's vaults and the method of infinitesimals adopted by Leibnitz as the foundation of his differential calculus). Women's robes open in front in two swelling festoon-like curtains, showing the skirt; the shirt emerges at the cuffs of the sleeves in billowing volumes of white linen, held fast by ribbons. The enormous, bell-shaped farthingale speaks for itself.

36. See L. Keller, *Piranèse et les romantiques français, le mythe des escaliers en spirale* (Paris: Corti, 1966).

37. Thus Paolo Portoghesi, apropos of the façade of Propaganda Fide and of the remarks of Sedlmayr, who sees it approaching the condition of music through a technique of variations on a set theme, writes (*Borromini*, p. 286): "It is certain that the total image of the façade, owing to the conditions of its enjoyment, is entirely entrusted to a mnemonic summing-up, in the same way as the perception of a musical performance is wholly entrusted to the acoustic memory, i.e., to the possibility of linking together, while evaluating their relations, events which take place in successive moments. Borromini, genially interpreting these limiting conditions, exploits the intrinsic possibilities by resorting to variations. Following him step by step, the onlooker is enabled to enjoy many possible groupings of single images gathered together in the great framework, while certain totalizing elements invite him continually to knit together in the episodes he has first appreciated in their value of sub-units." And he speaks of "sub-units highly characterized and unified by the continuous reappearance

of diagonal dirigents as well as by the thorough-bass of the magnificent cornice."

38. This poet has been rightly selected by Jean Rousset in his chapter on the Baroque in the *Histoire des littératures*, II, Encyclopédie de la Pléiade (Paris: Gallimard, 1956), p. 91.

39. "Out of Grotius his Tragedy of Christes sufferinges," *The Poems, English, Latin, and Greek of Richard Crashaw*, ed. L. C. Martin (2nd edn.; Oxford: Clarendon Press, 1957), p. 399.

40. (Paris: Vrin, 1966).

41. Letter to the Rev. W. Mason, 29 July 1773. *Horace Walpole's Correspondence with William Mason*, ed. W. S. Lewis, G. Cronin, Jr., C. H. Bennett, The Yale Edition of Horace Walpole's Correspondence, Vol. 28 (New Haven, Yale University Press, 1955), p. 102.

42. *Esthétique du Rococo*, p. 255.

43. G. Poulet, *La distance intérieure* (Paris: Plon, 1952), p. 1; quoted by Minguet, op.cit., p. 250.

44. E. et J. de Goncourt, *L'Art du XVIIIᵉ siècle* (Paris: Charpentier, 1906), I, 7.

45. Chr. Hussey, *The Picturesque* (London and New York: G. Putnam's Sons, 1927); Malins, *English Landscaping and Literature*.

46. R. Fry, *Reflections on British Painting* (London: Faber and Faber, 1934), p. 75: "Gradually his symbol for tree and rock forms became fixed—he never enriched it by new observations; it became one of those typical eighteenth-century generalized summaries of natural form which we accept because of their elegance, and which in the end bore us by their extreme fluency and emptiness. It becomes like the poetic diction of the day, which avoids the contact with particular things; for which all birds are 'the feathered tribe' and cows a 'lowing herd.'"

47. The remark is as old as the eighteenth-century *Livre de quatre couleurs*, where we read: "Les mœurs se veloutent à force de ne porter que du velours, comme l'esprit brille à force de voir des brillants. L'âme suit les impressions du corps, dit élégamment Platon dans son Livre de l'Immortalité des Ames, et il faut convenir que les Russes ont l'esprit beaucoup plus agile et plus élevé depuis que Pierre le Grand les fit raser, et habiller à la Françoise."

48. See P. Portoghesi, *Roma barocca* (Rome: Bestetti, 1966), pl. 200.

49. G. D. Oschepkov, *Architektor Tomon* (Moscow, 1950), p. 90 (in Russian).

50. Valenciennes, for instance, overawed by the academic tradition, forbore to transfuse into his official paintings any trace of his spirited sketches of buildings, skies, and trees. A distinction between isolated elements prevails both in painting and architecture, and in interior decoration as well. This has been remarked by Robert Rosenblum (*Transformations in Late Eighteenth Century Art* [Princeton University Press, 1967], p. 71, n. 74) apropos of David's *Horatii*, whose compositional scheme is the pictorial counterpart of the new formal systems closely analyzed in architecture by Emil Kaufmann (*Architecture in the Age of Reason* [Cambridge, Mass.: Harvard University Press, 1955]). Furniture is no longer fused with wall decoration, as in the Rococo, but regains an independence that soon leads to virtual isolation.

VI. TELESCOPIC, MICROSCOPIC, AND PHOTOSCOPIC STRUCTURE

1. Hans Sedlmayr, *Verlust der Mitte* (Salzburg: Otto Müller Verlag, 1948).

2. See Malins, *English Landscape and Literature*, pp. 11–13.

3. M. Yourcenar, *Sous bénéfice d'inventaire* (Paris: Gallimard, 1962).

4. Henri Peyre, in *Histoire des littératures*, II, Encyclopédie de la Pléiade, p. 137.

5. (Berlin: Propyläen Verlag, 1966), pp. 36ff.

6. *The Unmediated Vision; An Interpretation of Wordsworth, Hopkins, Rilke and Valéry* (New Haven: Yale University Press, 1954).

7. See Praz, *The Romantic Agony*, p. 289.

7a. Of the artists of the past, Rembrandt seems to be almost unique in regarding "the vitality directed to the outside world and its enjoyment as of little consequence beside the more passive qualities of introspection, sympathy and humility": Jakob Rosenberg, *Rembrandt, Life and Work* (London: Phaidon, 1964), p. 58. See also Rosenberg's comparison, p. 282, of Rembrandt's *Aristotle Contemplating the Bust of Homer* and Guercino's preparatory drawing of the companion piece ordered by Don Antonio Ruffo: "Guercino's scholar announces his profession by gestures and attributes, and looks out directly at the spectator, Rembrandt's figure, in contrast, is completely absorbed in its own world of deep meditation and mystery."

8. Rembrandt again may be quoted in this connection. Rosenberg (op.cit., p. 193) remarks apropos of *The Sacrifice of Manoah*: "Here, for the first time, the inner reaction dominates over the outward manifestation of a miracle. . . . the scene is interpreted in the new spirit of "inwardness.' " And (p. 222) comparing Rubens' *Bathsheba* in Dresden with Rembrandt's *Bathsheba* in the Louvre, Rosenberg observes that "Rubens used this Biblical motif primarily for the display of feminine charm and painterly brilliance. Rembrandt, however, not only arouses admiration of the nude but also makes one aware of Bathsheba's feelings." Rembrandt, however, did not aim at a fastidious reconstruction of the historical costume and setting; like Shakespeare, he gives us a personal and contemporary interpretation of the past. What Rosenberg writes of Rembrandt could be applied also to Shakespeare: "Rembrandt's people, wrapped in their own thoughts, are in communication, not with the outside world, like those of Rubens, Van Dyck, or Frans Hals, but with something within themselves that leads, at the same time, beyond themselves. Therefore, an introvert attitude, with Rembrandt, means the search for the spiritual force in man that conditions his life, its origin as well as its course" (p. 299).

9. *Opere*, IV, 146–47.

10. William Gaunt, *Victorian Olympus* (London: Cape, 1952), p. 127.

11. N. Sarraute, "Flaubert," *Partisan Review* (Spring 1966), p. 199, apropos of *Salammbô*.

12. L. Keller, *Piranèse et les romantiques français*, pp. 118–19 and 132–33; Jean Seznec, *John Martin en France* (London: Faber and Faber, 1964).

13. *Histoire du romantisme*, p. 18.

14. *The Works of John Ruskin*, ed. E. T. Cook and A. Wedderburn (London: George Allen; New York: Longmans, 1903–12), XIV, 234, 237, 172.

15. *Die Kunst des neunzehnten Jahrhunderts* (Munich: Prestel Verlag, 1960).

16. Pierre Francastel, however (*Peinture et Société, Naissance et destruction d'un espace plastique, De la Renaissance au cubisme* [Paris: Gallimard, 1965], pp. 129ff.), maintains that there has been a misunderstanding about the influence of photography; in his opinion it is not true that the camera, by registering a raw vision (*vision brute*) of the universe, has supplied painters with the means of enlarging the exploration of objective reality. He points out that the early photographers arranged the field of vision in such a way as to remind us of pictures; the image offered by photography is thus no less the result of selection than is a painter's composition. On the other hand, it is not the camera, Francastel observes, which first revealed to artists the possibility of registering raw or unmediated impressions. The importance of photography lies in the fact that the possibility of a mechanical registration of vision resulted in developing the *Kunstwollen*, the search after style in the artists themselves. Photography confirmed those who sought after possible new groupings of sensations ("nouveaux groupements possibles de sensations"); it would have confirmed Monet in his search after the dissociation of forms and Degas in his new schematization of

outlines. In any case, Francastel admits that photography has freed painting from a whole series of compulsory allegiances and stimulated it towards an interpretation of the universe which is not so much subjective as psychological and analytical. As Walter Benjamin puts it, the discovery of photography destroyed the time-hallowed ritual of beauty; not, however, Francastel adds, in order to put reality in its place, but to open the way for the elaboration of new incantations. The discovery of photography assisted the painters in their aspiration towards a widening of the universe not through a renewal of the picturesque setting, but rather through a deepening of their acquaintance with its intimate structures. The greatest attraction lies no longer in the appearance, the spectacle, but in the way things are contrived ("les mécanismes"). The vision of the Renaissance was a distant one; the modern vision is bent on the discovery of a secret in the details. The great mysteries of nature have ceased to be wholesale visions and visions at a distance; painters are now concerned with the close-at-hand details, and are interested not so much in the objects of sensation as in the sensations themselves, the raw data of the organ of perception.

17. This is a pessimistic view of the same phenomenon which Francastel (*Peinture et Société*, p. 202) has described from a different angle: "Il est remarquable de constater que, tandis que la littérature insiste sur le côté tourmenté de l'époque, la peinture exprime davantage le côté conquérant du siècle. Y aurait-il une relation entre cette opposition et le caractère attardé des techniques littéraires, tout entières dominées encore par les poncifs?"

18. *An Outline of European Architecture* (Harmondsworth: Penguin Books, 1953), pp. 273–74. The second passage appears in the 1960 Penguin edition, p. 661.

19. *Changing Ideals in Modern Architecture, 1750–1850* (London: Faber and Faber, 1965), p. 284.

20. See Reyner Banham, *Guide to Modern Architecture*, quoted by Collins, op.cit., p. 207.

21. See Chap. 23 in Collins, op.cit.: "The Influence of Painting and Sculpture on Architecture." Here, p. 284.

22. *An Outline of European Architecture* (1960), p. 700.

23. R. Schmutzler, *Art Nouveau* (New York: Abrams, 1962), p. 135.

24. See ibid., pp. 10–11.

25. Jules Laforgue, *Moralités légendaires* (Paris: Mercure de France, 1964), p. 214.

26. "And two deep goblets of delicately tinkling glass you put near a bright bowl, and poured a sweet foam / You poured, poured, poured, shook two scarlet glasses; more white than a lily, more red than a ruby, you were white and ruby-colored." From *The Flaming Circle*, Vol. VIII of Sologub's *Complete Works* (Moscow, 1908).

27. Princess Marsi Paribatra, *Le Romantisme contemporain; Essai sur l'inquiétude et l'évasion dans les lettres françaises de 1850 à 1950* (Paris: Les Éditions Polyglottes, 1954), pp. 81–82.

28. By Viola Hopkins, "Visual Art Devices and Parallels in the Fiction of Henry James," *PMLA*, LXXVI (December 1961), 561–74: "In his view of the interrelatedness of all experience, of consciousness not as fixed and stable but as ever in flux, and in his emphasis on the subjective aspects of experience, James had much in common with the Impressionist painter's response to reality" (p. 571).

29. "Perceptive Contemplation in the Work of Virginia Woolf," *English Studies*, XXXV:3 (June 1954), 97–116. Below, p. 114.

30. *The Waves* (New York: Harcourt Brace, 1931), pp. 29, 109–10.

31. " 'To the Lighthouse': Music and Sympathy," in the *English Miscellany*, vol. 19 (1968), pp. 181–95.

VII. SPATIAL AND TEMPORAL INTERPENETRATION

1. See Lucien Goldmann, *Pour une sociologie du roman* (Paris: Gallimard, 1964), pp. 33–34, where a parallel is drawn between the *anti-roman*, the *théâtre de l'absence* (Beckett, Ionesco, Adamov during a certain period of their careers) and certain aspects of abstract painting. The *anti-roman* had already been foreseen by Flaubert when he spoke of "writing a book about nothing." See Nathalie Sarraute, "Flaubert" (quoted above), p. 207: "Books about nothing, almost devoid of subject, rid of characters, plots and all the old accessories, reduced to pure movement, which brings them into proximity with abstract art, are these not the goals toward which the modern novel tends? And this being so, can there be any doubt that Flaubert was its precursor?"

2. Durrell, *Clea* (London: Faber and Faber, 1960), pp. 135–36.

3. Durrell, *Balthasar* (London: Faber and Faber, 1958), p. 226.

4. "The Evolution of Narrative Viewpoint in Robbe-Grillet," *Novel, a Forum in Fiction*, I:1 (Fall 1967), 31, 33.

5. On the pictorial construction of the *Cantos*—the ideogrammatic method, the procedure of superimposition similar to montage—and on the importance given to the appearance of the "object" on the page, particularly by one of Pound's disciples, E. E. Cummings, see K. L. Goodwin, *The Influence of Ezra Pound* (London: Oxford University Press, 1966).

6. Quoted by Harold Rosenberg, *The Anxious Object; Art Today and Its Audience* (New York: Horizon Press, 1964), p. 61. Rosenberg comments: "The transformation of things by displacing them into art and of art by embedding it in a setting of actuality is the specifically twentieth-century form of illusionism." It is also one of the chief characteristics of *Kitsch*. See Gillo Dorfles, *Il "Kitsch," antologia del cattivo gusto* (Milan: Gabriele Mazzotta Editore, 1968), p. 19: the displacing of a work of art from its normal context to an unsuitable setting is instanced by the use of Leonardo's *Gioconda* for an advertisement.

7. See Phoebe Pool, "Picasso's Neo-classicism—Second Period 1917–25," *Apollo* (March 1967), pp. 198–207.

8. See Donald Sutherland, *Gertrude Stein: A Biography of Her Work* (New Haven: Yale University Press, 1951), p. 69.

9. See Constant Lambert, *Music Ho!; A Study of Music in Decline* (New York: Charles Scribner's Sons, 1934).

10. See Giorgio Melchiori, *The Tightrope Walkers; Studies of Mannerism in Modern English Literature* (London: Routledge and Kegan Paul, 1956).

11. Arnold Hauser, *The Social History of Art* (London: Routledge and Kegan Paul, 1951), II, 935: "Picasso compromises the artistic means of expression by his indiscriminate use of the different artistic styles just as thoroughly and wilfully as do the surrealists by their renunciation of traditional forms." Already in a cento of quotations like the one at the end of *The Waste Land* we have the first inkling of pop art. Instead of the *Kunstwollen*, there is a gesture which may be the expression of either an obsession or only a whim. It is as if man, oppressed by the machine age, were making a desperate sign, to affirm the existence of the individual and of the irrational in a world where everything is standardized and mechanized. Thus in a painting called *Cable* there are a few random black letters with a mysterious numeral. Parallel cases: a performance of *Hamlet* by an English company (In-Theatre) in which the speeches were put into the mouths of the wrong characters, e.g., Gertrude's words were spoken by Hamlet; Queneau's poems, where lines can be substituted for one another ad infinitum (Raymond Queneau, *100.000.000 de poèmes* [Paris: Gallimard, 1961])—a world of universal availability. In Queneau's book every line is

printed on a strip of light cardboard, and there are many strips on top of each other, to allow innumerable combinations. Here the *technopaignion* of the modern poet joins up with that of the seventeenth-century Erycius Puteanus, who showed that the words of a line on the Virgin composed by the Jesuit Bernard Van Bauhuysen ("Tot tibi sunt dotes, Virgo, quot sidera caelo") could be combined in 1022 different ways, as many as the number of the stars known at the time. See Praz, *Studies in Seventeenth-Century Imagery*, p. 20. For another modern tendency, that of using poor, rough materials in art (Alberto Burri) and vulgar words and ungrammatical jargon in literature, there is a parallel in architecture. Collins, *Changing Ideals in Modern Architecture*, p. 217, speaks of "Admirers of Le Corbusier nailing special coarse planking to the interior surfaces of their smooth plywood formwork in order to obtain this roughness artificially and at considerable expense" (apropos of the New Brutalists).

12. Revulsion from mimesis is also Picasso's main concern. In Françoise Gilot and Carlton Lake's *Life with Picasso* (New York: McGraw-Hill, 1964, pp. 124–25) he is reported as saying: "When I make a tree, I don't choose the tree; I don't even look at one. The problem doesn't present itself on that basis for me. I have no pre-established aesthetic basis on which to make a choice. I have no pre-determined tree, either. My tree is one that doesn't exist, and I use my own psycho-physiological dynamism in my movement toward its branches. It's not really an aesthetic attitude at all."

13. Edmund Wilson, "The Dream of H. C. Earwicker," *The Wound and the Bow; Seven Studies in Literature* (Boston: Houghton Mifflin, 1941), p. 259. This language has been studied by Freud and his followers, from whom Joyce seems to have got the idea of its literary possibilities.

14. "L'hérésie de James Joyce," *English Miscellany*, vol. 2 (1951), 219, 222.

15. It may not be irrelevant that Picasso is a native of Spain, a country where, occasionally, one notices "a complete absence of the creative sense in nature about one" (Hilaire Belloc, "The Relic," *Selected Essays* [London: Methuen, 1948], p. 7).

16. *The Wound and the Bow*, p. 267.

17. Perhaps not everybody knows what a *cadavre exquis* is: it is a composite image, frequently a very surprising one, resulting from a party game in which each participant executes a portion of a drawing and then folds the paper over it, thus preventing the next from seeing anything of what he has executed except the two ends which mark the limits of the figure. The English term for this game is "picture consequences."

18. Cf. Sutherland, *Gertrude Stein*, pp. 90–91. The sentence is a metamorphosis of a popular enough phrase: "Sunburnt Susie is my dish." Sutherland remarks: "This metaphoric process, or rather this metamorphosis by words, is, with differences, a little like the distortions of Matisse in color and line or like the more complete conversions in the cubist paintings of Picasso. That is, as Matisse seeing a fairly rich curve or a pleasant spot of color in the subject matter would exaggerate these into a sumptuous curve or a gorgeous area of color on his canvas, and as Picasso would make any approximately flat or approximately angular surface in the subject matter into a very definite quadrangle on canvas, so Gertrude Stein, intensifying and converting the original qualities of the subject matter by isolation and metaphor, winds up with a result that exists in and for itself, as the paintings do." I think, however, that the *cadavre exquis* provides a closer simile.

19. *The Dehumanization of Art* (Princeton University Press, 1948), pp. 35–36. See also, in this connection, Hauser, *The Social History of Art*, II, 937–38: "The sewing machine and the umbrella on the dissecting table [Lautréamont], the donkey's corpse on the piano [Dali] or the naked woman's body which opens like a chest of drawers [Max Ernst], in brief, all the forms of juxtaposition and simultaneity into which the non-simultaneous and the incompatible are pressed, are only the expression of a desire to bring unity and coherence, certainly in a very paradoxical way, into the

atomized world in which we live. Art is seized by a real mania for totality. It seems possible to bring everything into relationship with everything else, everything seems to include within itself the law of the whole. The disparagement of man, the so-called 'dehumanization' of art, is connected above all with this feeling. In a world in which everything is significant or of equal significance, man loses his pre-eminence and psychology its authority."

Though apparently in contrast with this point of view, the following passage (from Sutherland, *Gertrude Stein*, pp. 193–94) oddly enough confirms the arbitrary character of things in the modern world (cf. Sutherland's remark, p. 85: "everything has been wildly disconnected and at the same time almost anything is made to connect with anything else"): "It is true that we are more comfortable in the composition of 19th century life and literature, in which an actual or a mentioned cup of tea was part of an hour which was part of a day which was part of a week, month, season, or year, which was part of say the annals of Britain, which were part of the general onward evolution of something that was part of a cosmic order. A sentence was part of a paragraph which was part of a chapter which was part of a book which was part of a shelf of books which was part of England or America or France and so on. Something belonged to everything automatically. But nothing now is really convincingly a part of anything else; anything stands by itself if at all and its connections are chance encounters.—Q: If it is true, it sounds scary. Do you mean to make it sound exhilarating?—A: Officially of course it is scary. But it is a godsend to an artist. It leaves everything open, and so many realities can still be made. Not dreamed, if you please, but made."

20. (Paris: Aux Éditions du Seuil, 1967).

21. *The Body* (London: The Hogarth Press, 1949), pp. 114, 128.

22. Green, *Concluding* (London: The Hogarth Press, 1948), p. 56.

23. Even the form of martyrdom chosen for Celia in *The Cocktail Party* may be due to a suggestion from Dali's frequent insistence on ants.

24. Eliot says in a note that the inspiration for this vision came to him from a passage of Hermann Hesse's *Blick in Chaos*, in which the eastern part of Europe is shown staggering towards chaos and singing a drunken song on the edge of a precipice; but there may be also besides a precise reminiscence of the popular thriller *Dracula*, and an unconscious recollection of the twenty-third section and second *canzone* of Dante's *La Vita Nuova*, in which the poet has a foreboding of Beatrice's death in a vision of "certain faces of women with their hair loosened" and "other terrible and unknown appearances," birds falling dead out of the sky, and great earthquakes. In Rossetti's translation of the *canzone* we read:

> *Then saw I many broken hinted sights*
>
> · · · · · ·
>
> *Meseem'd to be I know not in what place,*
> *Where ladies through the streets . . .*
> *Ran with loose hair . . .*
> *And birds dropp'd in mid-flight out of the sky;*
> *And earth shook suddenly.*

25. Mannerism, as we have said, had already started the revolt. Cf. Hauser, *The Social History of Art*, I, 358: "Mannerism begins by breaking up the Renaissance structure of space and the scene to be represented into separate, not merely externally separate but also inwardly differently organized, parts. It allows different spatial values, different standards, different possibilities of movement to predominate in the different sections of the picture: in one the principle of economy, and in another that of extravagance in the treatment of space. . . . The final effect is of real figures moving in an unreal, arbitrarily constructed space, the combination of real details in

an imaginary framework, the free manipulation of the spatial coefficients purely according to the purpose of the moment. The nearest analogy to this world of mingled reality is the dream, in which real connections are abolished and things are brought into an abstract relationship to one another, but in which the individual objects themselves are described with the greatest exactitude and the keenest fidelity to nature. It is, at the same time, reminiscent of contemporary art, as expressed in the description of associations in surrealistic painting, in Franz Kafka's dream world. in the montage-technique of Joyce's novels and the autocratic treatment of space in the film. Without the experience of these recent trends, mannerism could hardly have acquired its present significance for us." And ibid., II, 937: "Only mannerism had seen the contrast between the concrete and the abstract, the sensual and the spiritual, dreaming and waking in a similarly glaring light."

26. Ibid., pp. 939–40: "The new concept of time, whose basic element is simultaneity and whose nature consists in the spatialization of the temporal element, is expressed in no other genre so impressively as in this youngest art [the film], which dates from the same period as Bergson's philosophy of time. The agreement between the technical methods of the film and the characteristics of the new concept of time is so complete that one has the feeling that the time categories of modern art altogether must have arisen from the spirit of cinematic form, and one is inclined to consider the film itself as the stylistically most representative, though qualitatively perhaps not the most fertile genre of contemporary art."

27. See Olga W. Vickery, "*The Sound and the Fury;* A Study in Perspective," *PMLA,* LXIX (December 1954), 1017–37.

28. Excerpt above from "A Valentine for Sherwood Anderson," *Portraits and Prayers* (New York: Random House, 1934), p. 155. *Ida* (New York: Random House, 1941), p. 146.

29. Sutherland, *Gertrude Stein,* pp. 12, 54–55, 59, 117, 200–201.

30. *Selected Writings of Gertrude Stein,* ed. Carl Van Vechten (New York: Random House, 1946), p. 174.

31. The chief contribution of the Italian futurists consists in their manifestoes, which were usually in French. This is the conclusion which Renato Poggioli arrives at in his *Teoria dell'arte d' avanguardia* ([Bologna: Il Mulino, 1962], p. 254), a historical, ideological, and social panorama of modern aeshetic currents, (*The Theory of the Avant-Garde,* trans. G. Fitzgerald, Harvard University Press, 1968). On futurism, see Marianne W. Martin, *Futurist Art and Theory* (Oxford: Clarendon Press, 1968).

32. See K. L. Goodwin, *The Influence of Ezra Pound,* pp. 172–73.

33. *Poems: 1923–54* (New York: Harcourt Brace, 1954), p. 133.

34. *Useful Knowledge* (London: Bodley Head, s.d.), p. 83. See Sutherland, *Gertrude Stein,* p. 116: "as absolute as Mondriaan."

35. What follows is based on an essay by Giorgio Melchiori on "The Abstract Art of Henry Green" included in *The Tightrope Walkers,* pp. 188–212. For other instances of abstract tendencies in fiction see Julian Mitchell in *The London Magazine,* V (January 1966), 83–84.

36. *Living* (London and Toronto: Dent, 1931), p. 199.

37. *Back* (London: The Hogarth Press, 1946), pp. 7–8.

38. Hauser, *The Social History of Art,* I, 356–57, stresses the similarities between mannerism and the art of our time: "Only an age which had experienced the tension between form and content, between beauty and expression, as its own vital problem, could do justice to mannerism. . . ."

39. The abstract tendency, the dissolution of forms in an unreal, undefinable space, may be observed in El Greco's paintings, for instance in *The Visitation* (Dumbarton Oaks Collection), Washington.

40. Cf. Sutherland, *Gertrude Stein*, p. 193 (italics mine): "It amused Gertrude Stein to find that her early arrangements and abstractions, which had seemed to be *highly acrobatic and gratuitous* if refined formal exercises, were turning out to be literal transcriptions of the most evident realities, that is the same abstractions and arrangements on which life is more and more consciously conducted by people at large. (Cf. *Composition as Explanation*, p. 9.)"

41. *Pack My Bag* (London: The Hogarth Press, 1946), p. 88.

42. Herman Meyer, "Die Verwandlung des Sichtbaren, Die Bedeutung der modernen Bildenden Kunst für Rilkes späte Dichtung," *Deutsche Vierteljahrsschrift für Literaturwissenschaft und Geistesgeschichte*, XXXI:4 (1957), 465–505; later published in book form: *Zarte Empirie* (Stuttgart: J. B. Metzlersche Verlagsbuchhandlung, 1963), pp. 287–336.

43. Rainer Maria Rilke, *Briefe*, II, 1924–26 (Weimar: Insel-Verlag, 1950), p. 490. Another analogy between Rilke and abstract art has been pointed out by H. Rosenberg, *The Anxious Object*, p. 158: "In turning to action, abstract art abandons its alliance with architecture, as painting had earlier broken with music and with the novel, and offers its hand to pantomime and dance. . . . 'Liebesbaum' [by Hans Hofmann, 1955], is a tree danced—in the scent of one of Rilke's nymphs: 'Dance the orange. The warmer landscape, fling it out of you, that the ripe one be radiant in homeland breezes!' "

44. Francesco Arcangeli, "Picasso 'voce recitante,' " *Paragone*, No. 47 (1953), p. 62, has touched on the relation between cubism and music. How deceptive musical parallels can be, may be judged, for instance, from the assertion of T. S. Eliot that while writing his *Four Quartets* he had in mind Béla Bartók's *Quartets*. It could be more convincingly argued that there is an affinity between Proust and Gustav Mahler, whose *Ninth Symphony* presents a variegated texture without a very pronounced structure, so that it sounds like a continuous stream full of nuances.

45. Cf. Hauser, *The Social History of Art*, p. 946.

46. Wilson, *The Wound and the Bow*, p. 265.

47. For Sutherland, *Gertrude Stein*, p. 178, the reverse would be true: "Gertrude Stein is more difficult than Picasso because one can more readily take what goes on in paint qualitatively than one can what goes on in words, words being more habitually involved than lines and colors are in conveying information about the situations of real action—semantically. One does not understand a Picasso after recognizing the stray nose or table top, the rest is the simple experience of quality so intense and dramatic in itself that it holds the attention and excites and satisfies without the confusion of understanding. But when Gertrude Stein uses words and even numbers qualitatively, as experiential finalities and things in themselves, our attention is likely to fail because what normally keeps it up in words is information."

Index

INDEX